"*From death's arrest no age is free*
Remember this a warning call,
Prepare to follow after me.
The wise, the sober and the brave,
Must try the cold and silent grave."

—ORANGE, N.J., 1806

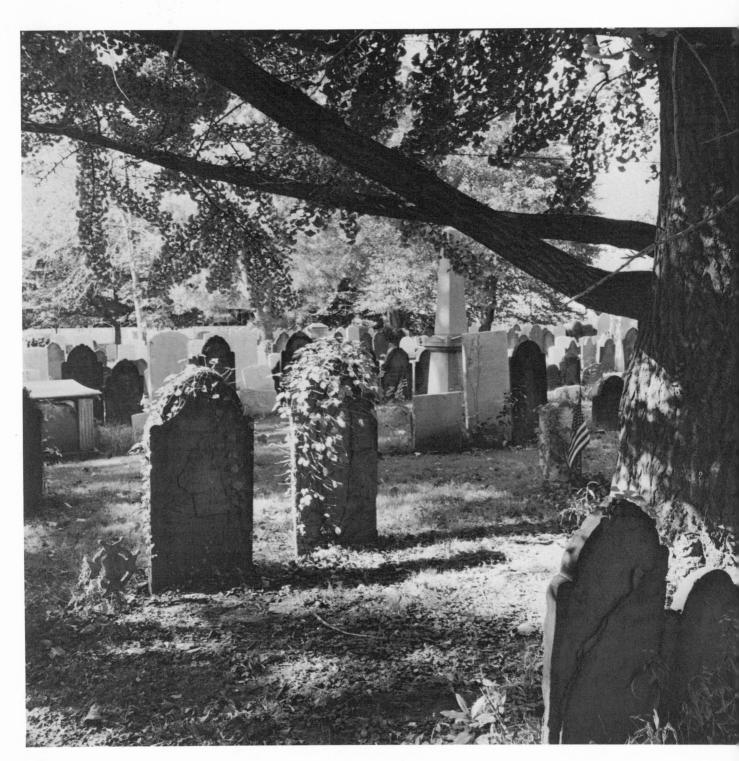

First Presbyterian Church burial ground, Elizabeth, N.J.

GRAVESTONE DESIGNS

RUBBINGS AND PHOTOGRAPHS

FROM EARLY NEW YORK & NEW JERSEY

Emily Wasserman

DOVER PUBLICATIONS, INC., NEW YORK

Published in Canada by General Publishing Company, Ltd., 30 Lesmill Road, Don Mills, Toronto, Ontario.
Published in the United Kingdom by Constable and Company, Ltd., 10 Orange Street, London WC 2.

Gravestone Designs: Rubbings and Photographs from Early New York and New Jersey is a new work, first published by Dover Publications, Inc., in 1972.

DOVER *Pictorial Archive* SERIES

International Standard Book Number: 0-486-22873-8
Library of Congress Catalog Card Number: 79-174493

Manufactured in the United States of America
Dover Publications, Inc.
180 Varick Street
New York, N.Y. 10014

DEDICATED TO MY PARENTS

FOREWORD

The art of gravestone cutting flourished in the American Colonies from about 1650 until the end of the eighteenth century. Although little significance was accorded to this special craft while it was being practiced, the tombstones themselves are an eloquent testimony to the instinctive skill of their carvers. For the most part, these were unsophisticated men who worked locally and in isolation, with little or no formal artistic training to guide their designs and inspirations. Yet these artisans—who left few, if any, personal records or documents about their clients, their imagery or their sources—may be credited with developing one of America's first truly native art forms. Until quite recently, the wealth of original decorative, symbolic and historical material which was carved into these handsome grave markers has received little recognition from art historians or the public.

I first began doing rubbings for the enjoyment of the craft itself. This soon developed into an effort to preserve some part of this rich storehouse of a vigorously individualistic American art before it weathered away or suffered vandalism and uprooting. This ancient method for obtaining exact readings of stone carvings in low relief was supplemented by photographs, taken to complete the record of epitaphs and other inscriptions, as well as to picture the actual appearance of the stones and to suggest the atmosphere of the cemetery settings. The two mediums provide complementary but different accounts of the tombstone sculpture. Where photographs fail to give a clear reading of especially shallow-cut carvings, the rubbing technique aims to bring out graphically the details of the more delicate incisions. Since I was working on a fine-grained but porous sandstone most of the time, I used a hard, resinous material (much like the English cobbler's "heel ball") which would not penetrate through the fibers of the rice paper. This solid substance was chosen instead of the traditional Oriental wet-ink method employed by some gravestone rubbing practitioners who deal with a smoother, less absorbent slate. I tried to duplicate the feeling of the hues and textures of the stones with a dark reddish-brown or blackened coloration in the rubbing print.

The principle of doing a rubbing is as simple as that of passing a soft pencil over a piece of paper pressed firmly onto a coin. The graphite will pick up the image of the coin in raised relief, leaving the shallower sections white—thus creating a "negative" of the original, since the incised areas of the coin would normally be seen in shadow, and the protruding relief would be in light. Reproducing the design from a gravestone requires some more special skills and patience, to be sure (along with a respect for the preservation of the sometimes fragile stones), but the approach is similar to the coin example, as long as one makes sure that the paper used is stuck tightly to the stone with masking tape to avoid slipping.

I usually confined myself to documenting the images at the top sections of the gravestones, because of limitations of time and interest, or be-

cause of the poor condition of many markers in their lettered areas, nearer to ground level. Some complete stones were recorded, however, when the pattern was particularly beautiful or distinctive. Most of my work with gravestones and the research about their cutters centered around northern New Jersey and New York City, where I lived, and where I felt that the markers were especially threatened by the elements, pollution or commercial and residential development. Some field work was also done in New England, and a few comparisons are included here to indicate regional differences in carving styles or intentions. This could not be the definitive study of the area I covered, since I worked alone and without the benefit of grants or academic support. It is hoped that this book and its illustrations may serve as a guide and handbook for those who are able to pursue the scholarship or fieldwork more fully.

E. W.

ACKNOWLEDGMENTS

During the past seven years many people have contributed to my efforts at making rubbings and at recording and documenting the gravestones and the men who carved them. I would like to thank most of all my father, who generously and unfailingly supported my needs for materials and excursions throughout this period, and my sister, Myra Epstein, who first stimulated me to do the rubbings and to investigate the Colonial cemeteries of New Jersey, my home state.

Those who granted permission for my periodic, and sometimes unsettling work in their churchyards are also to be thanked: Mr. Desmond L. Crawford, Comptroller of Trinity Church Corporation, N.Y., and the Reverend Raymond Wallace of the First Presbyterian Church of Elizabeth, N.J. in particular. Robert Beckwith of Dover, N.J., and Floyd Johnson of New York both lent help and advice in field work on various occasions. Mr. Donald Sinclair, Curator of the New Jersey Special Collections at Rutgers University, New Brunswick, N.J., aided patiently with my initial research on New Jersey stonecutters. Ann Parker and Avon Neal provided an exemplary model with their fine New England rubbings and photographs, as well as their friendly and professional interest in my project. Finally, Daniel Lenore and Jeffrey N. Brilliant helped significantly in the completion of the photographic documents.

CONTENTS

INTRODUCTION

I. Gravestone Monuments:
Their Origins and Their Purposes in America

The history of stone monuments erected over the tombs of the dead
stretches far back into man's past. The shapes used by the American
colonists for their grave markers were the ultimate descendants of an-
cient prototypes—from the pyramids, obelisks and effigies of the Egyp-
tians to the commemorative funerary stelae of the Greeks and the slabs
or sarcophagi of the Etruscans, Romans and medieval Christians. The
tradition of "magic imagery" adorning such monuments is equally old; in
Egypt it developed out of the need for permanent symbolic substitutes for
the real but perishable provisions that the dead person would require
during his afterlife. The use of engraved, sculptural or painted images
was a pagan practice, hesitantly adopted by the earliest Christians, who
had to transform the old mythological symbols in order to express suitably
the meanings of their new religion. Bacchic putti making wine became
heavenly cherubs, and winged victories were converted into Christ's
angelic messengers or allegorical, personified virtues. While it cannot be
claimed that the rustic markers of the American colonies represent a con-
scious, direct cultural continuation of these monuments of prehistoric,
ancient and European civilizations, they are nevertheless part of the same
archaic idiom of forms and the concomitant belief in respectful care for
the buried.

The conception of a grave as a bed of rest and an adequate house for
the dead is expressed by the very word "cemetery," whose Greek root
means "to lull to sleep."[1] The American Puritans also thought of the tomb
as a doorway through which a person's soul would pass en route to glorifi-
cation in heaven, a portal between the translation from flesh into spirit and
the translation from death into resurrection.[2] The references to these no-
tions are easily found in colonial epitaphs and in the characteristic shapes
of the stones as well. The idea of the grave as a residence is inscribed on
the marker of a Revolutionary War soldier, Thomas Parcel, who died in
Shorthills, N.J., on July 4, 1778 (author's italics):

> Inclosed within this gloomy *Mansion* lies
> One who was once regarded good and wise
> When Death's dark Cloud obscurd ye vital Sight
> Life's Sun wax'd dim and plung'd ye Shade of Night
> Attend ye fair ye wise Surround the Tomb
> Piruse these lines and learn to know your Doom.

Another frequent verse, seen especially on the small stones made for chil-
dren, such as that of Sarah Bonnorjelf in Succasunna, N.J. (d.1777, age 6
weeks; cf. Plate 12) reads:

> Sleep lovely babe since God hath called thee hence
> We must submit to his wise providence.

Or again, the suggestion of the grave as a bed of rest, from Plate 63b (1818; author's italics):

> My flesh shall *slumber in the ground*
> Till the arcangels trump shall sound
> Then burst the chains with sweet surprise
> And in my Saviour's image rise.

The typical forms of grave markers used in America included large, aboveground brick or stone *tombs* with flat carved slabs resting on their bases; *tablestones*, tablets raised off the ground by legs or pillars; *slabstones*, placed flush against the earth over the interred coffin; and most commonly, *headstones*, the simple upright tablets set at the head of the grave, sometimes complemented by a smaller *footstone*. The most frequent shape of these markers was a three-lobed, door-like silhouette, which recalls the traditional tripartite form of ancient triumphal arches—perhaps a reference here to the soul's passage to eternal rest and glory.[3]

The unrefined but emphatic images cut into the sandstone and slate tablets served a variety of purposes for the community of worshippers and for the individual craftsmen who made them. On the most apparent visual level, the imagery functioned decoratively, characterizing the Puritan's rarely evidenced artistic sense. But it also revealed in symbols his deep and abiding reverence for death and his hopes for resurrection. On other functional objects made by these settlers, one finds virtually no images and little creative decoration—there was simply no leisure time for such impractical frivolity, while life itself was so difficult to sustain. The primitive limner work, the equally graphic shop and trade sign paintings—even the early portrait attempts—do not express or exemplify a philosophy of life as conscious as that represented by the gravestone carvings and inscriptions.

The threatening pictures of hollow-eyed death's-heads, coffins, pickaxes and other emblems of burial or resurrection used from the late 1600's to the early 1700's gave way in time to the more gentle and elegiac angels, birds, flowers, cinerary urns and weeping willows, indicating mourning and the rewards of a heavenly paradise. The images were progressively stylized away from their original emphasis on the facts of mortality and death. This mitigating process certainly reflects the changes through which colonial life had passed—becoming less severe and more secularized in general during the later eighteenth century.

In her pioneering study of early New England gravestone cutters, Mrs. Harriette M. Forbes remarks that up to the middle of the colonial period, "death was a diversion"[4] in the monotonous, hard life of the settlers, and Allan Ludwig adds that "only in the rituals surrounding death, did the Puritan community as a whole indulge in image-making."[5] A death in town brought work to local artisans, and served as a source of literary inspiration for the poets or ministers who wrote the epitaphs. Because other kinds of imagery were so uncommon, the impact of the gravestone carvings must have been forceful, especially since literacy was not widespread, and few people could actually read the words below the pictures until a later period. The monuments thus relied heavily on the visual symbols to convey the lessons of man's mortality and the promises of Heaven's blessings, and to interpret the religious concepts to the layman in an immediate and graphically recognizable way.

Burial grounds in America were usually adjacent to the meetinghouses and churches, though they were often town (secular, rather than parish) property. A pleasant noon hour could be spent around the churchyard (which was usually planted with cool, shady trees), gathering with

friends, praying inside the sanctuary or meditating upon the stones outside. It was a spot for physical exercise and spiritual instruction, particularly during the break between morning and afternoon sermons on the Sabbath.[6]

The graphic images often point out a moral lesson; for example, the stark, hollow-eyed and primitive skull on the stone in Plate 5a (1733), or the one in Plate 5b (1733) with its triple rows of teeth, clearly warn the living viewers of the certainty of death. The thoughts or feelings invoked by the inscriptions and designs were both *commemorative* and *anticipatory* of the life of the soul after death. The phrases "Remember death" (*Memento mori*) and "Prepare for death" are echoed hundreds of times. The classic verse, which dates back at least as far as the Renaissance (it appears in Latin over the reclining skeleton painted beneath Masaccio's *Trinity* in the Florentine church of Santa Maria Novella), reads

> Behold and See as You Pass By
> As You are Now so Once was I
> As I am Now you Soon will Be
> Prepare for Death and Follow Me,

on the 1769 stone in Plate 24. Or, more pointedly, the grave of Daniel Soverel in Orange, N.J. (d. 1821, age 2) states:

> The Lord He call'd he thought it best
> That I should now be early blest,
> This world is folly you plainly see
> Therefore prepare to follow me.

There was room for the dirge, as well as for humor, even in the expression of these gloomy sentiments. The inscription on the stone of John Right in Orange, N.J. (d. 1806, age 18) reads:

> Farewell my young companions all
> From death's arrest no age is free;
> Remember this a warning call,
> Prepare to follow after me.
> The wise the sober and the brave
> Must try the cold and silent grave.

(He had learned the lesson of "death's arrest" verbatim from his primer.) The lines written for Lieutenant William Parsons in Northampton, Mass. (d. 1768, age 78) are more curt, even joking, in tone:

> While living men my tomb do view,
> Remember well—here is room for you.

One of the more original means of inscribing this warning appears in a unique cryptogram on a 1794 headstone in New York City (Plate 55a). The markings, when deciphered, mean "Remember death," and are engraved above Masonic symbols, a winged hourglass and a flaming cinerary urn which encompasses a tiny "soul-heart." The key to this cryptogram appeared in an old parish periodical, the *Trinity Record* of February 1889.

Other symbols and inscriptions refer to the flight of time, with winged hourglasses and crossbones (Plates 4a, 4b, 18b, 22 and 71), to the dead man's station in life (see note to Plate 27a) or occupation (Plates 24, 56b, 57 and 58), or to the activities of the soul when it is redeemed in Heaven. Sometimes the elegant scroll or floral designs simply crest the head of the grave with beautiful abstract or decorative motifs, as on a 1786 stone in New York City (Plate 53b). The luxury of ornamentation that was forbidden to the devout worshipper during his lifetime was permitted to him after death, as a kind of "final grace."[7]

More secular "portrait" types directly relating to the persons buried beneath the headstones were common during the later eighteenth century in New England, with both full-face and profile renditions, like the delightfully direct and vivid record of Major Lemuel Hide (Old Hadley, Mass.; cut by a man now called "the Carver of Enfield")[8] sporting his military buttons, high collar and neat wigged pigtail (Plate 50). The design is almost Egyptian in feeling, with its firmly contoured profile, tight lips and the staring frontal eye—except for the whimsy of a tiny double chin pushing up from the cinched collar! Such definitely personalized portraits are found often north of Connecticut, but they are virtually nonexistent in the New York Metropolitan area. The closest approximation to portraiture in New Jersey or New York would be a generalized male or female type angel effigy, such as those shown in Plate 21b (1736) and Plate 22 (1759). Semi-portraits of this kind only determine the gender of the effigy or of the deceased person, but the actual features are probably not attempts at accurate rendition (cf. Plates 43a, 45b, 46a, 46b, 47a, 48a, 49a and 49b). This lack of real portraiture cannot be ascribed to any deficiency in means or inspiration, since the New Jersey and New York carvers were as skilled and innovative in their time as their New England counterparts. With no records from the stonecutters themselves about this matter, the assumption is that the more moderate Presbyterian, Congregationalist or Quaker men and women of the middle states simply had less interest in direct portraiture. Perhaps the carvers had no appreciable clientele that was as concerned with immortalizing themselves individualistically in stone as were some of the staunch New Englanders.

II. The Stonecutters and Their Art

The men who prepared the local headstones were frequently engaged in other trades—blacksmithing, stone masonry, bricklaying, carpentry for domestic construction, leathercrafting, shoemaking—and practiced gravestone cutting as a subsidiary activity. The limited population in the early Colonial period meant that the tombstone carving business could not be an exclusive or lucrative occupation for anyone. The brazier, cordwainer or woodcarver who might have been recruited as the village stonecarver probably applied the details and patterns he knew from his main craft to the more permanent markers he was called upon to produce for the churchyard. So little significance was attached to the craft of the gravestone cutter during the height of this activity that contemporary records rarely mention more than the briefest lists of payments, dates or clients' names, let alone consider the carved reliefs as a form of art.[9] Very few of the stones were signed (although there are some exceptions), and the names of most of these early indigenous artists are lost to us now. Yet each stonecutter's unique imaginative motifs served as his own visual trademark, and it is usually easy to recognize the work of the same hand or workshop when scanning the stones in a single burial ground or region. Doubtless there was no need for a signature when a carver was the sole practitioner of his trade in a small area; and there are instances where a stonecutter would affix a name to his work only when he exported it to a town outside of his immediate locality.

The type of stone available locally determined the sizes of the tablets, the styles and to some extent the applicability of certain configurations. Red sandstone, quarried in New Jersey and along the Connecticut River Valley, was the material most frequently used in New Jersey and New York. A soft white marble was employed during and after the Civil War, but its porous, granular composition has resulted in the gradual breakdown of most of these later markers.

No records exist to the effect that the heavy, unwieldy (200 to 300-pound) stones were imported, already hewn, from England or elsewhere outside the country. It is certain, however, that instead of long-distance overland passage they were shipped along or across water routes from place to place within the Colonies (e.g., New England to New York; Connecticut to Long Island; New York to New Jersey shore; lower Manhattan to Staten Island, etc.), if there were no adequate stonecutters yet working in an area at the time that the deceased were buried. The earliest stones at Trinity churchyard in New York City bear the styles of Boston and Charlestown (Mass.) stonecutters' work of the period from 1680 to 1700. The marker in Plate 11 (1715), with its grimacing, feathery-winged skull; its capital lettering and its diagonally grained slate, looks like the documented carving style of Joseph Lamson, who worked at Charlestown and lived from 1656 to 1722. The fine-grained black slate of Plate 10, decorated with a smaller skull and fruit-filled borders, is in the manner of William Mumford, a Boston carver (1641-1718) also identified by Mrs. Forbes.[10] Since dark slate was commonly used in New England throughout the period from 1670 to the 1800's, but aside from these few instances is not found at all in New York or New Jersey much after 1730, this seems to be a clear case of importation. Beyond that date, New York could supply its own craftsmen.

The softer sandstone allowed for bolder, broader patterns and for larger headstones in general; the delicate incisions which outline the more intricate details on the smooth slate or schist stones of New England were not as possible stylistically for the New Jersey/New York carver. Probably the degree of isolation in which most stonecutters worked was a positive rather than a negative factor esthetically. It permitted an unfettered originality of invention which accounts for the wide divergences in style and motifs, if not in overall symbolic reference, within a limited geographical district.

It is apparent from the native originality of the stones themselves[11] that there was no appreciable immigration of trained gravestone cutters from England or the Continent to the Colonies. Most of these workers were locally born. The relationship between the type of stone used (often uniform for broad areas of a state) and each carver's personalized creative abilities is dramatically reflected in the diversity of styles to be found even in the smallest churchyards. The First Presbyterian churchyard at Orange, N.J., the larger and older burial ground on North Broad Street in Elizabeth, N.J., or those of Trinity and St. Paul's Churches on Broadway in New York City are all fine examples of this multiplicity of vital, unique styles and manners centered in one locale.

Most of the men who cut gravestones were uninstructed craftsmen, whose work was largely independent of formal principles of design. Although they may have been influenced in their use of symbols and emblems by a long and well-known tradition of religious iconography in popular thought, their techniques were mainly the result of individual improvisation and imagination. The average Colonial carver did not have access to a readily available body of artistic tradition, like his counterpart in the Old World. He was forced back upon his own visual fantasy, though he was theologically bolstered by the local preacher's version of orthodox belief, as expressed in the Sunday sermons and Bible lessons. It seems incredible that people would buy stones with crude designs, bad spelling or careless cutting.[12] But when we realize that the patrons had little choice, especially in the smaller towns, and that they had to settle for what they could get from the sole available stonecutter, it becomes clear why they accepted what might appear to us now as a bungled job!

With the growth of population, the business of providing gravestones became more profitable financially. As a result of the apprenticeship training system practiced by Colonial tradesmen, there emerged workshops or families of stonecutters who passed on their skills and designs through several generations. Sometimes deeds, probate records or infrequent signatures on the stones reveal the identity of the men who made them. In New York City signatures seem to be nonexistent, while in nearby New Jersey they appear at the bottom or top of the tombstones quite often, either initialed or with the name of the cutter written out in full. Even if an apprentice or son, following in his master's footsteps, adopted a similar manner and used the same designs, soon a personal style would crystallize, and his work would become distinct from the hand of the teacher. This kind of situation can be studied at Elizabeth, N.J., and in the surrounding communities.

Stones on which designs were cut by the master during his lifetime were sometimes left over and used after his death, with the lettering cut by an apprentice or by a friend of the deceased. If deaths were scarce in a locality where a man practiced tombstone cutting, this would make it look as if his working years were prolonged, since he would leave a surplus supply of already carved stones.[13] This results in confusions about the dating of a man's true span of original work. It may also provide a reason for discrepancies between well-designed images and misspelled or poorly cut inscriptions (and vice versa). An example of this can be seen on a large double stone (1751 and 1765) in New York (Plate 15b), where two reasonably well cut angel effigies with curling ringlets and rosette "crowns" flutter above an amusingly misspelled verse reading:

> Ly stil dear Bads: and Take your rest
> God cal'd You Hom Becas he though it Best—

or, more recognizably:

> Lie still, dear babes, and take your rest;
> God called you home because he thought it best.

Sometimes the work of one carver can be pinpointed by the type and quality of the stone material, along with his stylistic peculiarities, even when no signature can be located. One New Jersey cutter, whose handiwork dominates the cemetery at Orange, and turns up regularly at Elizabeth, Springfield and Parsippany, as well as in New York, worked on a fine-grained light red-orange sandstone, which was cut into generous-sized three- to five-foot-high markers. He was active from about 1764 to the 1780's or '90's (see Appendix D). The bold hand which fashioned his angels with their elongated faces and puffy cheeks, strikingly surrounded by stars, hearts, hourglasses and undulating bands of spirals, within an elegantly scored lunette framework, is distinctive identification even without a signature. The balanced, ample proportioning of the letters, the handsome clarity of the chiseling and the unwillingness of this carver to ever repeat himself identically on any two stones mark his manner as exceptionally fine and inventive (Plates 16a-20 and 81-85). The headstone of Anthony Ackley (1782), which still grins out to passersby on the busy intersection of Broadway and Wall Street, was no doubt shipped across the bay from the port of Newark at Elizabeth, near this carver's New Jersey workshop.

Other cases of such interstate exchange and passage are documented by the styles or signatures on two groups of stones in the churchyards of Trinity and St. Paul's, N.Y., and in a small country burying ground hidden among a grove of pines in Middletown, N.J., not far from the Atlantic sea-

coast. The unidentified carver, who probably worked out of New York,[14] is distinguished by round-faced, childish angels with sad, almond-shaped eyes, cleft noses, swelling wings with long tubular feathers, and a tiny trademark, a split "O" or eyelet, beneath the chins of some of the images (see notes to Plate 43). His alphabet style, the hue and grain of the extremely fine sandstone he used, and a fairly short working period dating from circa 1781 to 1785 locate this cutter's work in time, without naming him specifically. Perhaps he moved down from the Connecticut Valley for a short stay, and then moved somewhere else, where work was more plentiful or living conditions better.

So many of the men who produced the charming and instructive images in stone are themselves elusive figures. They are known to us only by these almost forgotten markers, which are gradually being obscured by the tangles of ivy and undergrowth in tiny rural cemeteries like the one at Middletown.

Another find at this same country graveyard identified one of New York's most prolific and original carvers, who apparently never signed his name on a stone within his home town. Both Trinity and St. Paul's, as well as the burying ground at Richmondtown, Staten Island, are populated by numerous tombstones cut in a similar manner, dating from circa 1759 to 1776. Many others by the same hand or workshop are also found at the Old Dutch Cemetery of Sleepy Hollow, in Tarrytown, N.Y. (see Plate 89), and some occur in the vicinity of Southold and Cutchogue in northeastern Long Island (see Index C). Angels of several types are the basic pattern. They appear with smiling and frowning elongated, pear-shaped or square puffy-jowled faces with tiny pointed chins, topped by whimsical crowns in an endless variety of designs: sprouting tulips, spiral-filled cones, "checkerboard," floral, and pronged versions. The wings are usually segmented into neat rows of scales defined by half-moon incisions. Round or flattened spirals serve as "finials" above the borders on either side of the inscription panels, which are chiseled with the finest lettering, often embellished with fancy calligraphy (see Plate 24) and finished by a few choice poetic verses. The archaically spelled lines on a double stone from Tarrytown are expressions of the sentiments typical of the grave designs of the period. One side reads:

> In Lives Full Joys And
> Virtuous Fareest Blome
> Untimely Chackt And
> Horeed To The Tomb
> Life How Short
> Eternity How Long

The other side supplements this melancholy sigh with the unflinching warning:

> Hark From the Tombs
> A Doulfull Voice
> My Ears Atends the Cry
> You Liven Men
> Com View The Ground
> Where You Must Shortly Lie.

Compare Plate 89.

This cast of carved characters—a true heavenly host—bore no exact repetition during the entire time that the cutter produced his distinctive stones. He must have been well known in his native city, since there are no visible initials or signatures on any of his New York work (unless they

are now buried far below present ground levels, which is unlikely); see Plates 24-29, 88, 90 and 91. But when a similarly designed and executed stone was sent across the river from New York, probably by barge, to Middletown, N.J., the proud artisan carefully placed his trademark "John Zuricher, Stonecutter, N.Y." (Plate 25a) at the bottom of Catherine N. Crookshank's large 1776 marker (Plate 25b). An unsigned tablet erected for Jonathan Stout, also at Middletown, whose angel is the kind seen in Plate 25b or 25c, is also inscribed with the same admonitions that appear on the most elegant and sizable tombstone made in New York by Zuricher, at St. Paul's (Plate 24). Perhaps when work was sent outside of a carver's native community, he was more apt to advertise his accomplishments with a signature. Close access to waterways provided the link for the interchange and transport of Zuricher's carvings around New York.[15]

III. Sources for Imagery and Styles of Stonecutting

There are few records which might give us direct contemporary information about the sources for the styles and imagery of the gravestone reliefs. It is evident from the repetition of many designs and epitaphs that the symbols and the meanings they were intended to express were used consciously by their carvers, but there is no way of knowing how well these visual and verbal symbols were understood by those who commissioned or viewed them. There are discernible differences between the images employed by the cutters from New Jersey and New York and those generally preferred by their New England counterparts, differences which go beyond mere individual idiosyncrasies of manner. The chiseling quality, degree of sophistication and crudity or finesse of design vary as much from artisan to artisan as they do farther north; certainly the tombstone carvers from the Manhattan area were no less inventive than their fellow Colonists. But an overall view reveals that the sandstone markers from New Jersey and New York City lack the fanciful imagination or spiritual extremity of New England's slate gravestones; they avoid elaborate theological notions and never depict complex eschatological allegories, as is the case on many early eighteenth-century stones from the Boston, Cape Cod, Rhode Island or Vermont regions. New York City has some of the most primitive (Plates 13-15) as well as the most elegantly conceived and executed images (those by Zuricher), so it is hardly a matter of ignorance or absence of craftsmanship on the part of the cutters who worked there during the latter part of that same century.

Differences in type of stone do account for certain variances, as pointed out already. What it is possible to cut into a slate or hard granite schist slab (the most common New England materials) is not feasible technically, or even esthetically, on the grainier, softer red sandstone used more often by the New York/New Jersey stoneworkers. But climatic and regional cultural conditions may also offer reasons for these contrasts. New England's extremes of climate, its isolation, and the sheer rigorousness of maintaining a comfortable life there during the era of settlement set the stage for the witch hunts and the requirements for a strict moral discipline which mark the spiritual atmosphere of its early history. The often harsh but still beautiful extremes of this culture and its landscape inspired mystical flights of the imagination, theological conjecture and a passionate and devoted religiosity on the part of the simple farmers as well as among the urbanized inhabitants of New England. It is understandable that this resulted in plastic forms different in kind and spirit from those of the middle states. The more temperate climate and

arable land of New Jersey and New York, their position as a busier commercial crossroads within the Colonies, and the coexistence of Quakers, Scotch Presbyterians, Episcopalians and Catholics along with the older Puritan Protestant stock probably made for a more urbane outlook altogether.

The merchant-farmers of the Metropolitan area were probably more politically and financially oriented than they were religious. And although the evangelical Puritan spokesman Jonathan Edwards came to preach about the heartfelt immediacy of faith to the parish members of Elizabeth's First Presbyterian Church (the church of the founding fathers of the state, which became Presbyterian only after about 1720), the spiritual mood in New Jersey at the time was certainly less fervent than that of New England. Indeed, Elizabeth's own minister, the Reverend Jonathan Dickinson, wrote a book of *Discourses on the Reasonableness of Christianity* in 1713. The earliest settlers of his parish—with names like Crane, Ogden, Young, Woodruff, King, Tuttle, Tucker, Osbourne, Marsh, Price, Meeker, Hatfield, Pearsal, Sayre, Ross, Oliver and Thompson— most of whom came from the eastern end of Long Island, and some from Connecticut, were of Puritan background and heritage. But they had chosen to move away from their first roots in the New World to start life elsewhere. During the Revolutionary period, the Reverend James Caldwell encouraged patriotism and independence for his community, while his churchmen supplied a large number of officers to the American cause: General Jonathan Dayton (Plate 65), Private Charles Tucker (Plate 110), Major Nehemiah Wade (Plate 31a), Lieutenant Moses Ogden (Plate 101), Private Farrington Price (Plate 61a) and others.

While these regional differences might be speculative, there were more definite and traceable general sources upon which the carvers of American mortuary monuments could draw. Back in England gravestone makers could look to the many already existing forms of volumetric stone ornament on buildings and statuary, or to the flatter printed emblems in pattern books that were popular during the seventeenth century among masons, wood engravers and other artisans.[16] Fine architectural or sculptural models were lacking in the Colonies, and such emblem books were probably unavailable to the more rural stonecutters, who worked in isolation under rather primitive conditions of craftsmanship and artistic education. But there was a vocabulary of mortuary art that had been carried over from the Old World and could serve as basic source material. The rituals attending death and burial, as practiced by the Puritans, were sometimes elaborate but still sombre. As Mrs. Forbes relates, they included processions of horses decorated with death's-heads on their foreheads and mortuary escutcheons draped over their flanks, escutcheons inscribed with pickaxes, coffins, the initials of the deceased, angels and other symbols of mortality.[17] These funerary emblems would then be printed on invitations and broadsides and sent to friends, in conjunction with the memorial sermons, eulogies and prayers recited at the burial ceremony.[18] It is possible that native carvers copied from these ephemeral broadsides.[19]

During the passage of the cortège from the meetinghouse to the graveyard, bells were tolled to signify the translation of flesh into spirit;[20] many such cemetery bells appear marginally on the stones or were hung as weights on guard chains strung around the more expensive and important tomb monuments. Most of these funeral trappings have now disappeared, but the culmination of the funeral rite was the erection of the more permanent engraved headstone. That the burying grounds of Colonial America are filled with such carved markers is sufficient testi-

mony to the fact that this act was the most important kind of respect which could be paid to the posterity of the deceased.

It may seem curious, in the midst of an economic context of austerity and a religious attitude of iconoclasm, that the Puritans would indulge in graven image making on such a wide scale.[21] But the annals of the history of art are interspersed with similar cases. During periods of intense opposition to visible symbols of the faith, religious art survives and is produced when there is enough popular need for the expressive outlet and instruction provided by imagery. In the early Christian paintings lining the walls of the Roman catacombs, the veiled emblems and figures were borrowed from the pagan sphere, for protective reasons, as well as for an understandable visual transition from one contextual vocabulary of meaning to another.

Another illustrated thematic source for the stonecutters was the *New England Primer,* printed in many editions around 1800. The first formal reading book in the Colonies, its alphabet and catechism verses were supplemented by small woodcuts depicting coffins, hearts, Bibles, suns and moons, hourglasses, Father Time and his scythe, the darts of Death, birds in the Tree of Life, etc. Motifs such as the winged timepiece accompanying the *Primer* verses "As runs the Glass,/Man's life doth pass," are found frequently, as on a tiny marker in Elizabeth, N.J. (Plate 54b). Beneath a well-formed skull and crossbones adorning a 1727 headstone (Plate 4a) are two small birds facing an hourglass—the same format, if not the same tree as in the *Primer* picture. The ornamental floral and calligraphic borders of "fraktur" documents, typesetting devices and other popular advertising broadsides may have offered other models.

But if American gravestone cutters used such graphic sources at all, their working process was one of diluting, abstracting and stylizing upon printed matter that was already a schematization of reality. This use of two-dimensional models was also due to the lack of any previous sculptural tradition in the New World. Thus, the style of the American tombstone carving—its flatness, its linearity, its conceptual and pictographic rather than plastic definition of shapes and forms—is partly due to the use of engravings, contemporary broadsides and reading-book woodcuts. Perhaps a carver would draw directly from nature to ornament the perpendicular side panels of his stone with thistles, wildflowers or fruits, suggesting a heavenly context (Plate 9). But like most "primitive" artists the world over, his ability to match what he perceived optically would fall far short of his skill to render it, and the result would be a conventional ideogram of the image rather than an accurate or realistic reproduction of it (see Plate 50).

It has been suggested that some of the earliest cutters may have brought designs in sketchbooks with them from the old countries, or that motifs could have been adapted from other crafts learned in Europe and practiced upon arrival in the New World—furniture carving, leather-tooling, metal-working, etc.[22] Drawing also from more indigenous arts and crafts forms, the cutters nevertheless transformed these ideas into something uniquely personal. Aside from the general tradition of mortuary symbolism and the random availability of printed source material, stylistically these rustic carvers worked with few artistic precedents. This lack of background no doubt permitted the constant variety of arrangement and pattern that is to be found within the work of each individual. Not until later in the eighteenth century, when the influence from Neo-Classic styles in architecture helped to dissolve the crude but expressive power of the earlier symbols, did a stonecutter ever make an exact replica of another gravestone carved by his own hand. From that

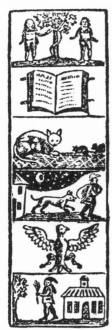

In Adam's Fall
We finned all.

Thy Life to mend,
God's Book attend.

The Cat doth play,
And after flay.

A Dog will bite
A Thief at Night.

The Eagle's Flight
Is out of Sight.

The idle Fool
Is whipt at School

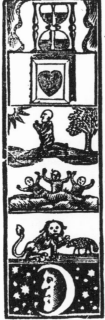

As runs the Glafs,
Man's life doth pafs.

My Book and Heart
Shall never part.

Job feels the Rod,
Yet blefles God.

Proud Korah's troop
Was fwallow'd up.

The Lion bold
The Lamb doth
hold.

The Moon gives light
In Time of Night.

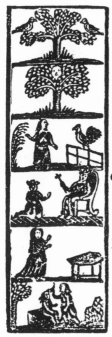

Nightingales fing
In Time of Spring.

The royal Oak, it
was the Tree
That fav'd his roy-
al Majefty.

Peter denies
His Lord, and cries.

Queen Efther comes
in royal State,
To fave the Jews
from difmal Fate.

Rachael doth mourn
For her firft born.

Samuel anoints
Whom God ap-
points.

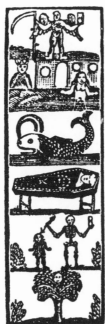

Time cuts down all,
Both great and fmall.

Uriah's beauteous
Wife
Made David feek
his life.

Whales in the Sea
God's Voice obey.

Xerxes the Great
did die,
And fo muft you
and I.

Youth forward flips,
Death fooneft nips.

Zaccheus, he
Did climb the Tree,
His Lord to fee.

An alphabet from the 'New England Primer' with verses and woodcuts.

point on, an eclectic repertoire of classical urns, willows, Federal and Greek Revival pilasters and sentimental Victorian motifs replaced the skulls and bones of former times, outdating (but not outliving) their harsh reminders with a softer, more decorous picture of death and the life to come.

IV. Epitaphs, Inscriptions, Lettering, Calligraphy

Even as far back in time as dynastic Egypt, a tomb or monument did not acquire significance or merit special observance and respect until it was inscribed with the name of its owner, patron or guardian deity or with the appropriate magical spells and prayers to insure its identifiable survival. The memorial inscriptions on English stones and, later, those used in America served to complement and amplify the accompanying images carved into the burial tablets, as well as to clarify symbolic themes, moral sentiments or beliefs. Often they added new and richer verbal images to the simple, emblematic designs already engraved on the headstones. The basic formula for an inscription was to set down the name of the deceased, the date of passing, the age at the time of death and sometimes the name of parents, husbands or wives. If there was room at the bottom of the stone, several verses were added, or perhaps they were allowed for in the original design. The repeated use of certain verses often helps to identify a carver whose signature is lacking. By means of alphabet styles, depth of carving, the preference for certain archaic expressions and spellings, and other eccentricities of hand or grammar, one man's work may often be singled out.

Epitaphs were sometimes composed by ministers or friends of the deceased, while other lines were taken from biblical quotations and themes, catechisms or sermons. During the eighteenth century, such popular features as the column called "Helicon Bag," printed in the *New Jersey Journal* (the earliest newspaper of wide circulation in that state), included sentimental poems, epigrams, epitaphs and bits of homely philosophy; these contents are reflected in the tombstone statements.[23] The thoughts expressed by the epitaphs range from brief Latin mottoes (*Fugit hora*—Time flies) and admonitions (*Memento mori*—Remember death) to religious precepts concerning salvation and resurrection and to graphically curt statements about mortality, such as the one on the grave of a newborn child at Northampton, Mass., which reads "From Womb to Tomb." The personification of Death as a cruel archer is recorded on many stones, both early and late, like that of Joanna Owen (d. 1813, age 5) and her sister Anne Halsted Owen (d. 1814, age 11 months) at Elizabeth, which registers the heartbreaking lament of the parent:

> Insatiate Archer! Would not one suffice!
> Thy shaft slew thrice and thrice my peace was slain.

Or on the half-obliterated grave of a person named Lester (d. 1766, age 30) in Trinity churchyard:

> Death thou hast Conquared me
> I By thy Darts am Slain
> But Christ Shall conquar thee
> And I Shall Rise Again.

Although many markers in the New Jersey/New York area bear inscriptions which speak in eschatological terms, the simple images cut in relief rarely echo the verbal elaboration. Such a discrepancy is found on the grave of Joseph Harrison Sr. (d. 1779, age 82) and his wife Mary (d. 1778, age 70) in Orange, N.J., which reads:

> See hear they Sleep in this Small Room
> Confined within the Ground
> And wait to See the Saviour Coume
> With Glory Flaming Round
>
> Thay Wait the Call Ye Dead Arise
> This Grave must then Obay
> And waking up with Joyfull Eyes
> Will hail the Glorious Day!

Some of the more sentimental verses are personalized addresses to the relations who survive the deceased. The 1764 Trinity stone of Mary Dalzell, who died at the youthful age of 28, speaks in a resigned fashion, viewing death as the great Equalizer:

> Adieu my dearest Babes and tender Husband dear
> The time of my departure is now drawing near
> And when I'm laid low in the Silent grave
> Where the Monarch is equal with the Slave
> Weep not my friends I hope to be at rest
> To be with Jesus Christ it is the Best.

Historical references are also common, especially in the cemeteries located on the sites of former battles. The stone of Nicholas Parcell (at Shorthills, N.J.), a Revolutionary War soldier who died at the hands of the Hessians in 1780 at the Battle of Connecticut Farms, Union (itself the location of a large Colonial burying ground), avoids any euphemisms in its account:

> Behold Me here as you Pass By
> Who bled and dy'd for Liberty
> From British Tyrents now am free.

The marker of his widow, Esther (d. 1816, age 68), who had to suffer the death of her husband as well as the loss of his brother Thomas and his children during the war years, attests to her faith and dignity of character in the face of successive tragedy:

> Call'd by affliction ev'ry grace to prove,
> In patience perfect and complete in love;
> O'er death victorious, through her Saviours might,
> She reigns, triumpant with the saints in light.

But again, the New Englanders go into greater detail, even in their historical inscriptions. The stone of Jonathan Allen, 1780, Northampton, Mass. (Plate 58), cut by Nathaniel Phelps, is a fine example of this explicit and thorough description of a man's station in life and religious convictions, accompanying one of the most intricate allegorical designs. It reads:

> Sacred to the Memory
> of
> Maj'r Jonathan Allen
> Who was slain as he
> was hunting on the
> 7th day of Jan., 1780
> Having just entered the
> 43rd Year of his Age.

(Apparently this hunting "accident" created a town scandal, and it was suspected that one Seth Lyman actually murdered Allen.) The stone continues:

The duties of a Son, of a Brother, and Husband, a Parent, and a faithful and brave officer in the Continental Service, were daily discharged by him. He for many years made a public profession of Christianity, and entertained an hope of a Resurrection to a glorious immortality, which did not leave him in the nearest approach to the other world.

The footstone finished with:

Earth's highest station
Ends in "Here he lies:"
And "Dust to dust"
Concludes her noblest Song.

As a reflection of both local and national history, and as a characterization of Colonial attitudes, beliefs and feelings, the record such epitaphs provide is a fascinating and invaluable one.

The styles of incised writing show as much variety in skill and manner as do the pictorial reliefs. There are crude, laboriously scratched characters on fieldstones and undressed boulders (i.e., stones without hewn or smooth sides) with naïve misspellings or omissions and uneven spacing. An undated slab of this type (at Spencer, Mass.), with errors intact, simply tells us:

Her lye
t he body
of peter peep.

Such stones were probably engraved by anyone available who could wield a chisel and outline a few words and initials. The scored traces of horizontal guidelines, used to rule off and straighten the words and verses, are still visible on some of the more conscientious attempts.

Initialed fieldstone markers such as the tiny one which reads "OOY" (Plate 59b) are also frequent, although the significance of this particular word is more curious than most. According to a local resident, it means "friend" in the Leni-Lenape Indian tribe's language. The stone rests in the small burying ground of a Colonial Quaker meetinghouse in Randolph Township, N.J., an area where this tribe formerly lived. Some current Friends from this community speculated that it might be the grave of a Leni-Lenape convert to their religion, or perhaps that of an Indian who was a companion or servant to the early Quaker settlers. Another suggestion (if the stone dates from the later Victorian period, when the practice of burying pets was common) is that it is a memorial for an animal that was given an Indian name!

Finely wrought script initials are seen on later tablets, as in Plate 61a. The more baroque arabesque lettering on a 1795 headstone (Plate 59a) echoes the silhouette of the framework, and announces that it is "In Memory" of the deceased. This motto replaces a pictorial relief altogether, a development which indicates the general decline of interest in, or ability to render, the old symbols. The ornate calligraphic capitals heading the epitaph in Plate 24 and the curly-haired and haloed angel in Plate 53a are transcriptions of fine quill-pen work onto stone (cf. Plates 51a, 51b, 52a, 52b, 53b and 60).

V. Stonecutters: New York and New Jersey Practitioners

The names of some gravestone cutters who worked in New Jersey during the eighteenth century are known from extracts of wills, signatures on

stones and advertisements listed in leaflets and local newspapers. Genealogical societies sometimes have records of practicing craftsmen in a family. Signatures on New York City gravestones are rare or nonexistent, and the original church or workshop records from that period have perished—in fires, or when businesses were liquidated. Tracing the identity of the cutters who lived in the City is difficult, if not impossible, although a single stone in Trinity churchyard reads:

> In memory of Robert
> Hartley, Stonecutter
> who Departed this Life
> November ye . . . ,

but the top is broken off, and the date is also obliterated by weathering, so that concrete evidence of imagery or period is missing. "Stonecutter" may simply refer to one of the masonry or building trades rather than to the gravestone carving profession. Yet it is typical of the tantalizing clues that turn up often, but lead nowhere, in the course of examining early tombstones and trying to determine something about their makers. In New Jersey, however, signatures and single initials are more frequently seen, and the identity of its stonecutters is less of a mystery.

Of special interest is the work of one New Jersey man whose carvings are found on tombstones in Elizabeth, Orange, Union, Woodbridge and possibly also at Succasunna. The production of a workshop, apprentices or a son extend the original period in which his work appeared (1747 to 1788) into the 1790's. These markers display an informed and harmonious sense of design and configuration, coupled with a fine, distinctive style of lettering. The stones are signed in several ways, but the same motifs appear in interrelated though varied combinations, confirming that they are the versatile handiwork of one man. The printed capitals "E. P." appear in 1747 (stone of Elisabeth Miller, d. age 73, Elizabeth), 1757, 1759 (see Plate 32), 1776 and 1784 (stone of Elizabeth Price, Elizabeth); the legend "E. Price" or "Cut by E. Price" occurs in 1772 and 1774; "E. P." is also located between or below two sets of crossed bones in 1757 (Plates 100 and 104d) or beneath one larger set dating from 1776 and 1783 (Plates 30a and 31a) or along with bones and two flower rosettes in the same years (Plate 31a and stone of Susanna Crane, 1781, Elizabeth). Just the bones (Plate 103, 1786) and flowers are carved alone (stone of Catherine Boudinot, 1765, Elizabeth) with no initials accompanying them, also. In two cases, from 1776 and 1787 (Plates 98 and 104b, 30b and 33b), the name "E. Price" appears opposite a tiny gloved hand which points to the signature at the end of a line of hyphens—a typesetting index device for advertisements used in the newspapers of the period. Sometimes the initials "E. P." are incised in script, rather than printing, flanking an arc cut at ground level (Plates 102 and 104e), or written out within the scalloped upper framework of the headstone (Plate 33a). Often, although the designs and lettering manner are identifiably Price's creations, there will be no signature. This may indicate a son's or apprentice's hand at work on the master's design, even after the latter's death.

The typical features of Price's designs are numerous. He loved floral motifs climbing along the perpendicular borders, enveloping heart-shaped inscription fields or even heading the tablets with bunches of heavenly blooms (Plates 30a, 30b and 98)—tulips, round and pointed clover-like leaves and five-petaled rosettes are the favorites. An angel with a flat, squarish nose, distinct eyebrows, lashes and separate curling locks of hair in a wigged band was also a trademark. Sometimes the hair was only a striated ridge, ending in two tight round curls; above the face was a small

pronged crown or an ornamental "fillip" suggesting a tiara. The wings were segmented into scaly feathers by crescent-shaped incisions directed downwards. Later, fluted pilasters were used to edge the fancier stones, but this may have been an addition to the original style, made by the apprentices.

Genealogies (usually incomplete), tombstone inscription books and early copies of the *New Jersey Journal* listed many E. Prices, named either Ebenezer or Ephraim. The Price family, headed by Benjamin Sr., had emigrated from Easthampton, L.I., along with the earliest settlers of Elizabeth, to live in northern New Jersey, where they established a sizable lineage. But the life span of one man in particular seemed to fit the period when the gravestones were produced, and an obscure newspaper advertisement finally confirmed the identification. The man in question was Ebenezer Price, who was born at Elizabeth in 1728, died there in 1788 at the age of 60 and was buried in the yard where most of his work is found. The inscription on his own tombstone (which seems to have been removed for a paved pathway, or may have fallen down—original maps of the burying ground show its former location) was recorded as late as 1892.[24] It read:

> In Memory of
> Mr. Ebenezer Price, who
> departed this Life De-
> -cember the 23rd 1788,
> In the LXth Year of his
> Age.
>
> Seek ye' the Lord
> While he may be found.
>
> Wife and Children May Deplore
> The Husband Father is no more.
> His frugal hands no more provide
> We trust he rests at Jesus side.

Meagre as this document is, it is notable in referring to his livelihood using the word "hands." Although this may be simply a stock figure of speech here, most inscriptions are quite pointed and specific when it comes to a man or woman's station in life or profession. This inscription also records the fact that Price had children—who might have followed his vocation. Furthermore, a notice appeared in the *New Jersey Journal* on June 4th of the year Price died (1788), advertising for a runaway apprentice by the name of Abner Stewart:[25]

THREE POUNDS REWARD

Run away from the subscriber about 3 weeks ago, an apprentice boy, named Abner Stewart, strong and able, near 20 years, 5 feet 8 inches high, brown hair, bluish eyes, cloathed in a half worn suit of blue coating, plated buttons, and good wool hat; went away on account of a riot, &c. committed in this town, in which he was supposed to have been an agressor; it all being settled by his father, who is desirous that he should return to his master and serve out his time, being his duty and interest to do so.
—All persons are hereby forewarned entertaining, employing or carrying him off, but should he return immediately, all shall be well, if not, whoever will take up said apprentice and bring him home, or secure him in any gaol, so that his said master may have him again shall have the above reward, and all reasonable charges paid by

> Ebenezer Price,
> Stonecutter.
> Elizabethtown, June 3, 1788.

A year after this announcement, Abner Stewart gave notice in the same newspaper that he was now in charge of his old master's workshop:[26]

> The Subscriber takes the liberty of informing the public that he carries on the stonecutting business in its various branches, with neatness and dispatch, and as reasonable as was formerly done by his late employer, Mr. E. Price.
>
> Abner Stewart
> Elizabeth-Town, June 15, 1789.

Proof of Stewart's apprenticeship exists on several signed and unsigned stones in and around Elizabeth. Not far from a row of Elizabeth markers signed "E. P." "E. Price" (see Plate 32) appears a 1798 stone cut with the same style angel and other decorative or architectural motifs, but signed, as Price was apt to do also, between a set of crossed bones and a scored arc at the bottom: "Cut by Abner Stewart." This is the stone of Daniel Sale (see Plates 105, 106 and 33c, and compare 101), which is similar in design to the adjacent memorial for his wife Phebe Sale, 1757 (Plate 100) and to Stephen Crane's, 1780 (Plate 102), both of which are signed by Price—establishing the stylistic association quite clearly. The shape of the five-lobed scalloped lunette, with the small fan-like finials above the narrow pilaster borders, the crowned angel and the two rosettes below the inscription, on Benjamin Williams' 1789 stone, is another link in this chain of affinity. In a nearby cemetery (probably at Parsippany—author's records incomplete), the gravestone of Captain Job Alin (d. March 16, 1798) is signed "A. Stewart in Ex-Town," so it is probable that Stewart sent his work to other yards in the vicinity of his home town. Also at Elizabeth, there are simple late tablets which substitute the initials of the deceased in script letters for the traditional images. Some are signed and some are not: Daniel Price's (d. 1785, age 4 months) is initialed "A. S.," while his brother Daniel's (d. 1783, age 4 months also) is more complete, with "Cut by A. Stewart" inscribed over an arc-line. Identical unsigned markers, with the script initials and tiny fan-like insets that appear on the other Price Brothers' graves, are those of two more children of the same unlucky parents, Joseph Periam Price (d. 1792, age 1 year) and Rachel Price (d. 1809, age 18 months). Aside from the scanty information contained in the *New Jersey Journal* and the visible evidence of the stones he cut after his master's death, Stewart's personal history was not discoverable.

Two more Price apprentices are equally mysterious, their names not even appearing in advertisements or genealogies of the time: David Jeffries and J. Acken, who worked both before and after Stewart. It is only by their imitative styles that they are known. David Jeffries' name first appears in the same row of markers as his master's, on the stone of Mary Price, 1766 (Plates 33d, 107a and 107b), where his name is ended with a coiled line, sometimes used by Price himself to finish off inscriptions. The design is a modified replica of an adjacent stone (Plate 32) made by Ebenezer Price in 1759. Jeffries retains the open book at the top, the angel with veined, feathery wings, the heart-shaped field and the surrounding floriated vines, adding a tiny hourglass below the face and eliminating the crown and flanking pilasters of the model. One of the distinctions that can be made between his style and his master's is in the tulip-like flowers; Jeffries' versions tend to be bolder and many-petaled, fuller than Price's conservatively drawn three- or four-petaled blooms (see Plate 30a). Another slight general difference is seen in the angels; Jeffries' figures have scored wing-feathers, while Price's are usually flat and scaly (Plate 32 is an ornate exception to this rule). The hair of Price's angels is in the form of compact, ridged wigs, while Jeffries prefers puffier curls. This apprentice also used the pointing, glove-like hand to call attention to his name on several occasions. A tiny indicator of this type points downward at the arched signature "Cut by

D. Jeffries" on Mary Chandler's 1763 stone at Elizabeth (see Plates 33c and 109, 100 and 105). The same angel from this marker is repeated on a 1767 headstone (Plate 108), where a double set of crossed bones serves as signature. Similar emblems sign Abigail Chandler's 1763 grave, Sarah Chandler's 1794 tablet and Stephen Willcock's 1770 tombstone, whose tulip-adorned borders are identical to the floral ornamentation of the marker in Plate 33d. Like his teacher, Jeffries did not confine himself to one form of signature, or to one strictly unalterable design.

J. Acken has fewer identifiable gravestone reliefs in the cemetery at Elizabeth than Jeffries, but it is clear that he was also a Price trainee. On a 1784 stone (Plate 111) topped by a crowned angel of the typical Price pattern, is a signature which Price had also used in 1787 (Plates 104b and 33b), the hand pointing along a dotted line toward the name of the carver. The 1791 tablet in Plate 110 is probably also by Acken, judging from the similarity to a 1792 stone signed by crossed bones with the initials "JA" beneath their juncture, and decorated with the familiar angel, narrow pilasters and small fan-shaped finials (Plate 112a).

Where Price's style originated, or why he used particular motifs and forms, cannot be determined without personal accounts. That he had a specific vocabulary of images at his disposal, which he could vary in pattern and use interchangeably according to the needs and pocketbooks of his patrons or to suit his own sense of inventiveness, is obvious from the stones themselves. His earliest signed work displays the same high level of carving skill as the latest examples. Perhaps he had a father who had the same initials and who had taught him the craft, but the existing family genealogies do not establish such a connection. He frequently used the tulip, clover, and rosette clusters, or borders of sinuous vines, spirals and hearts, as well as the angels, to head a stone. Two of his most unusual attempts are seen in Plates 31a and 65.

In its scalloped lunette the stone in Plate 31a frames a dove of peace holding an olive branch in its beak, with the legend "Come unto me" written next to it. The stone is signed beneath Abigail's epitaph with two rosettes, crossed bones and the initials "E. P." (Plate 31b). Although the bottom area, where signatures usually occur, had chipped off the second stone, comparison of lettering style, cutting technique, date, the type of sandstone and foliage motifs seem to assure that this image of the tree felled by an axe lying near the stump is from the hand of Price. Over the tree, partly broken away (but filled in with the help of an old inscription book), curved the phrase: "As the tree falls, so it lies," a verse from *Ecclesiastes* expressing the idea that death is inevitable, just as new life grows, by analogy with a young tree. Such visual metaphors using the tree or the cut branch as a symbol of life were common. They were pictured on funeral invitations, on needlework mourning samplers and in watercolors (see note to Plate 65).

Price's flowers have a particularly close resemblance to "fraktur" ornaments of (Pennsylvania "Dutch") German origin, in which a three-stemmed tulip plant was used as a symbol for the Trinity. It is known that beginning in the early 1700's, many German and Dutch immigrants were landing in New York and were frequently indentured there as artisans' apprentices. These "invisible craftsmen," unknown to official records, could have easily passed over to Elizabeth, just across the river. If they did bring such patterns and motifs with them from the old country, it is possible that they exercised some influence on local styles of woodworking, sign painting or even stonecutting. Like many Colonials, Price's family might have possessed a piece of painted or carved furniture, brought over from Europe, on which he could have based some designs. But in the absence of any extant

evidence of this kind, these suggestions may be far-fetched. It is more enjoyable to simply appreciate the visual material of the carvings for their own sake.

John Frazee was born in 1790 in Rahway, N.J., and eventually became one of the country's first notable sculptors. The date of his birth would ordinarily put his achievement beyond the scope of this book, but in considering the background of early American stonecutting, his autobiography is of great value, in spite of its later period (1835). He recounts his development from a bricklayer to an apprentice stonemason, then to a gravestone cutter and finally to sculptor. Most of his statements ought not to be taken at face value; with only the mildest pretense of humility, Frazee tried to depict himself as the paragon of the self-made, morally indestructible and hardworking American rustic. Nevertheless, as a rare document of the processes and influences which caused a man to become a tombstone cutter in the middle states, it contains some useful and no doubt reliable information.

In 1808, while working as a bricklayer during the construction of a bridge in New Jersey, John had the opportunity to view the process of chiseling in stone, by observing stonecutters from New York whom his master had employed. Given the chance to engrave the cornerstone, he "fell quite in love with the mallet and chisel operation," which, he modestly claimed,

> begat in my mind the notion that stonecutting was a craft much
> better suited to my genius and taste than bricklaying; and from
> that period I began to ponder upon the creations of the chisel,
> and dream of tombstones.[27]

Frazee was ambitious and he applied himself diligently. He spent every noon hour and spare moment learning the craft of gravestone work from a cutter named Ward Baldwin. His industry made him unable to bear the thought of the idle winter months, when the call for stonemasons' and bricklayers' skills slackened. He describes his first efforts at setting up a business:

> . . . Exceedingly dissatisfied with dreams, I was determined to
> convert them into tangible realities. . . . So I looked around to see
> how many recent cases of mortality I could sum up within the
> parish district, in which I was now generally known. . . . I col-
> lected a half a dozen or so of what, in these present times of fash-
> ion and etiquette, would be called respectable deaths, and candi-
> dates for sculptural eulogy. . . .

(Frazee's old master complied with his request for a place to cut the stones, and for furnishing rough slabs from the quarries of Newark.)

> . . . In less than ten days after I made him my proposal, Lawrence
> had two waggonloads of unwrought gravestones . . . in his house,
> and I began in good earnest to hew and prepare them for the epi-
> taphs. There was not, nor had there ever been any stonecutter in
> Rahway. The headstones in our burying grounds were purchased
> in Woodbridge, Elizabethtown, and Newark. . . .[28]

This passage reveals that stonecutters were still somewhat scarce in rural areas, even late into the eighteenth and early nineteenth centuries. It also provides an inadvertent document for the occurrence of Ebenezer Price's work in the towns of Woodbridge, Newark (now Orange), etc., surrounding his home locale of Elizabeth.

When Frazee was without other employment, or on rainy days, the carving always afforded something to do, and he would "prepare more gravestones; ornament them, and have them in readiness for inscribing . . ."[29] This points to the practice of keeping a supply of stones available for local

needs, which might result in a surplus after a cutter's own death. John also worked for his church as a songmaster, writing many lyrics on various topics, which he later turned into "epitaph verses; and funny rhymes they sometimes were."[30] In 1813 Frazee joined in partnership with William Dunham, and moved to New Brunswick. He commented (author's italics):

> . . . I continued to ornament my gravestones with vines, flowers, and various little devices, appropriate, as I thought, to the tomb; but, in truth, *there was in much of it more whim than meaning;* and though traces of skill and handicraft were everywhere discoverable in my works, and while I outstripped all my contemporaries in the craft, there was still abundant room for improvement. . . . While I remained in New Jersey, *I never saw a book that treated upon the arts, either historical or elementary. I knew nothing about the arts of antiquity*—their rise, progress, uses, and philosophy; and my genius . . . ran wild and wandering.

Once in New York (by 1818), where he practiced on Greenwich St. and Broadway, around the corner from Trinity and St. Paul's, he said:

> . . . I was resolved to strike out a new path, both in ornament and lettering . . .

since he disliked that of his fellow cutters for its servile imitation of old printed books and its use of unexciting strings of "beads and buttons" for decoration. Instead, he claimed:

> . . . I carved vines of ivy and flowers. *But I knew nothing strictly speaking, of emblematic ornaments, and I had no means what ever afforded me for obtaining a knowledge of such things.* I began my career among the tombstones, utterly ignorant of every rule of art, and of those symbols, images and attributes that had their origin in the classic ages, and that lived and breathed in the beautiful sculptures upon the tombs and sarcophagi of Egypt and Greece. Many years were destined to bind me in ignorance and hard toil, ere I could be permitted to see that there were such things in existence, and that it would be necessary for me to study their origin and meaning, in order to qualify myself as an artist even in the inferior branch which I had adopted.[31]

This whole statement is a goldmine of information. Although its intent is surely to emphasize his own enterprise and originality in the face of such restricted access to the fine arts traditions of past cultures, the fact that Frazee speaks so pointedly of his lack of precedents and about the general unavailability of visual and thematic materials early in his career as a rural stonecarver, is not without significance for the history of American gravestone cutting on a wider scale. Frazee does imply that he may have been influenced by the techniques and designs of other crafts which he practiced alongside of his tombstone work. In winter, when unemployed:

> . . . I made interest with the cabinet-makers to make lions' feet, and various other furniture ornaments. I was also applied to from different parishes in the country for Doves and other ornaments, carved in wood, and gilded, for the pulpits of churches. Brand cutting (in iron, copper, or steel) was another profession, in which I embarked with equal success.[32]

His jack-of-all-trades ability probably led Frazee into his 1831 partnership with Robert Launitz, a journeyman in ornamental sculpture, after the gravestone cutter from Rahway had mastered the finer aspects of chiseled lettering and mortuary relief. Eventually he became a popular sculptor of busts (some of which are in Trinity Church), and was finally acknowledged as an artist by New York's Academy of Fine Arts.[33]

VI. ICONOGRAPHY: THE FUNCTION OF
SYMBOLISM FOR THE COLONIAL COMMUNITY

When the psychologist Carl G. Jung spoke of true symbols, he stressed the notion that because they pertain to both conscious, rational spheres of thinking and to unconscious, irrational realms, their content stands for something mysteriously antithetical.[34] Paradoxical opposites are magically fused: life and death, light and darkness, regeneration and decay, salvation and damnation. Every symbol must be interpreted on collective and individual levels in order to comprehend its significance; whether or not something actually functions as a symbol depends on the attitudes of those who contemplate it.[35] Signs—like the shopkeepers' emblems familiar to any Colonial consumer—represent known qualities and things, while symbols transcend that materialism. Symbols may even go beyond allegories, which transform the unknown into known formats (e.g., the overwhelming forces of the elements, personified as mythological power figures like Zeus or Pluto). Usage may force a symbol to "degenerate" into a sign, when the richness of its original implication is too fully explained or rationalized;[36] an empty structure may be all that remains if the old symbolic significance is lost. Primordial themes and motifs which stem from the unconscious of all mankind were called "archetypes" by Jung;[37] symbols like those found on the early gravestones of America are important concrete manifestations of such archetypes, on a level not obscured by too many layers of cultivation.

While the Colonial carver was surely ignorant of this complex psychological vocabulary, the emblems he used were part of its universal repertory of forms.[38] There is no reason to establish any "direct" historical connections between features like the crosses, spirals or stylized linear incisions that define the faces and ornaments on so many American carvings, and the Celtic crosses or ancient sarcophagi they resemble on the surface. Such geometric and organic patterns—zigzag and sinuous bands, meander "steps," rosettes, discs and lozenges—occur repeatedly in diverse cultures widely separated in time and space. Many subsidiary designs (like the floral vines encircling the inscriptions on Price's stones) were used suggestively rather than to project any explicit meaning. Forms varied greatly because the personality, skill and innovative capacity of the carvers differed—this was observed in the slight transformations of the structural details from the stones of Price to those of his follower Jeffries. Probably a shift in meaning—an iconographic evolution—was not intended in such a case. Frazee's words can be recalled again here:

> . . . I continued to ornament my gravestones with vines, flowers, and various little devices, appropriate, as I thought, to the tomb; but, in truth, there was in much of it more whim than meaning. . . .[39]

It is important to note that the stonecutters practiced their craft as secular tradesmen, not necessarily bound to the exposition of officially sanctioned beliefs in their carvings—though many of the men were probably willing to serve them. Symbols undergo many reinterpretations during the course of their use, so it is difficult to ascertain exactly what the configurations on the gravestones may have meant to contemporary minds. The literary evidence of the period often stands in contrast to the more vernacular usage of symbols in these mortuary reliefs.[40] When it came to committing the deceased to that "cold and silent grave" to which the epitaphs often refer, the Colonial worshippers were not satisfied with the abstract or iconoclastic dogma preached by the ministers and intellectuals in their sermons and tracts. Although the clothing, implements,

furniture and buildings of these people remained largely undecorated at first, the carved images in stone played a vital role in making their fears about death and the prospects for the life of the resurrected soul immediate and imminent.[41] The carvers did not follow any theological programs, like the great architects and sculptors of Europe's Romanesque churches or Gothic cathedrals. Probably many of their conceptions and renditions even contradicted orthodox tenets,[42] since popular demands for imagery itself violated the austerity of the institutional religion. Nevertheless, the conventions of primitive religious art forms all over the world are marked by the same concrete visual and thematic immediacy as the American gravestone designs.

The funerary reliefs utilize a wide variety of symbolic forms and decorative motifs; but the themes portrayed are not that numerous. Reminders of death and time's quick passage; predictions of resurrection in the form of angelic messengers or guardians; or suggestions of hell, paradise and the gloomy terrors of the grave are the basic material for the carvings. The emblems are not always specifically Christian, however. Skulls and crossbones were used by pirates and brigadeers for centuries as a warning banner; or by apothecaries, to indicate the presence of a lethal substance inside a container. The hourglass has long been associated with scholars, books, alchemy and science, as well as with Father Time or Death. Most of these images are so general on the gravestones, that they cannot even be ascribed to particular religious denominations.[43] Nevertheless, they do have specifiable meanings.

A. Mortality Emblems: Skulls, Bones, Winged Effigies

Among the earliest images to appear on New England gravestones were those which signified the passing away of the flesh, the objects used for its entombment and the ultimate triumph of death. These included coffins, spades, palls, skulls, skeletons and bones. Tiny evil demons armed with Death's darts, or carrying the coffin and pall, were also devices used briefly in New England before 1710,[44] but they are not found at all in New Jersey or New York. The crowned death's-heads—bony skulls with their cleft foreheads, hollow nose and eye sockets, and rows of teeth grinning from lipless mouths—portray dramatically the inevitability of death and its ultimate victory over life. Winged forms suggest the transitory nature of life on earth, and are among the most frequent types in all regions. The crossbones used with the skull, in their original Christian context, may refer to the legendary skull and bones of Adam on Mt. Golgotha, the site of the Crucifixion. By extension, the emblem would suggest the eternal life of the resurrected spirit after death, like Christ's example.

The earliest New York skull image is at Trinity, and dates to 1681 (Plates 70 and 71). The high relief carvings on the back face of the stone resemble English baroque styles of sculpture, and the marker may have been a rare case of something imported from England by a wealthy family. The carving is too refined to be the production of any New York craftsmen, whose first work dates from the 1730's and '40's and is highly schematized and flat. This very plastic carving is a combination of the winged hourglass and the skull and crossbones—the flight of time, and the final end, as separate emblems, but when fused, also symbolizing the future of the soul.

The 1691 stone in Plate 10 is decked with a tiny winged death's-head. It seems to originate from the Boston area, like the stone in Plate 11, the back face of which was recut fifteen years after the front side (in 1730) with a cruder, less sophisticated version of a skull. Most likely this was done by a New York carver, and it illustrates the contrasting lack of skill in tech-

nique and style between local cutters and New England artisans at that early date. One half of its inscription panel still remains empty, waiting to receive the memorial for Thomas, the husband of Mary Corrin.

The crossbones appear alone at times, but are usually combined with hourglasses (Plates 1a and following) or with leaves and flowers (Plates 4a, 3b, etc., and 72-78), or else are hovering over the enveloping flames of hell (Plates 75 and 4b). Skull-like soul effigies in flight rattle their pronged teeth at busy pedestrians on Broadway, raising their wings, as if in salute, to reveal the bones beneath them, on a unique 1752 stone at Trinity (Plate 7a). Mary Arding's slate stone displays a more sophisticated carving style (1730—perhaps another import), with leafy scrollwork surrounding a human-faced angel whose wings are also uplifted toward a set of bones. This relief is a diametric contrast to the sketchy, linear skull and crooked, curving bones on Jeremiah Reding's 172? stone on the other side of the same yard.

Both Ebenezer Price and one of his apprentices, J. Acken, had used single or double sets of crossed bones as a trademark for their signatures. The full skeleton is not found in New Jersey or New York, but it occurs several times in New England during the early part of the Colonial period, where strong Puritan traditions probably had closer contacts with ancient or European models and emblem books.

B. Death and Time: the Hourglass

In Colonial meetinghouses, the minister might set an hourglass on the pulpit in front of himself to measure the duration of his sermon. The congregation (especially the bored and the children) was thus well aware of the fact that a representation of this timepiece on the stones adjacent to their churches meant a passage of time. Its use as an attribute for personified figures of Death and Father Time comes out of a long tradition of mortuary symbolism. Hourglasses were rarely used alone, though winged versions are seen early at Trinity (Plate 7l and, along with Masonic emblems, Plate 55a). On a small 1733 marker (Plate 54b), it projects pictorially some *New England Primer* verses which are also echoed on the stone of Elizabeth Young, Succasunna, N.J.:

> My glass is run
> My grave you see
> Prepare for death
> And follow me.

The hourglass usually appeared along with hearts, stars, leaves, and sacred flowering vines (Plates 1b, 3b and 74, 23, 76). It was also the frequent companion of winged death's-heads and bones (Plates 1a and 77). In Plate 2b it appears in heart-shaped sections inside a round medallion announcing "Here Lye ye Remains Of . . ." between two bony messengers. Angels are often flanked by the timepieces (Plates 18b and 107a) and on a fine, emblem-filled 1759 headstone (Plates 22 and 86) the sand has already trickled down into the bottom of the two glasses. This rich profusion of motifs evokes the transitoriness of life, the terrors of sin and hell and the ultimate resurrection of the soul through the vine and guardianship of the Lord.

C. Angels, Seraphim, Cherubim, Soul Effigies

It is not easy to make clear-cut distinctions between representations of angels, angelic cherubim, seraphim or the so-called "soul effigies."[45] The latter are winged faces which lie somewhere between the personalized human face and the angel or skull. The stones themselves are equivocal,

and the carver (or his patrons) did not always indicate clearly which type of heavenly or earthly inhabitant was intended. The result was a blending of many forms and symbols, all aimed at evoking the presence of the heavenly tribe.

Three-dimensionally modeled cherub-like heads on some graves suggest prototypes in English baroque monuments; those of Adam Allyn, "Comedian," 1768 (Plate 92), and John Burns at Trinity are examples. Cherubim are classic emblems for Divine Wisdom and its assistants. The delightfully chubby winged and swaddled baby on the 1802 stone in Plate 40 clearly recalls the ancient pagan Eros child or Christian images of putti. It is also the sole instance where a full figure is portrayed on a New York stone. In New Jersey and northeastern Long Island, complete figures are shown leaning in mourning, but on much later markers of mid-nineteenth century date (Plates 125b and 126). Two winged cherubic heads escorting the 1772 portrait-type bust of Margaret Barron to heaven also seem to derive from European images of coupled cherubs (Plate 117).[46]

Graceful crowned seraphim, high in the angelic hierarchy, with traditionally crossed or overlapping folded wings also occur from time to time on slabstones and headstones (Plates 34, 35 and 113, 36a). In heavenly lore, they are said to represent perpetual Divine Love.

An ambiguous group of images which evolved from the crudely executed winged death's-heads and skulls of the earlier period into the more anthropomorphic faces of later times, have been called "soul effigies"[47] by one authority. The hollow eye-sockets became filled with pupils or discs for eyes, and the jagged rows of teeth were covered with human lips and contracted into tiny frowns or smiles. These images seem to refer to the (physical) state of the soul as it passes through death and the life after it.

Curly-haired children with floral-rosette crowns, scaly wings or subtly chiseled cherubic faces, sometimes weary-eyed and sleeping, appear often as soul-effigy forms in New Jersey and New York. An inventive, if inexperienced, New York cutter varied these pictures from child-like types (Plate 15b) to dour-faced females (Plates 14a and 14b) and almost animalized characters (Plates 13a, 13b, 15a); he worked from 1751 to 1769 at Trinity. Another city carver who was fond of demure, sleeping babies for the stones of infants did about six markers at Trinity and St. Paul's yards, (as well as one at Lawrence Manor, Astoria, Queens) around 1770 (Plates 42b, 41a, 41b, 42a). The downturned, foreshortened heads with their finely delineated wavy locks are unusual in their suggestion of three-dimensional volume and space within the confines of the normally flat medium of incised linear carving.

More stylized heads occur singly, in pairs, or multiply, representing the number of souls buried beneath the markers. In Orange, N.J., a four-fold image of angelic faces testifies to the sad death of John and Elizabeth Wright's four children in 1784 (Plate 39a). Other effigies are topped with tiaras (Plate 43c), leaves (as on a striking and curious image from 1749, Plate 45a), sprouts (Plates 49b, 25c) or rays of light (Plate 51a). The rest of these winged icons seem to settle for the more prosaic human crown of hair (Plates 39b and 39c).

D. Resurrection's Call: Trumpeting Figures, Bugles, etc.

Seminude allegorical type figures, announcing the Resurrection with their trumpets, or trailing the legends "Arise Ye Dead" and "The Trumpet Shall Sound and the Dead be Raised Incorruptible," appear on stones in Massachusetts, Rhode Island and Connecticut, but not in New York or New Jersey.

The allegorical figures are combined with many other symbols, all suggesting glorious resurrection, while the epitaphs often refer to the instruments' call. The stone of Jane Spingler, 1790 (Plate 52b), reads:

> Wak'd by the trumpet's sound,
> I from the grave shall rise,
> And see the [spirits?] with glory crown,
> And see the [flaming?] Skies!
> Array'd in glorious grace
> Shall saints forever shine,
> And every shape and every face,
> Be heav'nly and divine. ·
> There I shall love my God . . .
> [rest of poem under present ground level]

An 1818 stone in Livingston, N.J. (Plate 63b), and the 1799 stone of Gaumetta Shaw in New York City both bear the same verses:

> My flesh shall slumber in the ground
> Till the archangels trump shall sound
> Then burst the chains in sweet surprise
> And in my saviour's image rise.

Two New England examples are included here for comparison with the simpler stones farther south. One stonecutter, Nathaniel Phelps, whose work is found in Northampton and Hadley, Mass., carved the stone of Jonathen Allen, 1780 (Plate 58), which shows two reclining trumpeters wearing scalloped loin cloths and bearing a chalice that is pulled upward by tassels held in the hands of God, who is reaching from the clouds. From the chalice (or basket) grow heavenly flowers, surrounding a beaded crown, which is topped by the (rarely depicted) cross itself. Similar complex motifs are used by this man on another marker (Plate 57), which combines standing, feathery-winged angels, bugling as they hold aloft a crown and another haloed cross, flanked by military emblems and flags. The deceased colonel's initialed insignia complete the picture. On Sarah Porter's 1775 stone in Hadley[48] Phelps has flying angels holding the crown and cross toward the sky as they perch on flowering orbs, with branches and garlands in their other hands, over the motto "Gloria In Eclesus Deo" [sic]. A badly weathered marble stone in Trinity churchyard must have once depicted a crown surrounded by palm fronds, next to crossed trumpets and, possibly, angels or a family escutcheon—but its surface was too fragile to support a rubbing.

E. Crown of Righteousness

The crown of righteousness is another widespread motif. Its use is based on many scriptural passages, as well as on the acknowledged imagery of earthly royalty. The passage 2 Timothy, 4:8 reads:

> Henceforth there is laid up for me a crown of righteousness,
> which the Lord, the righteous judge, shall give me at that day;
> and not me only, but unto all them also that love his appearing.

The crown honors glorified souls and angels, or points to the triumph of death, when it caps a winged skull. Crowns appear in all forms: banded, jeweled and beaded, sometimes topped with a cross (Plates 57, 58, 3a); pointed, crested, scalloped, fluted and pronged, on soul effigies and skulls (Plates 8a, 32, 21b), a really outlandish feathery version appearing on the stone in Plates 17 and 84. Stylized tulips were especially popular, and are seen in Plates 20, 49a and 26a.

An endless, almost comical range of shapes and patterns occurs on John Zuricher's work in New York, Staten Island, Tarrytown and Long Island: a serrated tiara (Plate 26b), a leafy acorn or conifer (Plate 27a), a plume-topped checkerboard over an angel (Plate 27b), a tiered spiral over another (Plate 28a), and a somewhat feathery, splayed version on two tablets dating from 1763 and 1765 (Plates 29 and 89).

The coveted crown of heavenly salvation appears again and again in inscriptions, many reading like Abigail Brown's from Orange, N.J.:

> Now I rejoice to leave this world
> of sorrow, sin, and pain;
> I know I'm wash'd in Jesus' blood
> And shall a crown obtain.

F. Cosmological Symbols: Sun, Moon, Stars, Clouds

The cosmological symbols found on some tombstones had a specific religious meaning, though in general, they were also depicted to provide an appropriate celestial setting or backdrop for souls and angels. The Northampton, Mass., minister Jonathan Edwards wrote:[49]

> The Different glory of the sun, the moon, and the stars represents the different glory of Christ and the glorified saints.

The sun or its rays thus indicated the presence of Christ, along with its broader connotation of spiritual illumination and life-giving warmth or nourishment. The reference to Christ as the sun stems not only from pagan antecedents (Apollo the sun god, Mithras the Persian diety), but from scriptural tradition too. The sun and moon were also used in medieval and Renaissance iconography of the Crucifixion to indicate the sorrow of all creation at the death of the Saviour,[50] and stars to represent divine guidance. While the rural stonecarvers in America may not have been familiar with these Old World sources, they were aware of the many Biblical passages and stories in which these images are employed.

The sun, connoting resurrection, appears triumphant over a glaring skull and bones on a stone at Trinity (Plate 80). On a highly modeled relief at St. Paul's from the same period (Plate 116), shafts of sunlight pierce through the clouds to shine on two cherubs whose wings are swept back upon themselves, as if they were making way for the windy entrance of God's providence. A sunburst, crescent moon and star of holy favor adorn the Masonic marker of Elias Darby (Plate 60). Stars encircling angels in flight were used liberally by the New Jersey carver who also transformed them into inscribed rosettes (Plates 17 and 20). The star indicates guidance for the soul, which accounts for its presence in the same field as these angelic soul effigies.

Clouds usually pertain to the atmospheric veil which conceals God from his worshippers. Sometimes the hand of divine omnipotence may reach from a billowing mass (Plate 58), but this particular feature does not occur outside of New England in such an explicit form.

G. Trees: the Fallen Tree, the Willow, Cut Branches, Mourning Figures

A universal theme since ancient times was the tree—symbolic of life or death depending on whether it was depicted verdant and foliated or barren and felled. These traditions stem from the organic cycle of the plant itself, as well as from man's use of trees. In religious terms, they go back to the biblical story of the Tree of Life and the Tree of Knowledge in the Garden of Eden. The tree can stand for celestial and earthly paradise, the fall of man through sin, and human fruition or frailty, in this context. Many variants appear on the gravestones, since the tree also had great

popularity in books and broadsides in America. The axe lying alone by a felled stump was one of Ebenezer Price's finer creations (Plate 65), though the design (unlike most New England versions) merely leaves it implicit that it is God who wielded the implement.

Later in the eighteenth and nineteenth centuries, trees take over in the form of willows, often based on stitched mourning pictures and burial invitation designs. They are used alone (Plate 123) or in conjunction with coffins, cinerary urns and, much later, with mourning figures (Plate 125b). Plate 122 displays the willow planted next to a coffin or tomb, on top of which lies an open book. A white marble at Elizabeth (Plate 125a) shows the willow bending its branches over an obelisk-shaped monument.

According to Christian legends, the willow continues to flourish and remain whole, no matter how many of its branches are cut. Thus it also becomes a symbol of the gospel of Christ, which remained intact however widely distributed.[51] Generally the snipped branches indicate the number of lives cut off by death and buried beneath the marker (Plates 119 and 120). Epitaphs refer to this image, especially in the latter part of the eighteenth century. The memorial to Electa Hunt in Northampton, Mass., 1776, tells us that

> . . . after a short illness she was
> Cut down in the bloom of life. . . .

The willow was often planted in a position to overhang a favored tomb, like some perpetual mourner;[52] there are many versions of this type of design. J. C. Mooney, whose stones are in Union, Springfield and Elizabeth, used a standardized stencil or pattern for the triple headstone of the Wade children (Plate 62b), where identical delicate willows arch over identical sarcophagi lettered with the individual initials of the boys Robert, William and Matthias (see also Plate 121). In Plate 62a a separate branch curves over an erect willow with its cut sprigs, and this is in turn flanked by the script initials of Elias Osborn. This stone was probably carved by Jonathan Hand Osborn. A handsomely stylized willow of late date (1882) on a marker at Richmondtown, Staten Island (Plate 64) sways above a tomb with a coped roof. The willow became the dominant image for the expression of Victorian sentiment, when the vivid symbology and direct force of the older images declined.

H. Cinerary Urns

Cinerary urns appeared early in New England iconography. Farther south they were not commonly featured until the development of the later Neo-Classic styles of carving. With the approach of the nineteenth century, willows and urns were practically the only images used on tombstones. The ashes contained within the depicted urn signified penitence, the death of the body, and its return to dust in the final resting place— "Ashes to ashes, dust to dust," as the funeral verse goes. Urns occurred on many stones without the accompaniment of willows or coffins (see Plates 63a and 63b).

I. The Heart

The symbol of the heart was a popular one in Europe after the Counter-Reformation. Aside from its ordinary connotations as the source of physical life, love, devotion, understanding, piety or contrition, it also stood for the Trinity and the love of the soul for God. In America it was sometimes associated with the triumphant soul.[53] It was used as a shield for the engraved inscription, and was often encircled with flowers and vines. E. Price and his workshop favored this pattern, and their stones were copied by

other carvers throughout the entire burying ground at Elizabeth.

The heart could have a number of meanings, however, and it was also employed as an emblem for the soul itself. On Farrington Price's marker, 1802 (Plate 61a), there is a tiny heart containing the initials of the deceased. As a soul emblem blessed by guardian flowers, it rises over the larger script initials "F." and "P.," which probably denote the earthly body. Sinuous vine stems and clover also line the borders here (suggesting the vine of the Lord and the Trinity). The signature on the lower right reads "H. O.," perhaps an abbreviation for Jonathan Hand Osborn, who was working around the area in 1800. A similar "soul-heart" appears along with stars above the head of an angel on Benjamin Hunt's stone at Elizabeth, dated 1763, though it contains no initials.

Sometimes the heart actually forms the "body" of a soul effigy, as seen on two very fine stones from different regions. On Mrs. Lucy Parsons' 1782 marker in Northampton, Mass. (Plate 94), one of Nathaniel Phelps' most bizarrely inventive designs, the uplifted feathery wings, spinning rosettes and odd peaked cap frame a cross-eyed humanized face. On a 1779 headstone in New York (Plate 93), budding tendrils wind over the head of the winged soul icon (see also Plate 55a).

J. Flowers, Foliage, Fruits, Thistles, etc.

Epitaphs, as well as engraved images, reflect on the traditional association of man's life with the course of a flower's blooming and withering. The stone of David Dewey, 1821, Northampton, says:

> Our days are as the grass
> Or like the morning flower
> If one sharp blast sweeps oe'r the field
> They wither in an hour.

Flowers and leafy clusters were used both emblematically and for the sake of beautiful adornment on hundreds of headstones. Crowning anthropomorphic effigies or angels, they suggest the lushness of Heavenly paradise, where the souls of the just will reside. Some markers by Zuricher show this motif (Plates 24 and 25b), while on Phelps' New England version (Plate 58) a variety of blooms spring forth from a basket or chalice borne aloft by the hands of the Lord. Many cutters couched the skulls and stone icons in pleasant surroundings, with real or fanciful floral forms (see Plates 8b and 79).

Bunches of foliage, especially tulips, were popular in New Jersey throughout the eighteenth century. A large headstone from 1776 is one of the more elaborate versions (Plates 30a and 96), with its spreading cluster of spring flowers. The suggestion of seasonal regeneration was implicit in such an image, expressing the hope for the spirit's resurrection beyond the grave. A carver active in New Jersey, and possibly New York City, from 1733 to 1747, who sometimes pictured a small, sheepishly smiling seraph (Plate 36a), also favored fleur-de-lis, rosettes and flowers composed of geometric diamond shapes for borders and top lunettes (Plate 36b). Tulips and other posies deck the headstones in Plates 37a, 38a and 38b in a number of different formats. A stone at Whippany (Plate 37b) shows an unusually stylized pattern, with stiffened stems forming a cross and supporting three many-petaled tulips.

Lilies, the Christian symbol for purity and chastity, occur especially on the graves of infants and women. Sets of lilies soften the ferocious grimace of the death's-heads on two arresting carvings (Plates 12 and 4b). Inscription verses also allude to this plant:

See from the earth the fading lily rise,
It springs, it grows, it flourishes and dies,
So this fair flow'r scarce blossom'd for a day
Short was the bloom and short the decay

is the commentary on the stone of Mary Ann Hedden (d. 1824, age 8 months, 10 days) in Orange, N.J.

Thistles and conifers hardly appear at all on the New Jersey/New York stones, but the carver of Joseph Crampton's beautifully proportioned tablet at Elizabeth (Plate 9) used a schematized version of one of those forms to top its perpendicular side panels. The thistle may allude to the thorny crown of Christ's Passion or to the "thorns and thistles" from the ground that were part of the curse against Adam's sin in Genesis 3:17-18. The cones of the evergreen would probably suggest the regenerative powers of salvation in this context.

A pomegranate (large, round "scored" or segmented forms) alludes either to the Church, because of the inner unity of a multitude of seeds within one fruit,[54] to fertility or to the Resurrection, by association with the ancient pagan myth symbolizing Proserpina's periodic return to earth in the Spring. It appears within the borders of early New England stones along with gourds, which symbolize life and death, as in Plate 10. But like the graceful acanthus scrolls edging Ann Walling's slate (Plate 11, also located in New York City, but of New England origin), these fruits are not used by New Jersey/New York cutters, who seem to prefer simpler, more generalized plants. The absence of these motifs may also point to the fact that the Manhattan area workmen were farther removed from the older, European sources of symbolic imagery than were their earlier New England colleagues.

K. Birds

The flight of a glorified soul to heaven has been represented since ancient times by the image of a bird—probably one of the loveliest and most poetic of visual metaphors. The mythology of many cultures considers the bird and its feathers to be emblematic messengers of Heaven's or the deities' spiritual powers (one of the more important symbols for native American Indian tribes was the eagle's feather). On Colonial gravestones, "soul birds" are sometimes seen pecking at an hourglass (Plate 4a, where the skull and bones are embowered by flowery vines). On Phebe Brant's headstone, two sprightly birds stop to kiss each other in mid-flight (Plate 54a). Another Old World prototype for this format might be found in early medieval sarcophagus reliefs picturing two birds sitting on the arms of a cross which bears an emblem of the Resurrection of Christ.[55]

The dove is a classic symbol of Christian constancy and devotion, as well as a reference to the Holy Ghost. When it is depicted holding an olive branch in its beak, it signifies the hope for God's providence, based on the Biblical story of Noah's ark and its dove messenger. Such a bird was used by Price in Plate 31a.

L. Military Trappings

The trappings of military valor and combat appear from time to time on the markers erected for soldiers who died in the Revolutionary War battles or for veterans of the Continental Army. Often combined with the angels of spiritual glory, the bugles, banners, drums, cannons and swords serve to indicate either the dead man's rank or his role in the Colonial militia.

Seth Pomeroy—the first Brigadier General of the United States under George Washington—though he died in service at Peekskill, N.Y. in 1777, where he was buried, was also honored by a marker in his home cemetery of Northampton, Mass., with an extraordinary panoply of symbols, to his military and spiritual credit (Plate 57). Two flags, initialed "B. G.," refer to his rank, and a pair of cannons bear his initials on their bases. Drums and drumstick sets, crossed rapiers on a pedestal, and bugling angels holding up the crown and cross of the Lord in a radiant aureole complete this design by Phelps, the town's virtuoso carver. The stone of Moses Ogden, killed at the battle of Connecticut Farms in 1780, is bordered by sabres, and its angelic effigy is crowned by crossed blades rather than crossed bones (see Plates 101 and 56a). The inscription tells that at twenty years of age

> This lovely Youth
> Adorn'd with Truth
> A brave Commander Shone

In Plate 56b, three cannons on wheels, accurate in detail, are stacked up over the 1777 New York City headstone of Daniel Rowls Carpenter,

> Who belong'd to the company of officers sent to this place by the Honourable Board of Ordnance under the direction of Major Dixon: Chief Engineer of America.

M. The Bible and the Hand of the Lord

The Bible was not a widely used emblem, in spite of the importance the Scriptures held for the Church as an instrument of divine revelation. David Jeffries placed the open Book on the crest of his stone for Mary Price (Plate 107a) in imitation of his master Price's identical setting for the neighboring stone of the husband (Plate 32). A spread volume rests over the pictured tomb on a headstone at Orange (Plate 122); it may be a Psalter rather than a Bible here. The hand of a devout mourner or worshipper touches the pages of a book, while the sun's resurrecting rays shine from above, on a late marble at Elizabeth (Plate 131).

The hand of the Lord, signifying omnipotence and providential guidance, is rarely employed in the middle states. When it does appear, it may be shown either pointing upward at a bank of clouds, as in the 1861 marble in Plate 132a, or toward Heaven, the path of the spirit's ultimate voyage (Plate 133).

N. Miscellaneous Motifs: Rosettes, Ornamental Oddities, Masonic Emblems

Floral and geometrical rosettes are persistent motifs on stones from the earliest to the latest dates. Probably they served merely as ornamental space-fillers, although they do frequently accompany soul images. Some are abstracted into stars, while others retain their connection to the petals of flowers. They fill out the side lobes of arched markers (Plates 14b, 51a, 51b) or may appear as part of a signature, as in the case of E. Price and his workshop.

Round or flattened spirals were also popular in the New Jersey/New York region. They were used with particular relish by John Zuricher, by another New York man, and by a carver centered in Elizabeth and Orange, N.J., as finials to crest the side borders of their stones (Plates 14a, 15a, 15b, 16b and 81, 26b, 27b, 28a, 28b, 29, 89).

The bold, meandering and coiling bands on the stones in Plates 20 (and 83), 17, 16a and 85 are virtually a stylistic trademark for their maker. Sinuous linear flourishes and small whirling discs distinguish the designs

of a skilled late carver whose work appears on headstones at St. Paul's (Plate 52b), in Elizabeth (Plate 52a) and at Tarrytown (Plate 95), as well as in Long Island. They resemble the designs of some Connecticut stonecutters who worked about the same period, which may point to another example of interstate exchange.[56]

Masonic emblems are used on a number of New York stones (much as the military trappings were displayed at an earlier date) to indicate membership in the brotherhood of Freemasons. On the 1801 Trinity stone of James Woods, a "native of Ireland," the compass and square appear alone, while on Stephen Fitzpatrick's, from 1760, they are bordered by sprouting plants, and on another marker, a plumb-weight and sector are added to the square rule and compass (Plates 55b and 118). On James Leeson's headstone at the same place, the Masonic implements accompany other motifs relating to the soul and the passage of time (Plate 55a). The compass usually denotes rationality, the square suggests moral uprightness, and the crescent moon and sunburst stand for nature's obedience to God and His all-seeing eye (see Plate 60).

VII. Conclusion

The development of a vernacular language—of words or of visible plastic forms—is not an altogether conscious one, for it derives organically from a complex of contemporary needs. The meaning of symbolic images evolves likewise in an unstudied but still symbiotic relationship to the cultural and religious situations of the times in which they function. In Colonial America, every soul who aspired to eternal rest and grace after death required an appropriate gravestone; the markers pictured here answered that need with an admirable directness and dignity. The development of a craft is, however, a more cultivated technical effort of method and mind than the general popular impulses for imagery. Some progression in ability and in the degree of sophistication of vision may be observed and traced in the rural stonecarvings, with allowance for regional variations and personal eccentricities of hand or training. Although designs differ in detail from place to place and from carver to carver, the local form components cannot be isolated from a larger human tradition of universal patterns and configurations. Elements of the American gravestone relief styles are common to primitive levels of visual expression all over the world. A stylized, symmetrical, linear geometry, flatness rather than volume in the definition of forms and an hieratic frontality in the disposition of designs are some of these characteristic features.

By around 1820, the intense graphic vitality of the older mortuary sculpture had waned and virtually disappeared. The formal decline of this tradition, which had flowered during the eighteenth century with such beauty and originality throughout the Colonies, was determined by the nature of the changing society which the gravestone cutters' profession served. Nineteenth-century science and technology made Christianity dispense with the fear-inspired eschatological notions which had motivated the earlier use of soul effigies and threatening death's-heads. The country was on the brink of a far-reaching industrial and cultural revolution. Religious symbols, which had been such awesome reminders and potent teachers for the population of the Colonial period, were outdated by the secularized nineteenth-century attitudes of an age preoccupied by powerful commercial interests and territorial expansion.

The verse from Margaret Price's 1777 headstone at Elizabeth expresses the inevitability of this history more fittingly than any other conclusion:

> Death like an overflowing Stream
> Sweeps us away, This Life's a dream.

NOTES

1. B. Puckle, *Funeral Customs,* N.Y., 1926, p. 261.
2. Allan Ludwig, *Graven Images,* Middletown, Conn., 1966, p. 233.
3. *Ibid.*
4. Harriette M. Forbes, *Gravestones of Early New England, and the Men Who Made Them,* Boston, 1927 (reprint, N.Y., 1968), p. 1.
5. Ludwig, *op. cit.,* p. 58.
6. Edmund V. Gillon, *Early New England Gravestone Rubbings,* N.Y., 1966, p. ix.
7. Forbes, *op. cit.,* p. 114.
8. Samuel Green, *American Art,* 1966, p. 178.
9. Ann Parker and Avon Neal, "Carvers in Stone," *Vermont Life,* Fall 1964, p. 47.
10. Cf. Forbes, *op. cit.,* p. 16, for an illustration.
11. —and documented by the researches of Forbes, Ludwig, and Parker & Neal.
12. Forbes, *op. cit.,* ch. 2.
13. *Ibid.,* pp. 16-18.
14. Ludwig, *op. cit.,* pictures a Stratford, Conn., stone, done for the Pixlee family, which is probably by this carver. It shows the same style angel as the Caty Leonard stone in Middletown (Plate 43b). Cf. Ludwig, Plate 122b.
15. Forbes, *op. cit.,* also photographed the stone of William Wells, Southold, L.I., who died in 1696 (cf. Forbes, p. 2), although his stone was undoubtedly made much later, and probably by the Zuricher workshop, as a replacement for some previous, cruder marker.
16. Frederick Burgess, *English Churchyard Memorials,* London, 1963, pp. 167-8.
17. Forbes, *op. cit.,* pp. 1-2.
18. Ludwig, *op. cit.,* pp. 58-60.
19. *Ibid.,* Fig. 8 and Plate 42.
20. *Ibid.,* pp. 57-60.
21. *Ibid.,* p. 58.
22. Forbes, *op. cit.,* pp. 18-19.
23. *New Jersey Journal,* Elizabeth, July 12, 1786.
24. William Ogden Wheeler, *Inscriptions on Tombstones,* Elizabeth, 1892, p. 103.
25. *New Jersey Journal,* June 4, 1788.
26. *Ibid.,* June 15, 1789.
27. "John Frazee," *North American Quarterly,* 1835, p. 2.
28. *Ibid.,* pp. 6-7.
29. *Ibid.,* p. 8.
30. *Ibid.,* p. 9.
31. *Ibid.,* pp. 11, 12, 7.
32. *Ibid.,* p. 14.
33. *Ibid.,* p. 17.
34. Jolande Jacobi, *Psychology of C. G. Jung,* New Haven, 1964, pp. 93-4.
35. *Ibid.,* p. 94.
36. *Ibid.*
37. *Ibid.,* p. 39.
38. Ludwig., *op. cit.,* pp. 7, 9, 426, etc. He discusses this matter in greater detail in the context of Puritanism and its mortuary art.
39. Frazee, *op. cit.,* pp. 11, 12, 7.
40. Ludwig., *op. cit., passim.*
41. *Ibid.,* p. 44.
42. *Ibid.,* pp. 5-6, 33.
43. *Ibid.,* p. 66.
44. *Ibid.,* p. 100.
45. *Ibid.,* p. 216.
46. *Ibid.,* Plate 130.
47. *Ibid.,* p. 67.
48. Forbes, *op. cit.,* see photo opposite p. 119 for Sarah Porter stone.
49. Ludwig, *op. cit.,* p. 189: Jonathan Edwards, *Images and Shadows of Divine Things,* ed. Perry Miller, New Haven, 1948.
50. George Ferguson, *Dictionary of Christian Symbols,* N.Y., 1961, p. 44.

51. *Ibid.*, p. 40.
52. B. Puckle, *op. cit.*, p. 16.
53. Ludwig, *op. cit.*, p. 69: Perry Miller, *The New England Mind: the 17th Century*, Cambridge, 1954, pp. 3–35.
54. Ferguson, *op. cit.*, p. 37.
55. Cf. Erwin Panofsky, *Tomb Sculpture*, N.Y., 1964, Plate 145.
56. Cf. Ludwig, *op. cit.*, Plates 240a & 240b.

THE RUBBINGS

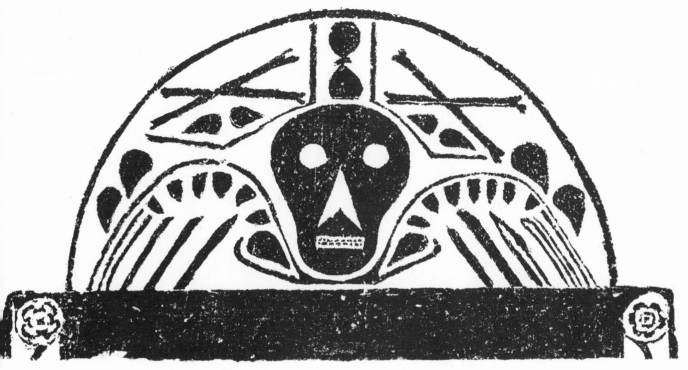

a

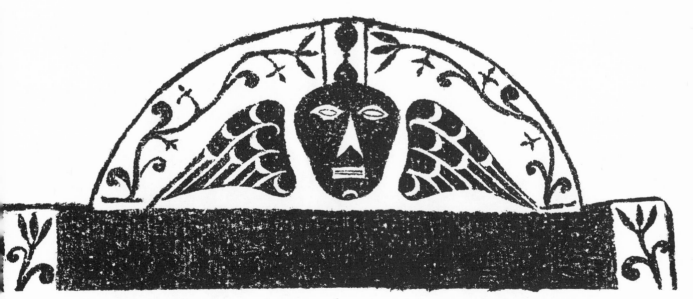

b

Plate 1

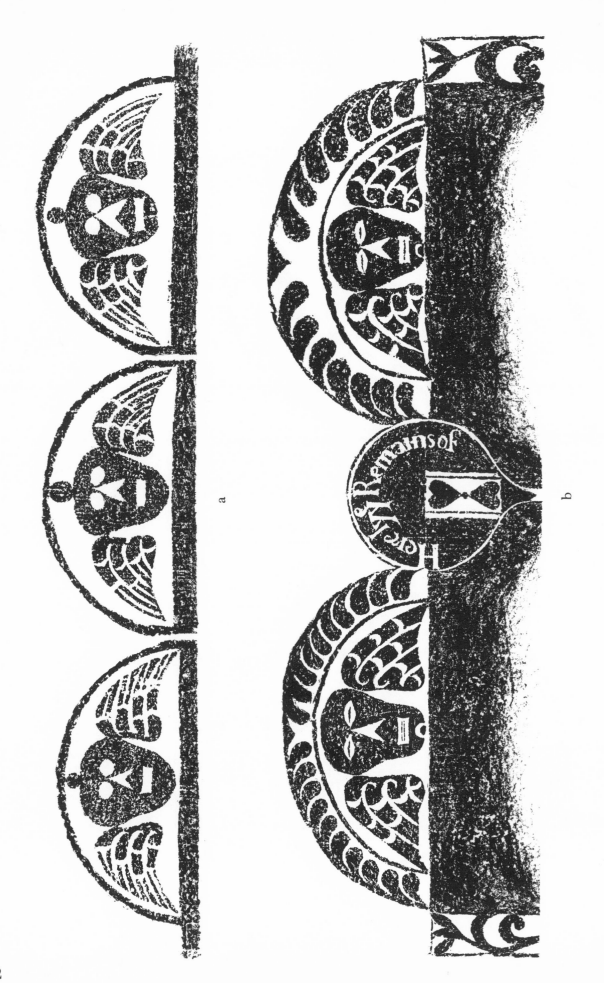

Plate 2

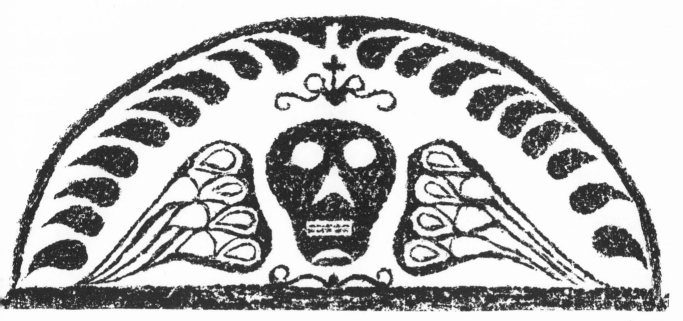

a

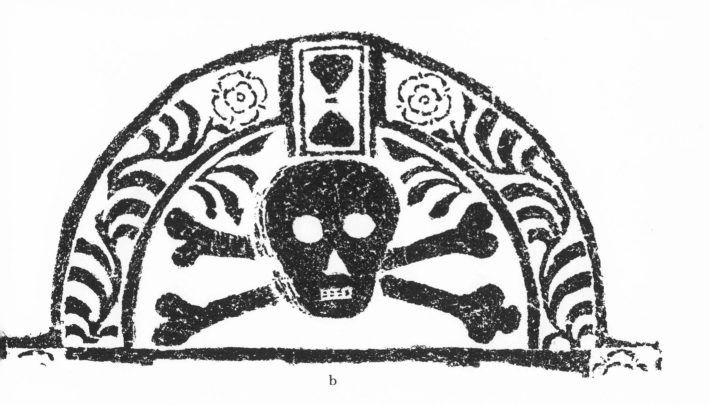

b

Plate 3

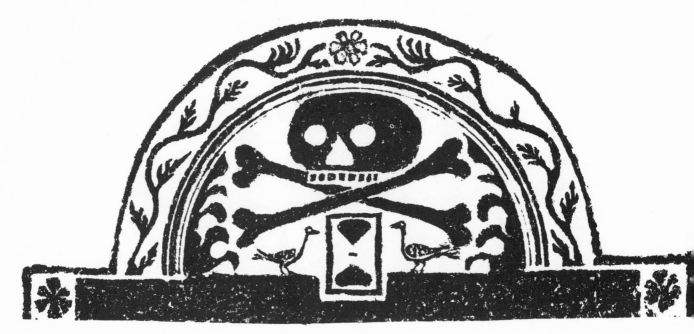

a

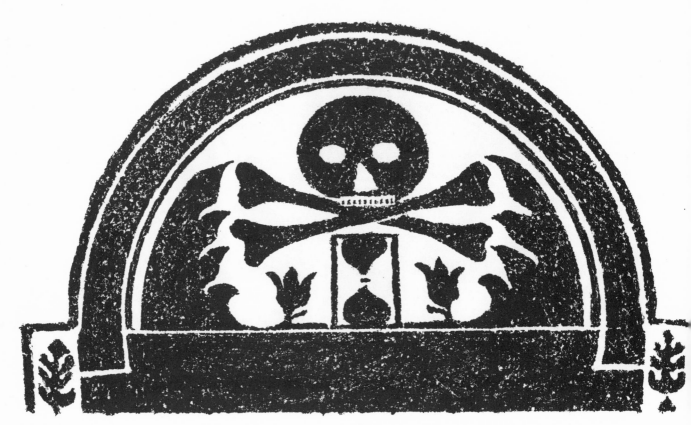

b

Plate 4

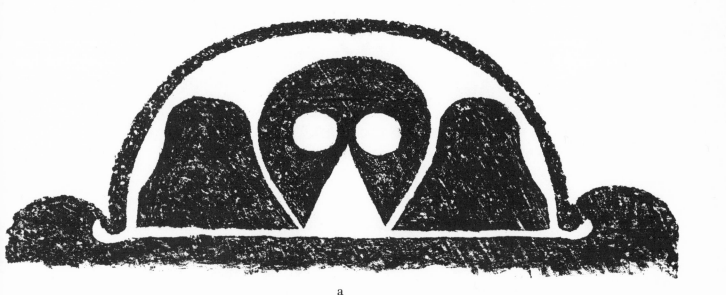

a

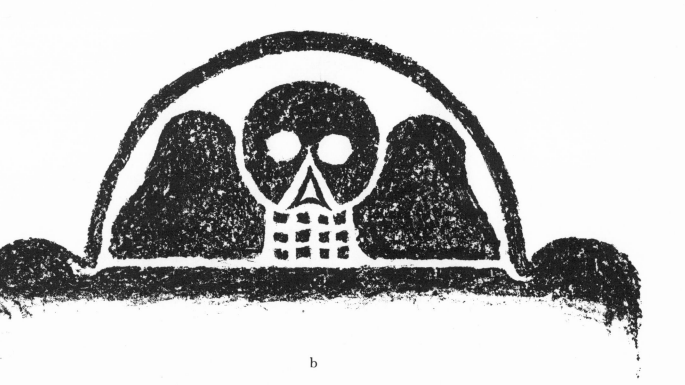

b

Plate 5

a

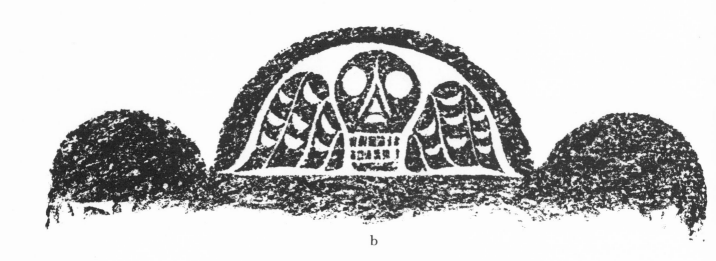

b

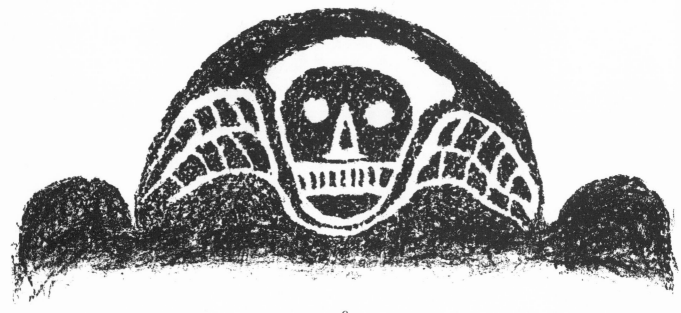

c

Plate 6

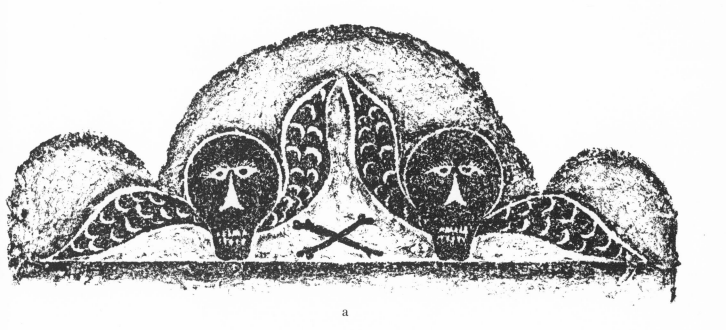

a

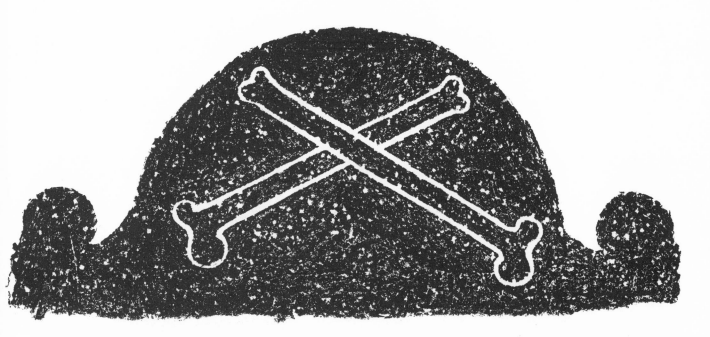

b

Plate 7

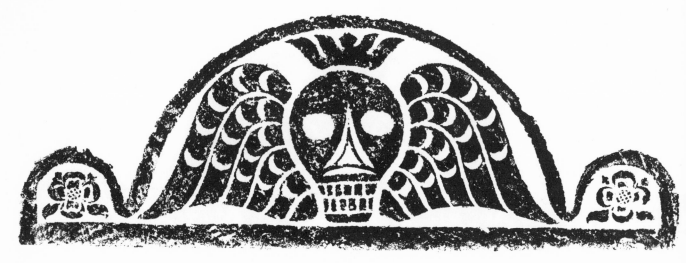

a

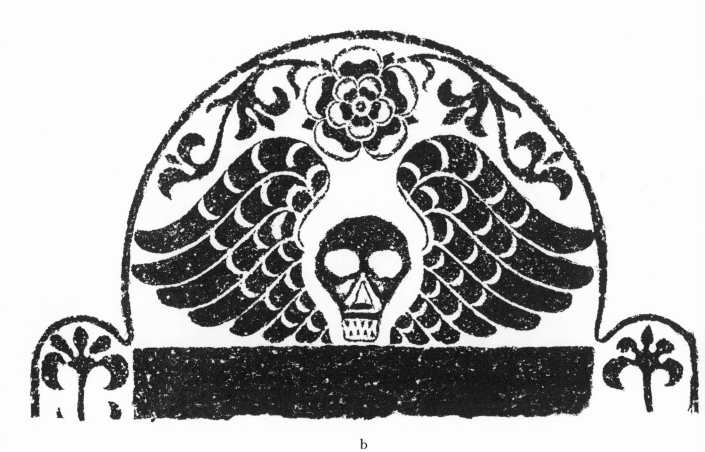

b

Plate 8

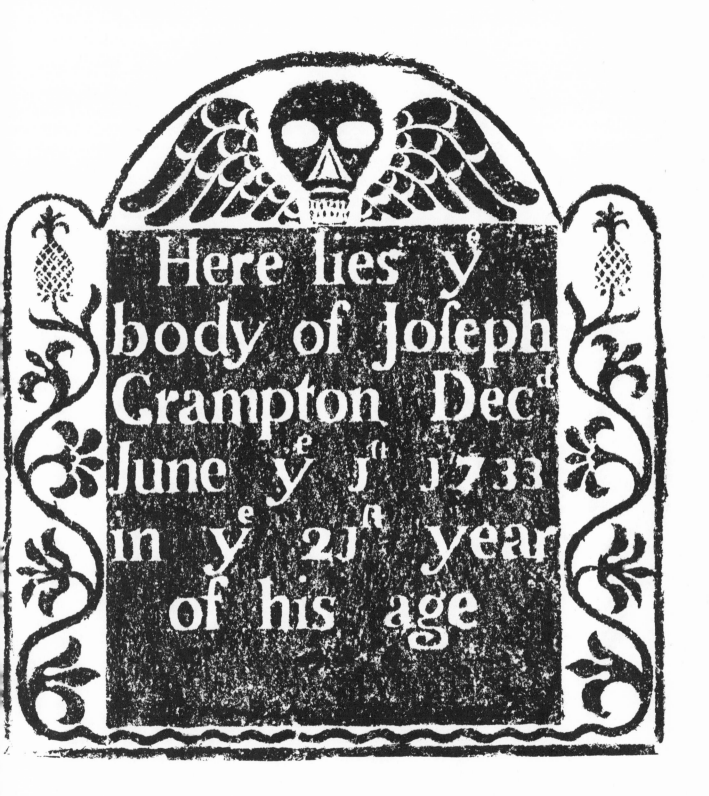

Plate 9

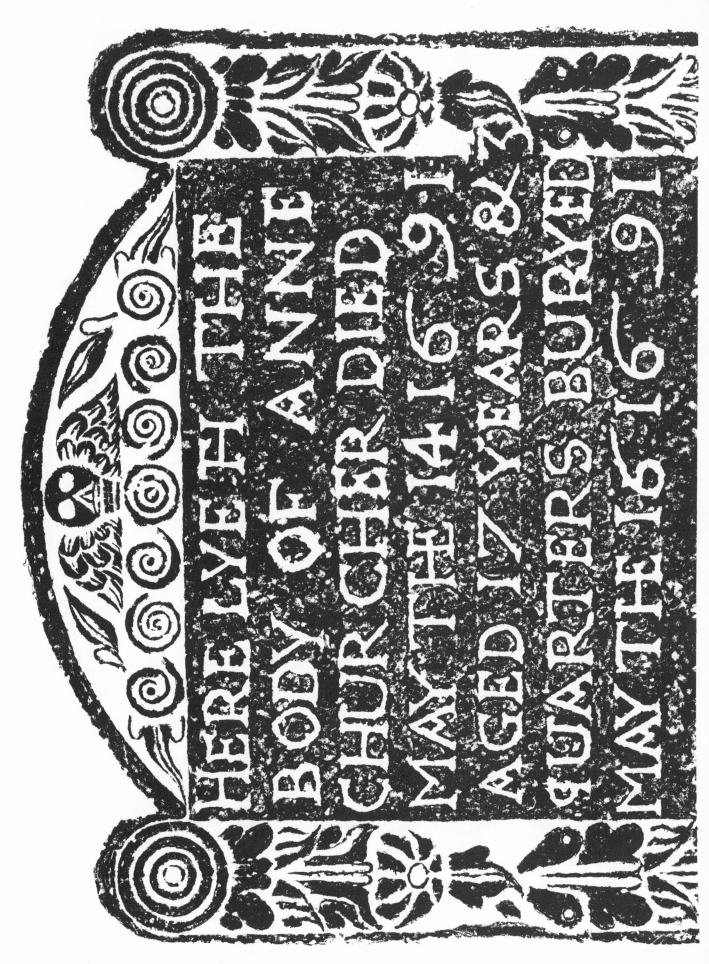

Plate 10

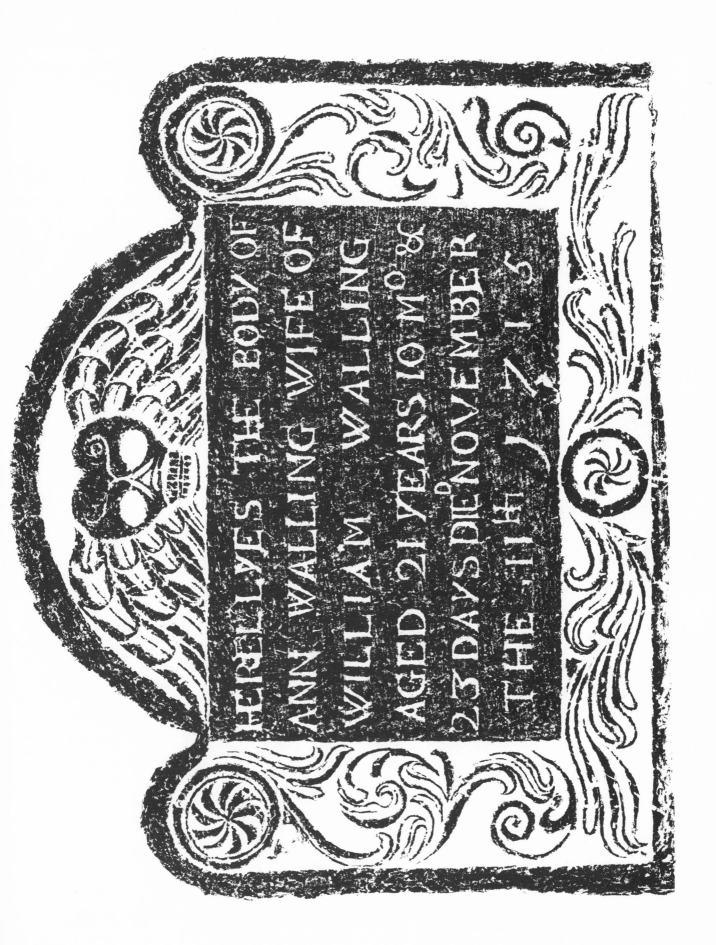

Plate 11

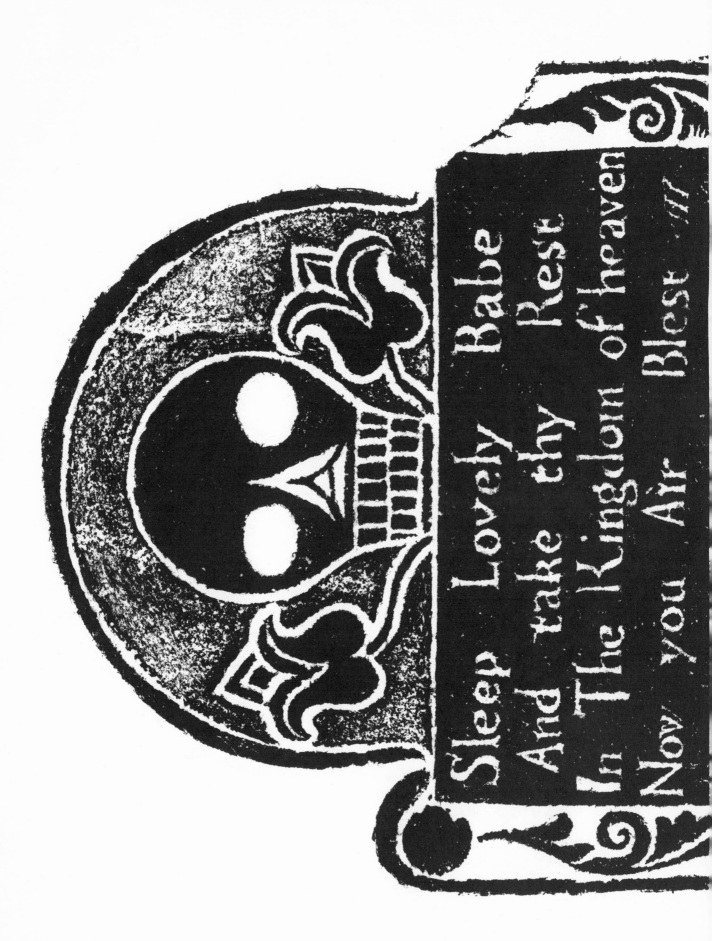

Sleep Lovely Babe
And take thy Rest
In The Kingdom of heaven
Now you Air Blest

Plate 12

a

b

Plate 13

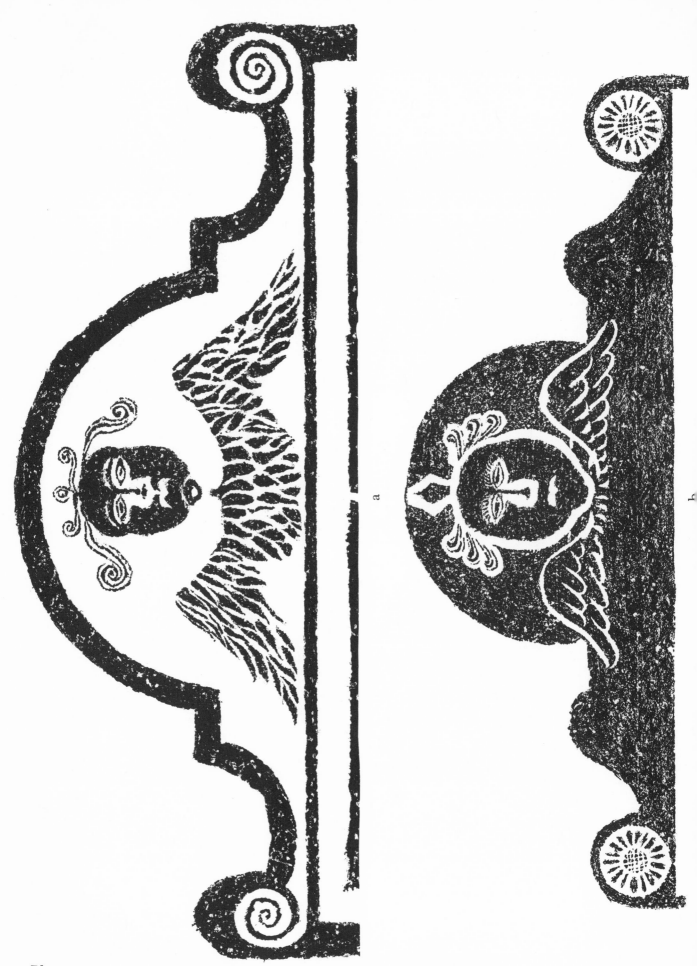

a

b

Plate 14

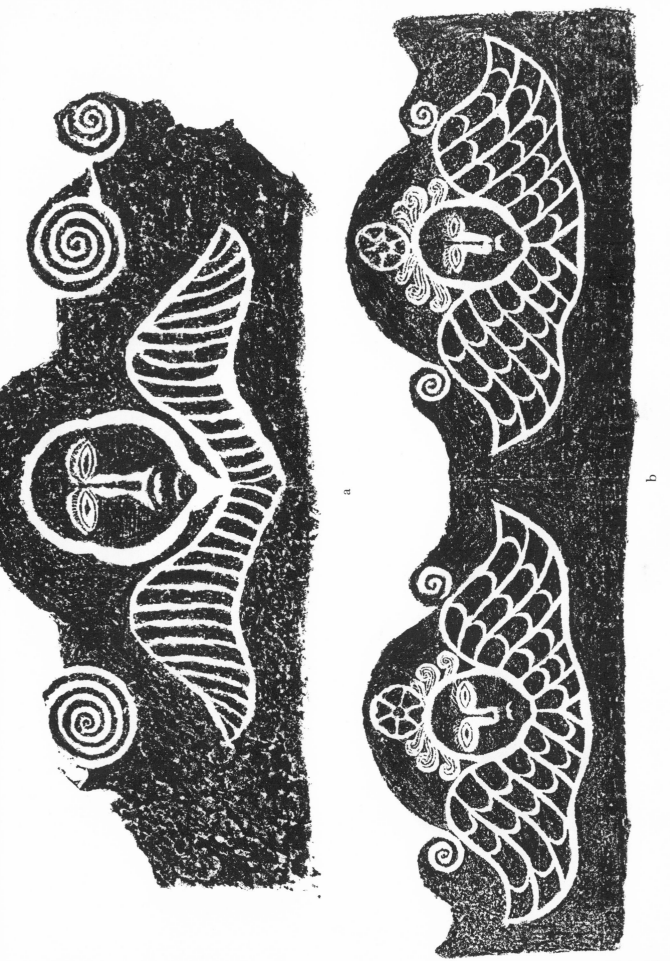

a

b

Plate 15

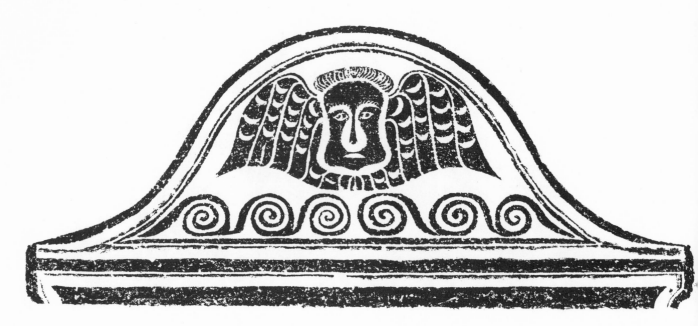

a

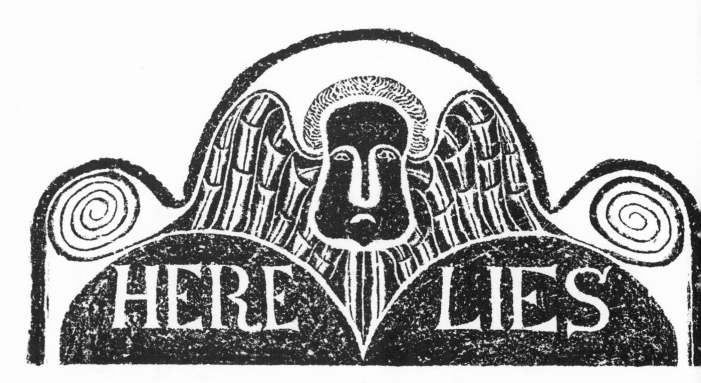

b

Plate 16

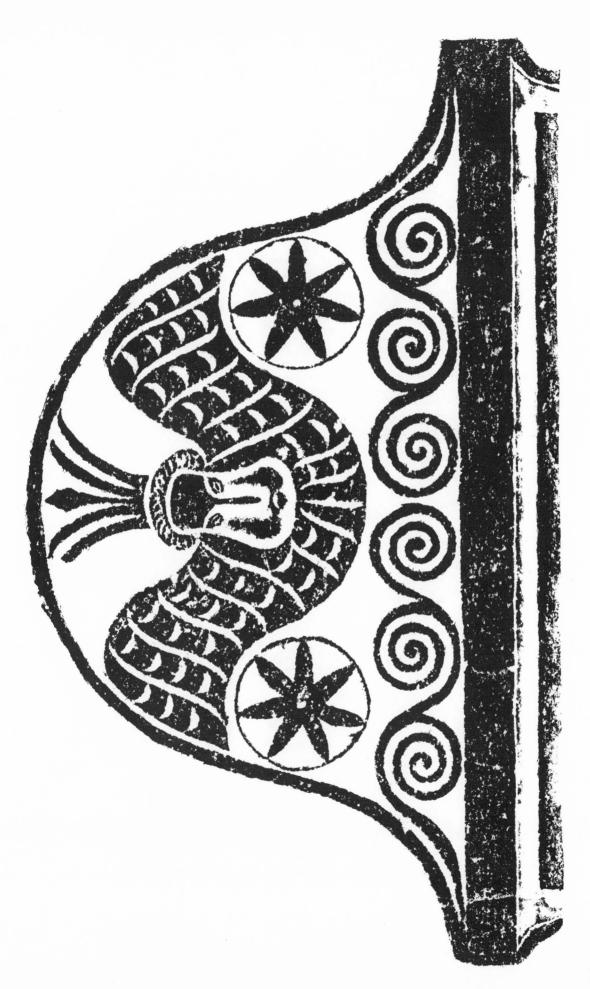

Plate 17

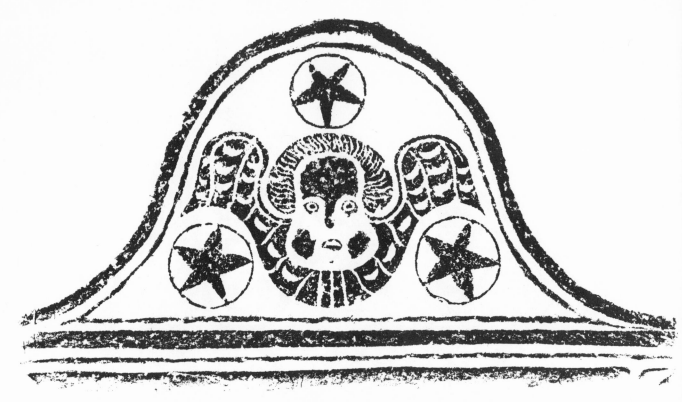

a

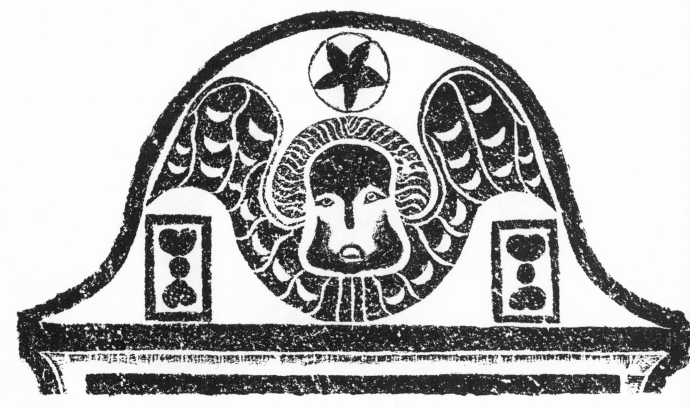

b

Plate 18

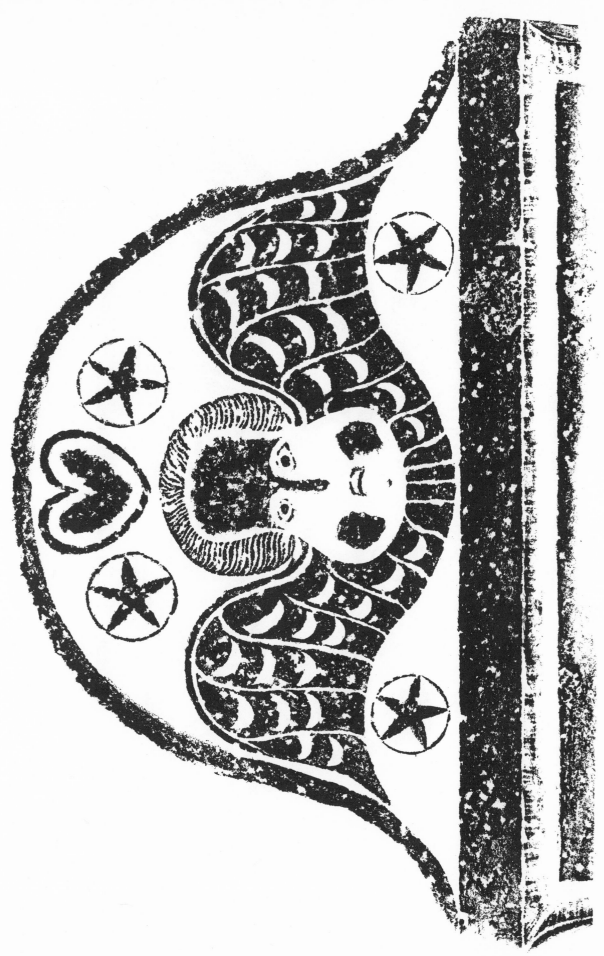

Plate 19

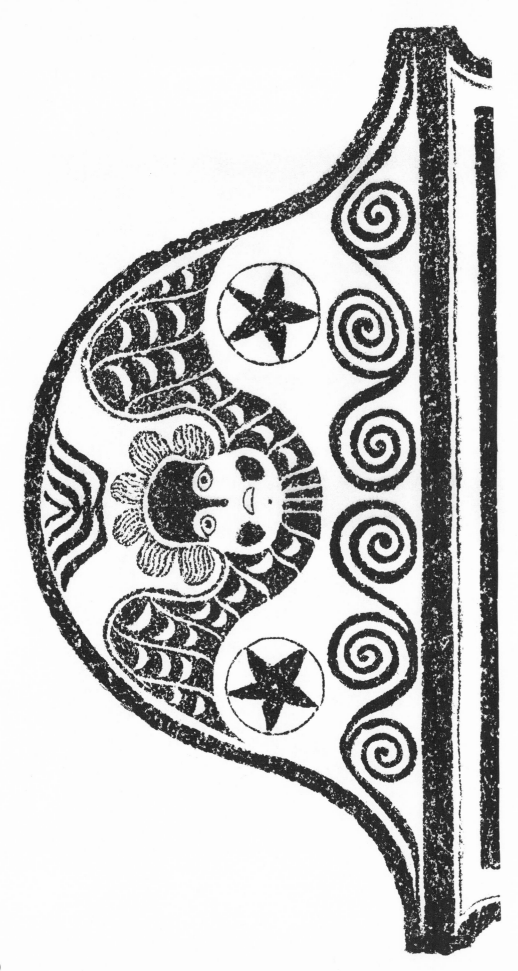

Plate 20

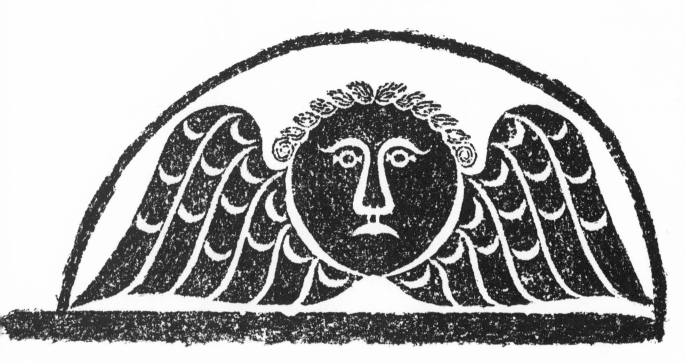

a

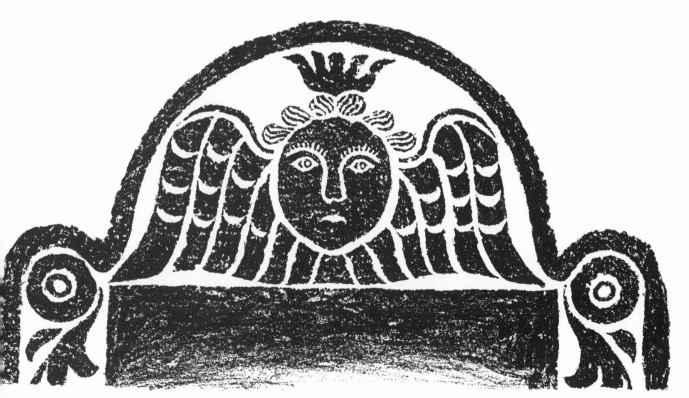

b

Plate 21

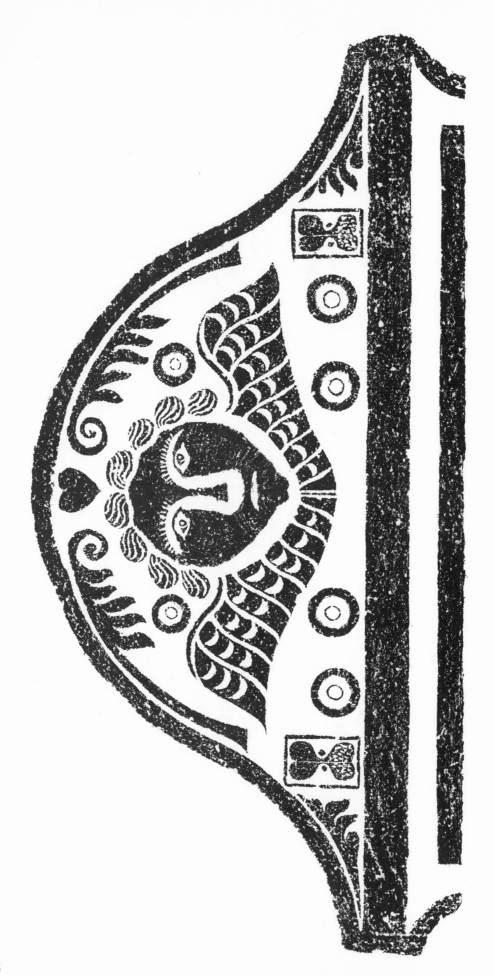

Plate 22

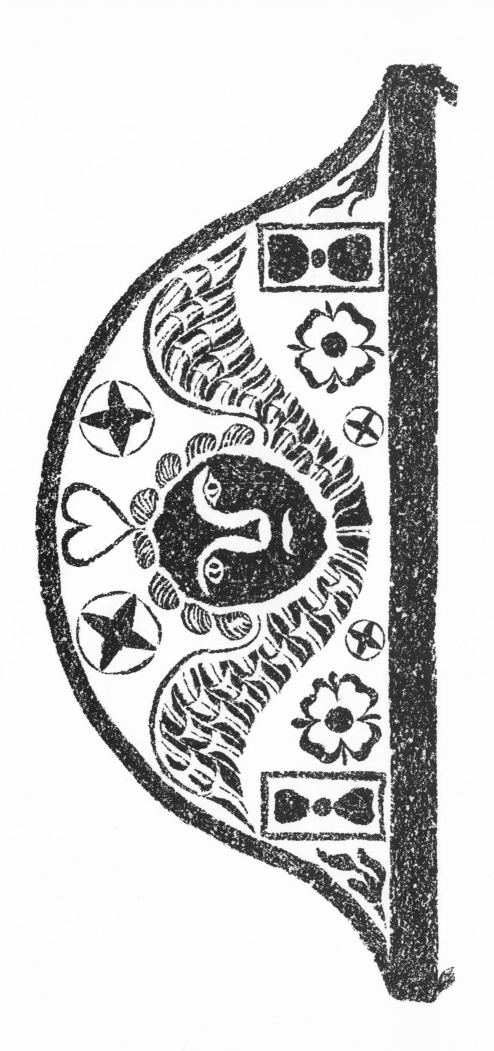

Plate 23

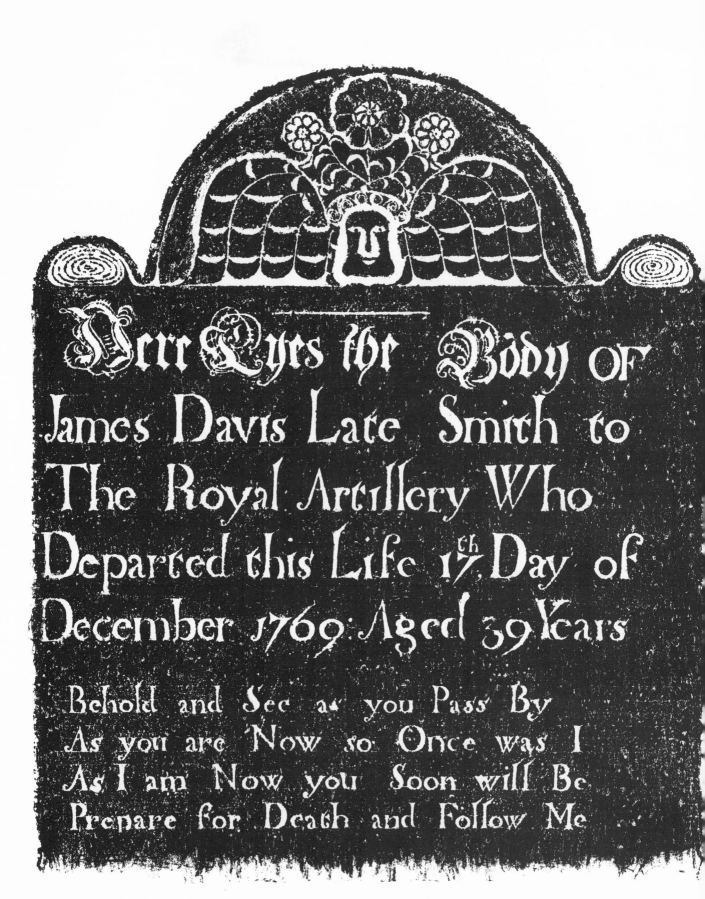

Plate 24

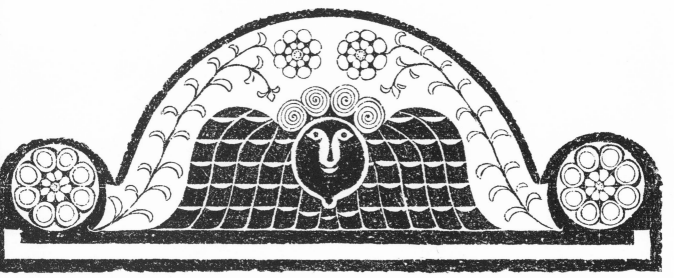

Iohn Zuricher Stone Cutter N, Y

a

b

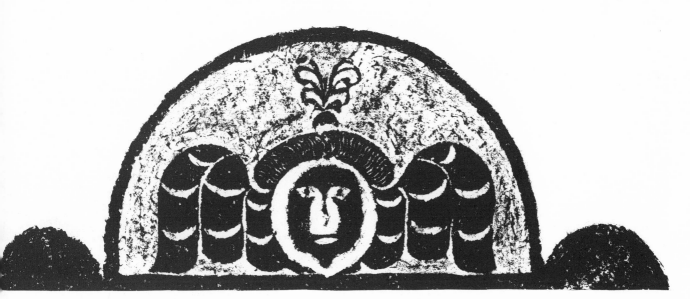

c

Plate 25

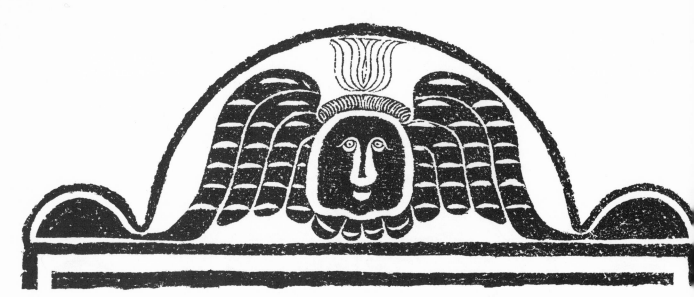

a

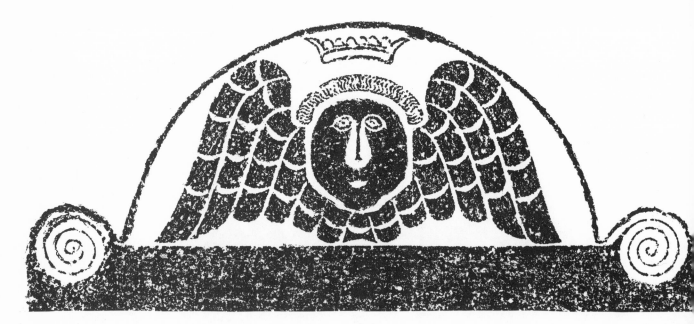

b

Plate 26

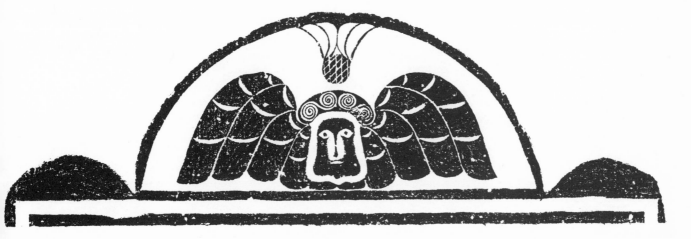

a

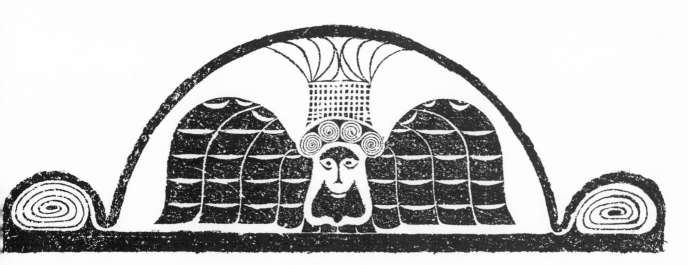

b

Plate 27

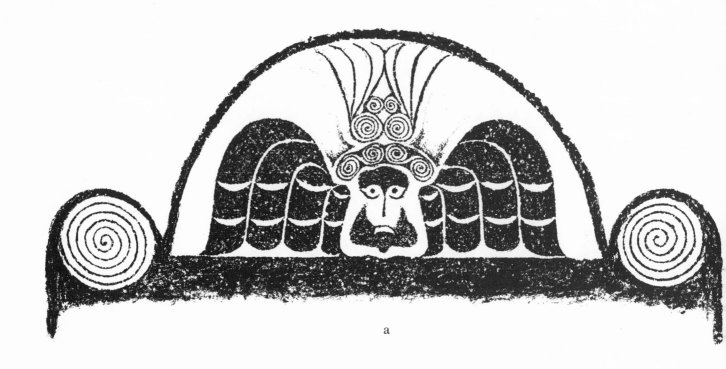

a

b

Plate 28

Here Lyes The Body of Sarah Jauncey Wife of John Jauncey of This City Mariner

Plate 29

a

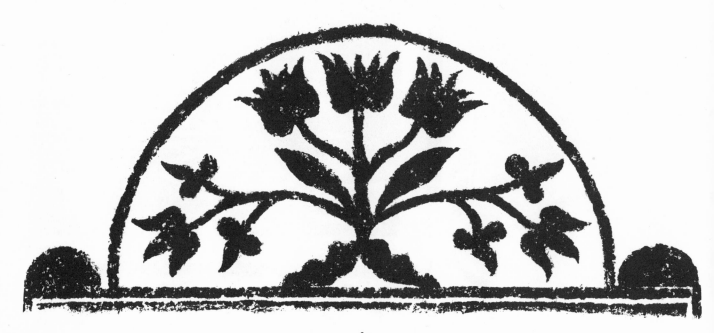

b

Plate 30

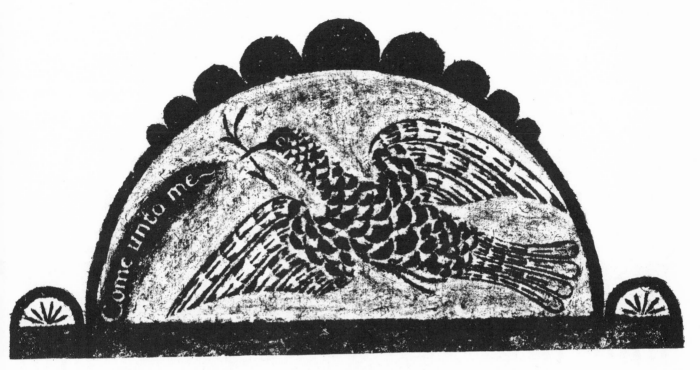

a

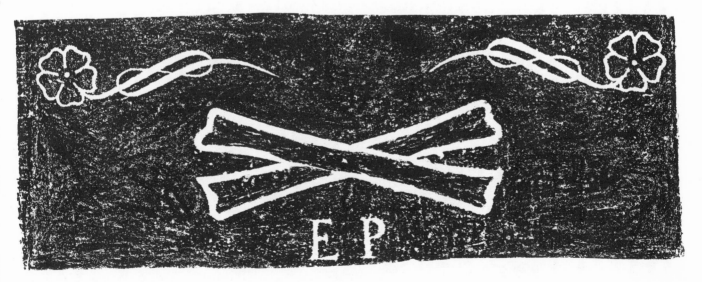

b

Plate 31

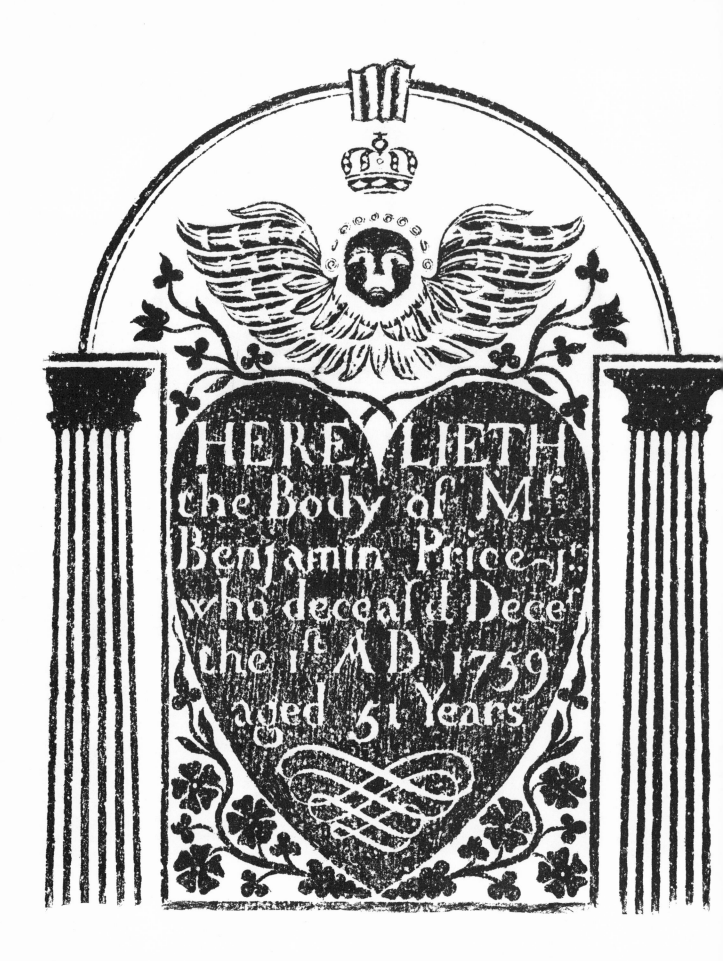

Plate 32

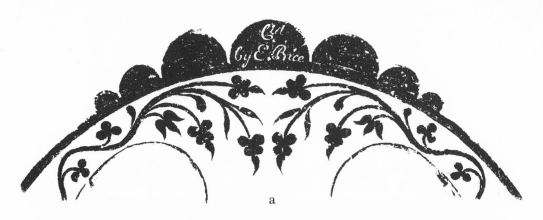

a

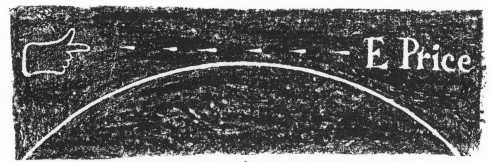

b

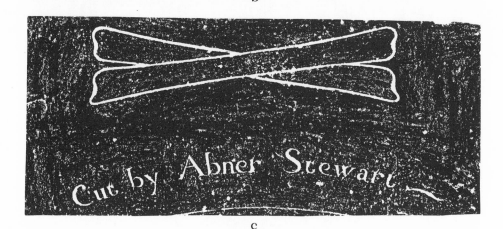

c

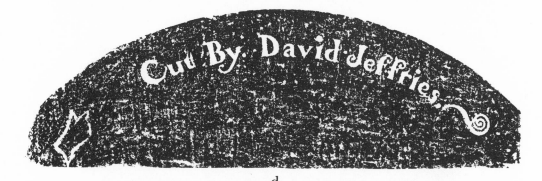

d

e

Plate 33

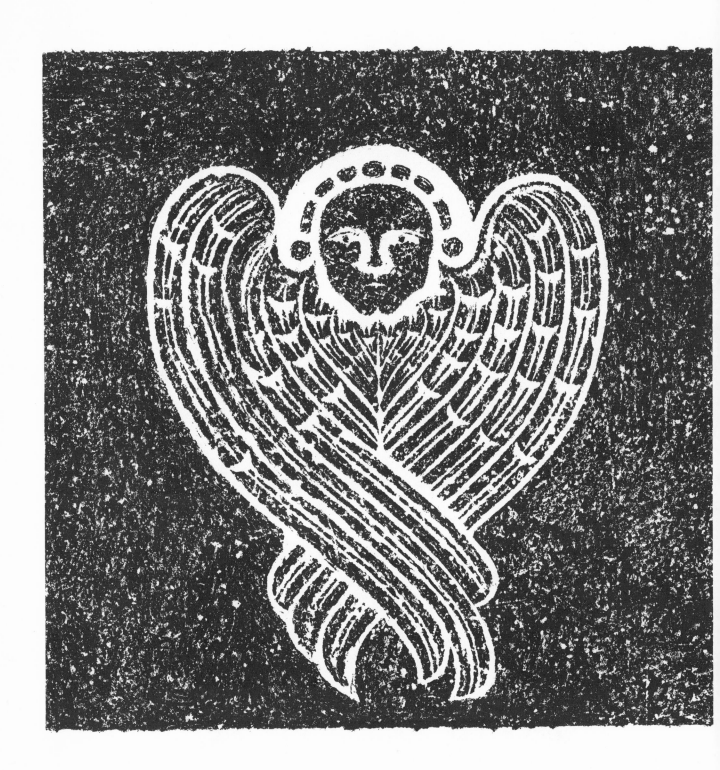

Plate 34

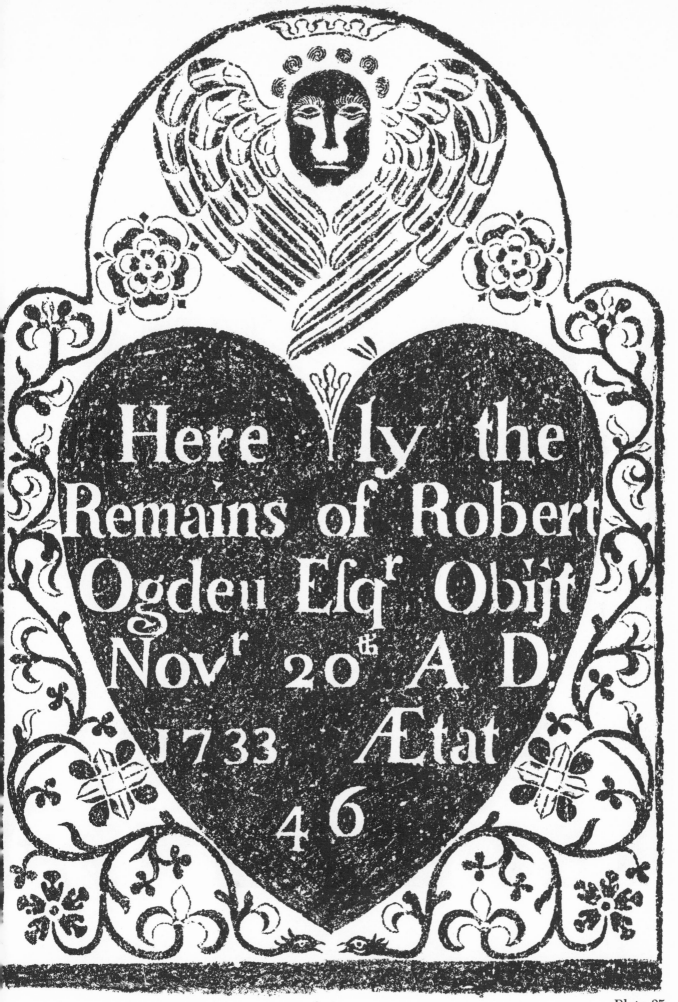

Here ly the Remains of Robert Ogdeu Esqʳ Obijt Novʳ 20ᵗʰ A D 1733 Ætat 46

Plate 35

a

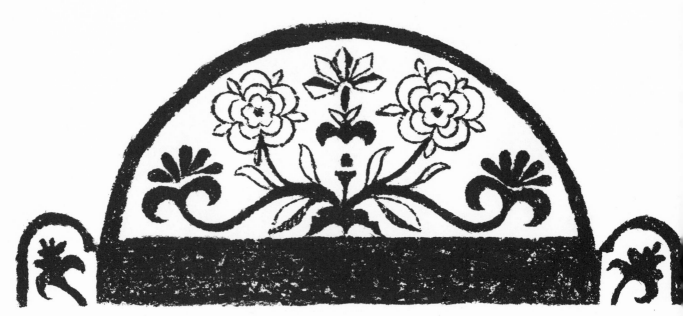

b

Plate 36

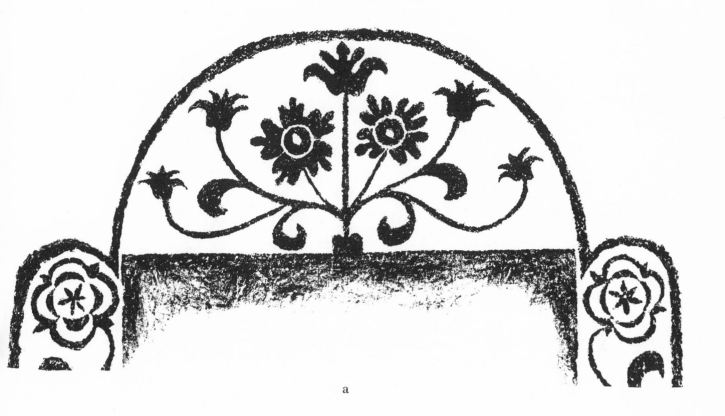

a

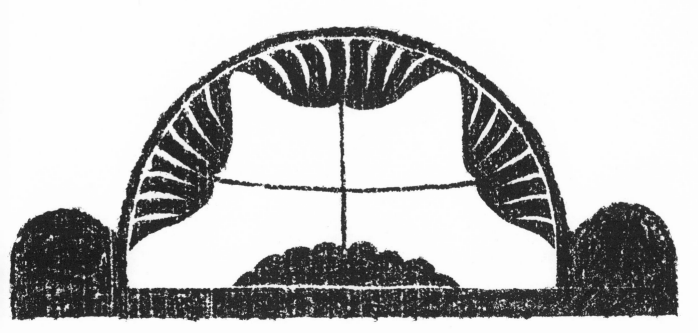

b

Plate 37

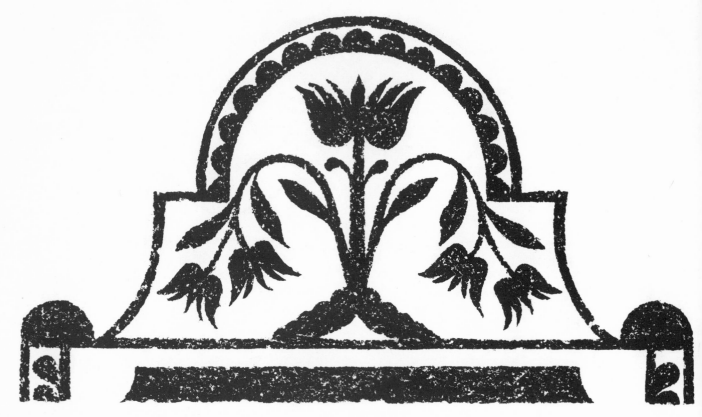

a

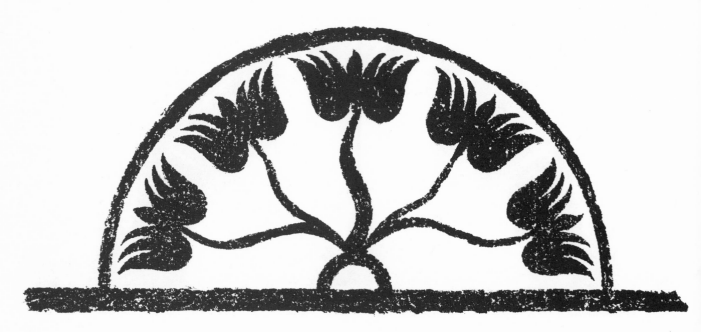

b

Plate 38

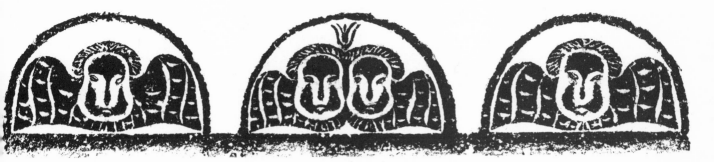

a

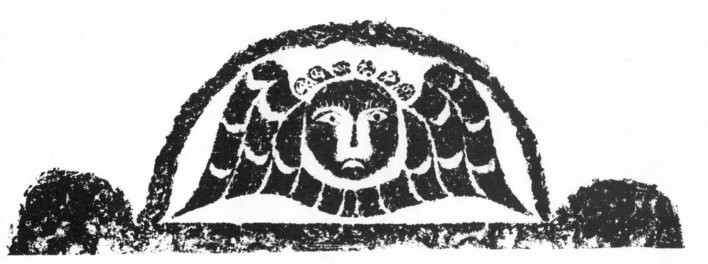

b

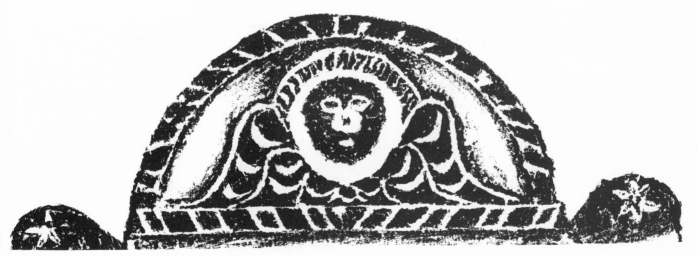

c

Plate 39

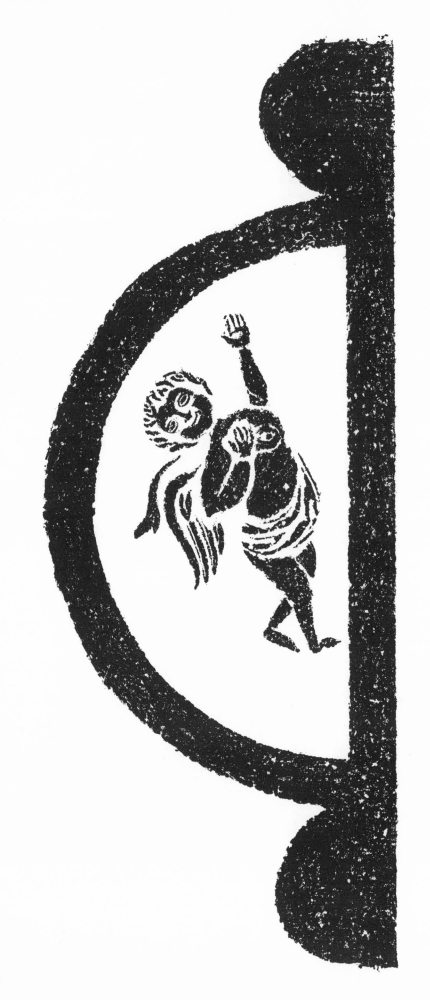

Plate 40

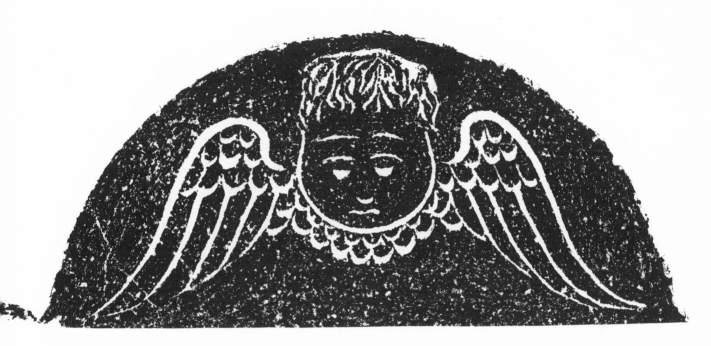

a

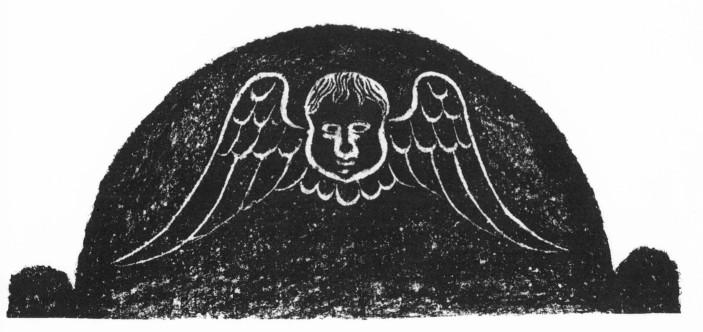

b

Plate 41

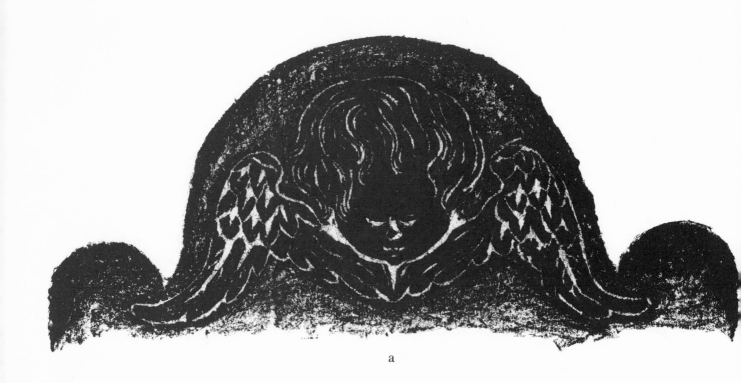

a

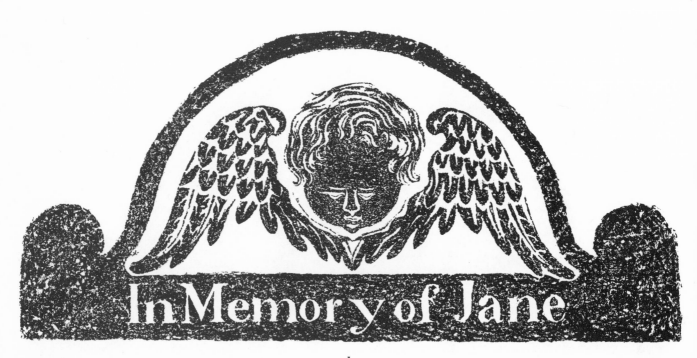

b

Plate 42

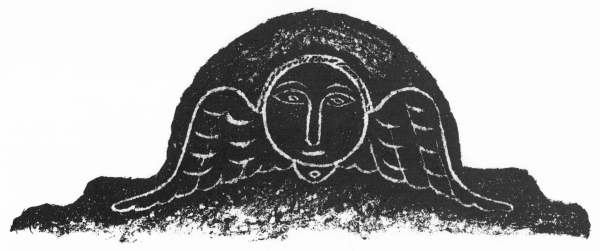

a

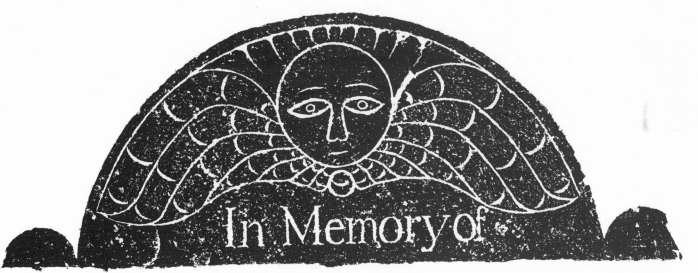

b

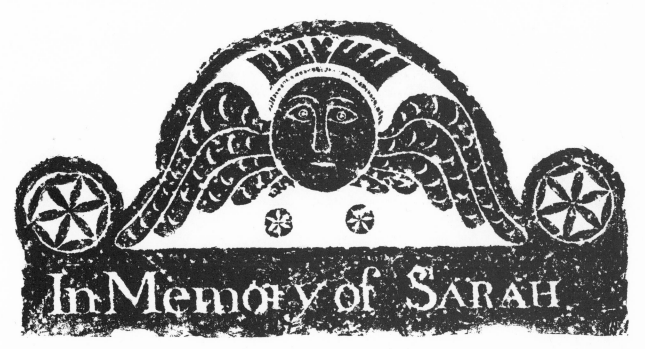

c

Plate 43

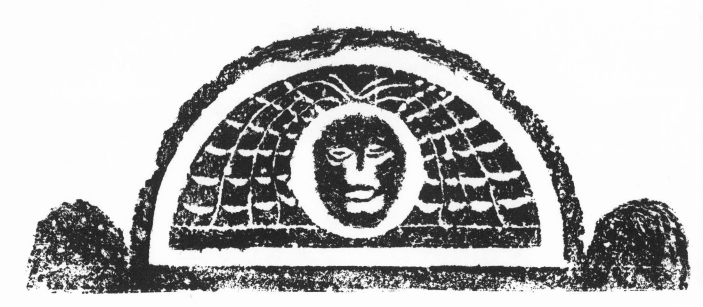

a

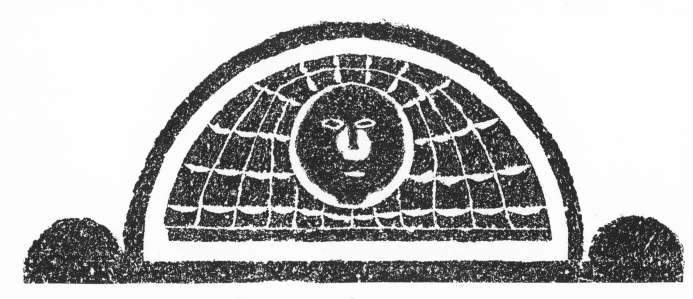

b

Plate 44

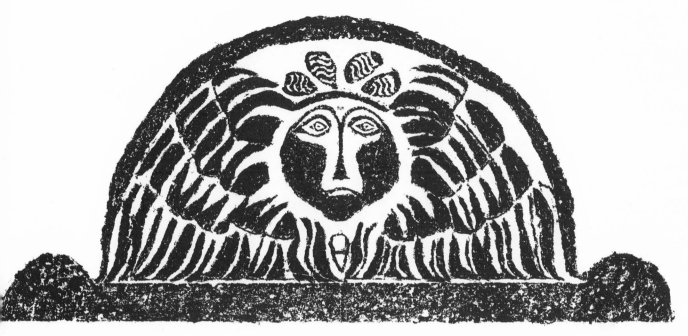

a

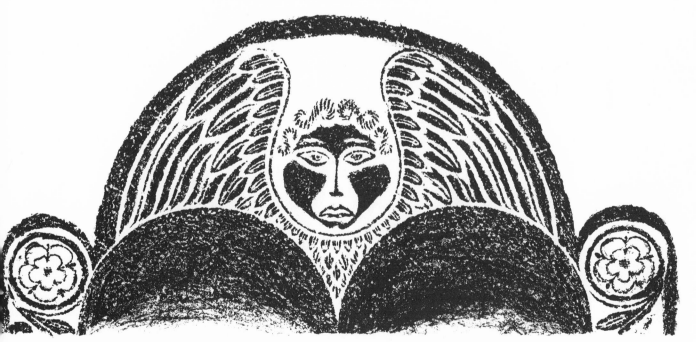

b

Plate 45

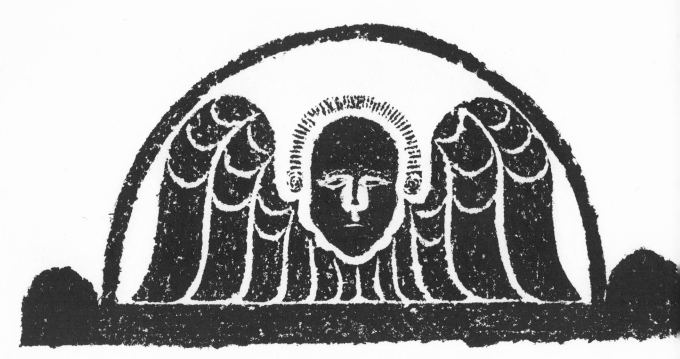

a

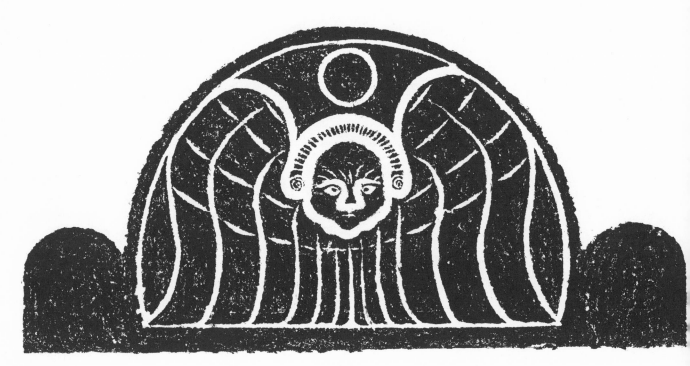

b

Plate 46

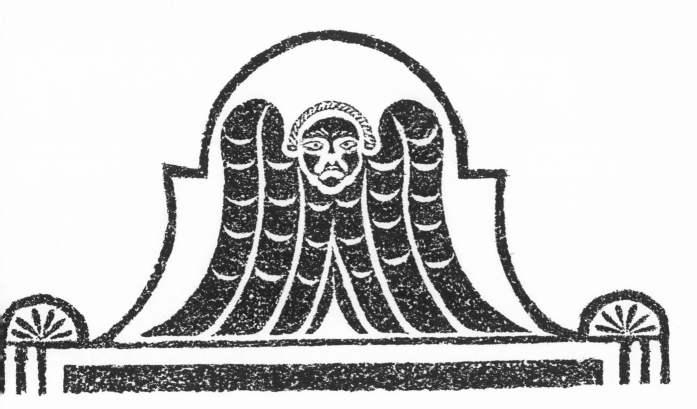

a

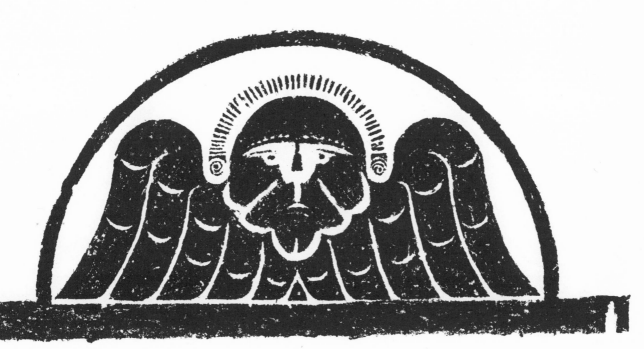

b

Plate 47

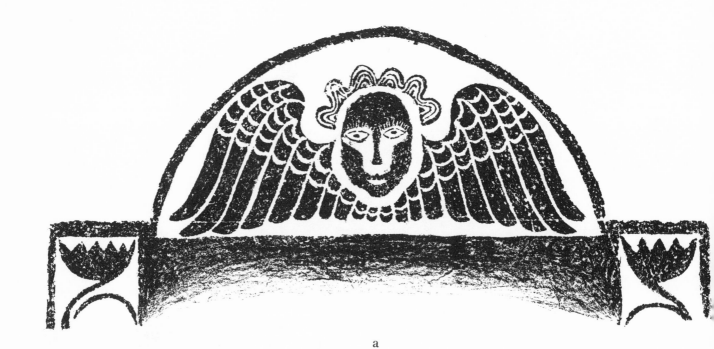

a

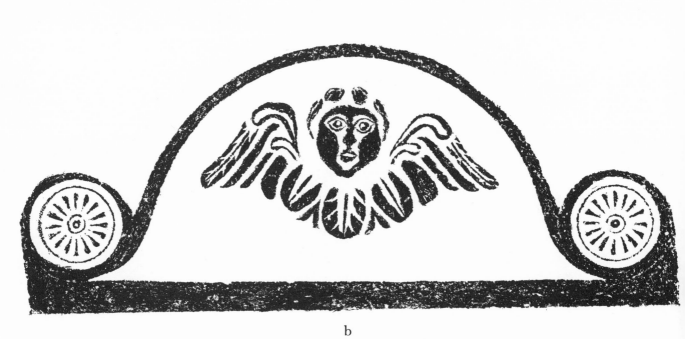

b

Plate 48

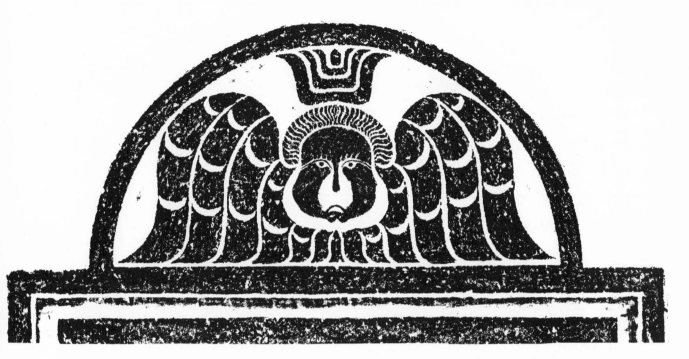

a

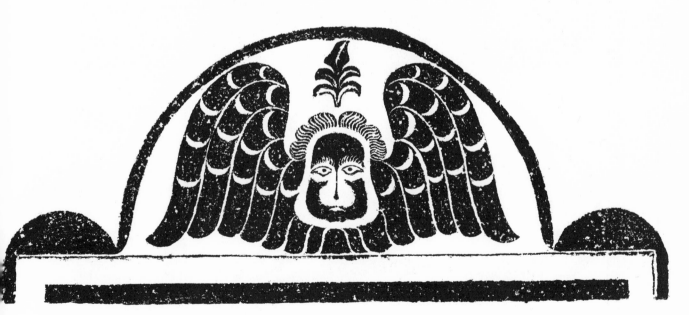

b

Plate 49

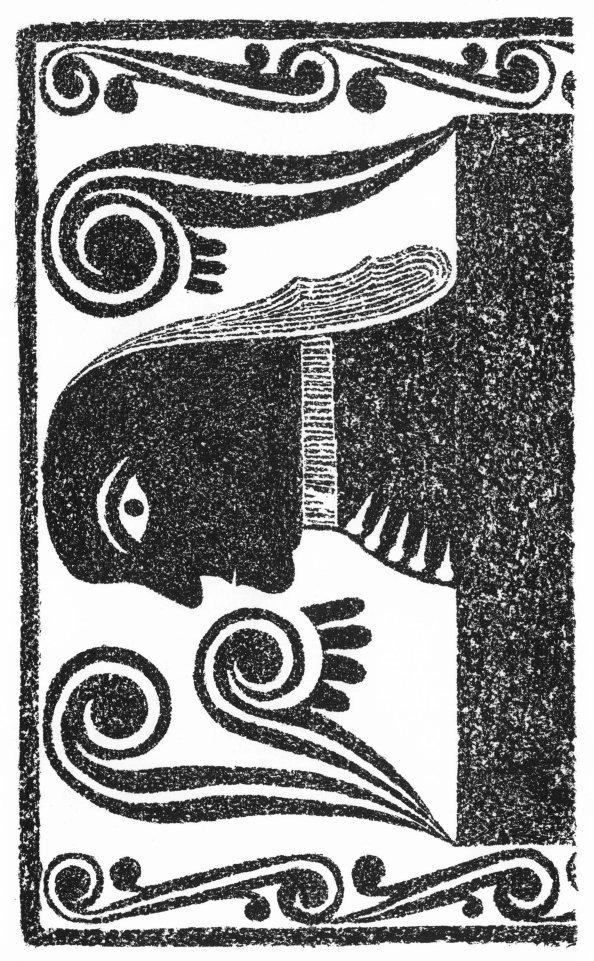

Plate 50

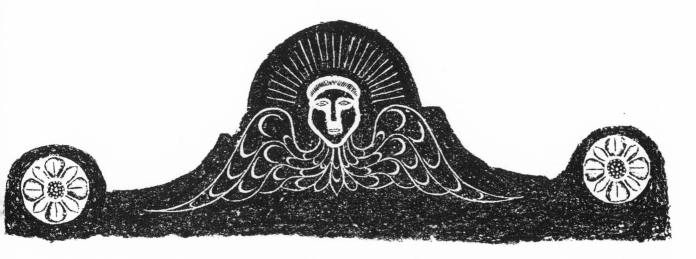

a

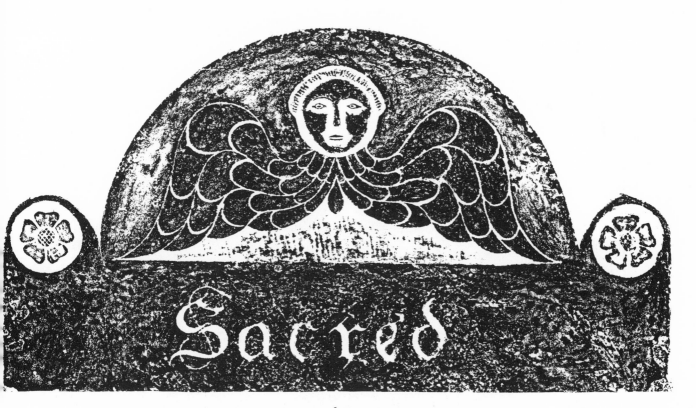

b

Plate 51

a

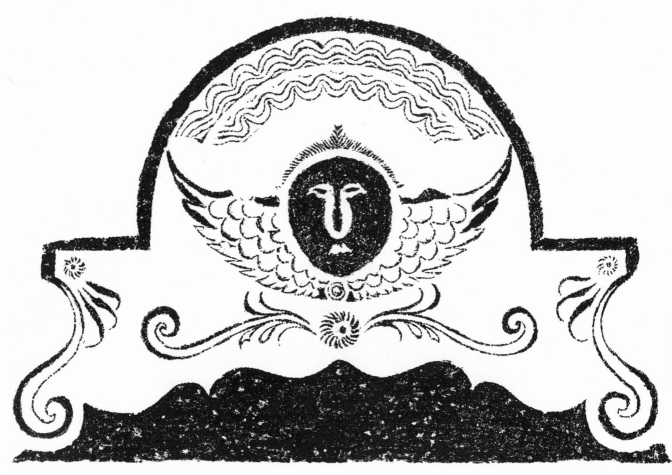

b

Plate 52

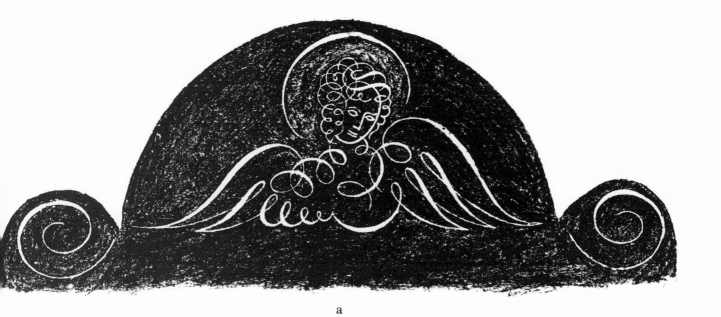

a

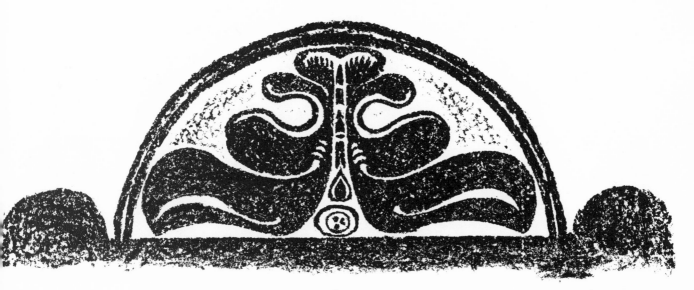

b

Plate 53

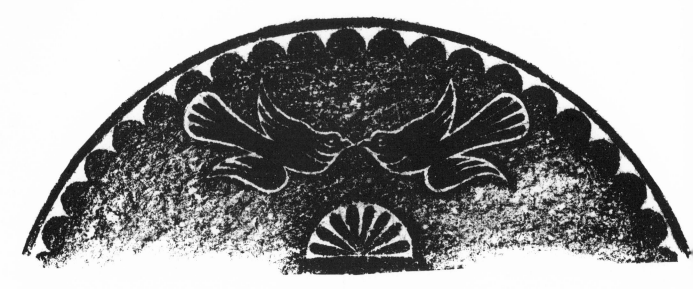

a

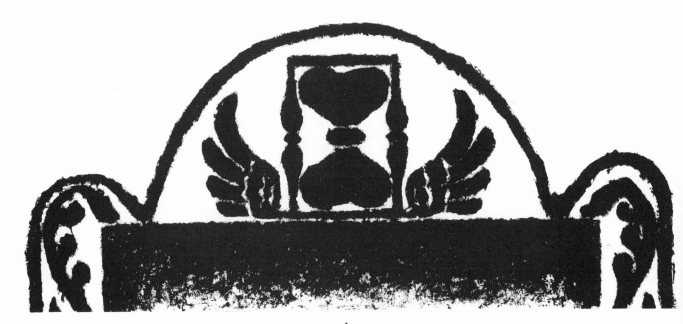

b

Plate 54

a

b

Plate 55

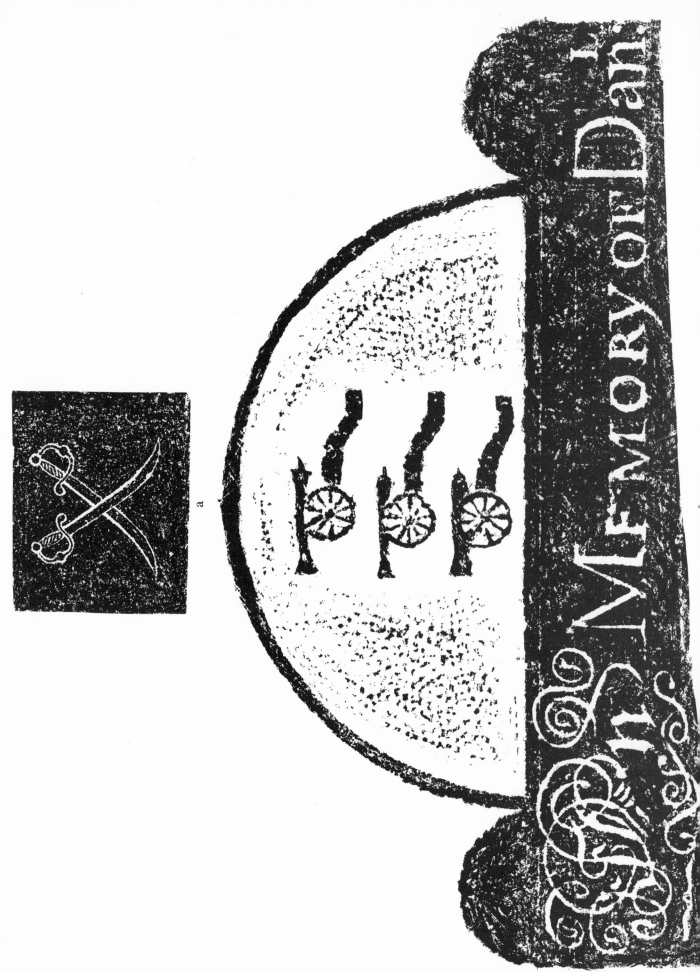

a

Plate 56

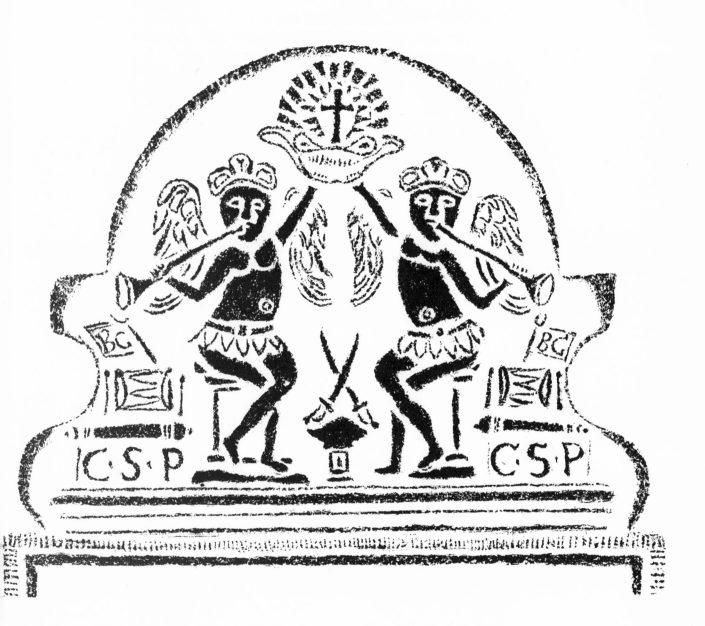

Plate 57

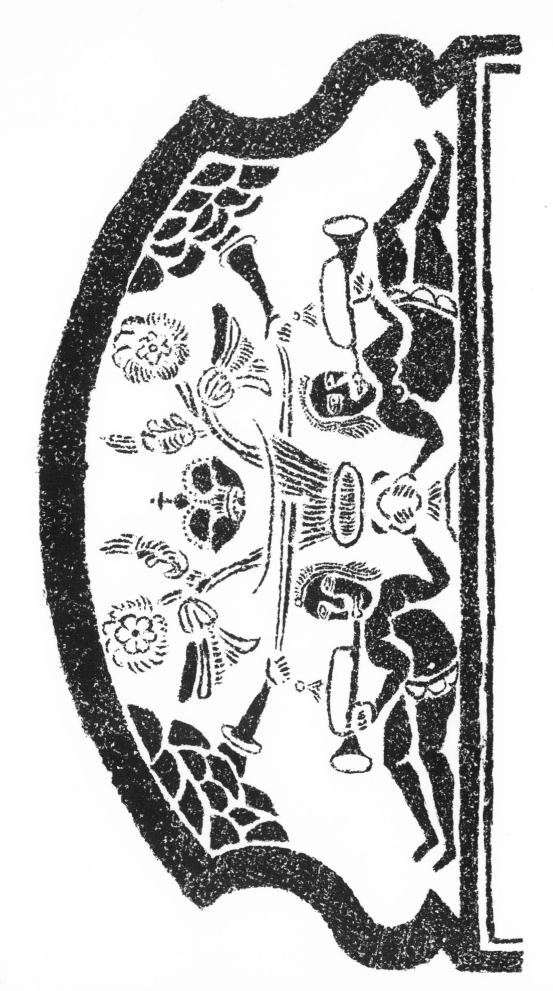

Plate 58

a

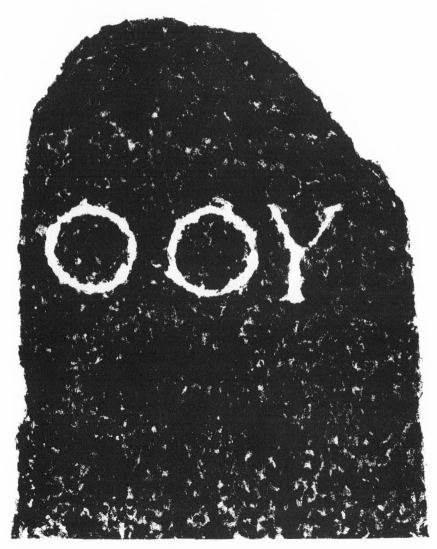

b

Plate 59

Plate 60

a

b

Plate 61

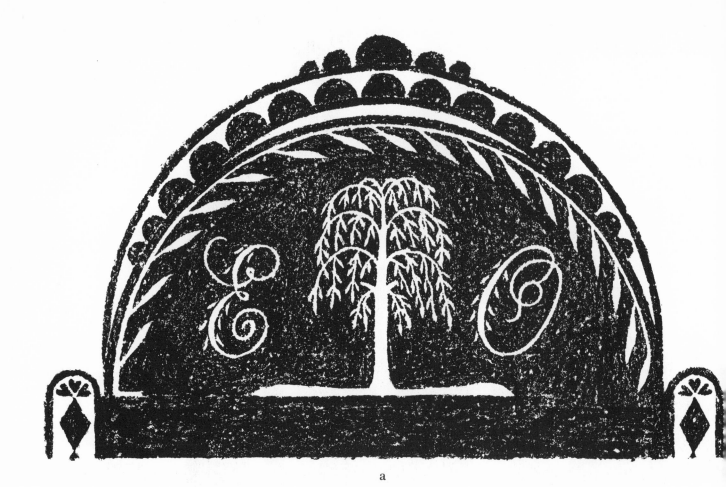

a

b

c

Plate 62

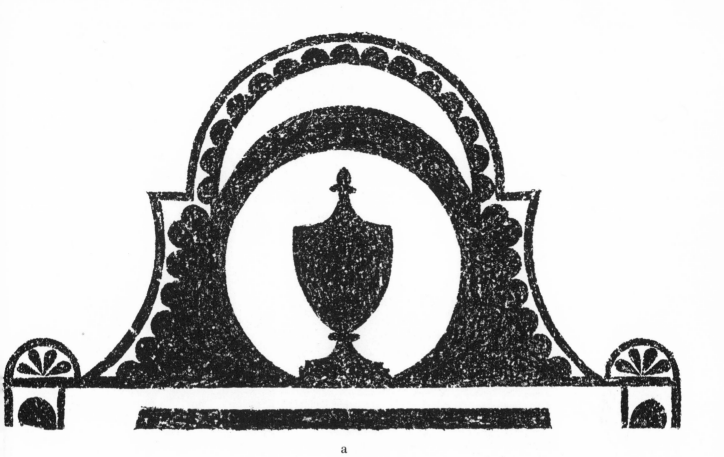

a

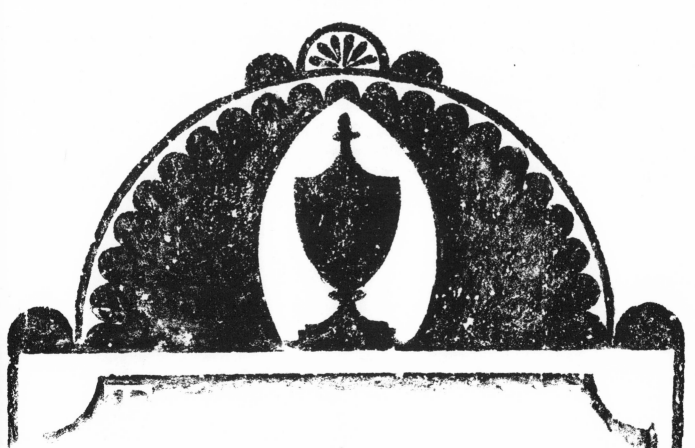

b

Plate 63

Plate 64

Plate 65

THE PHOTOGRAPHS

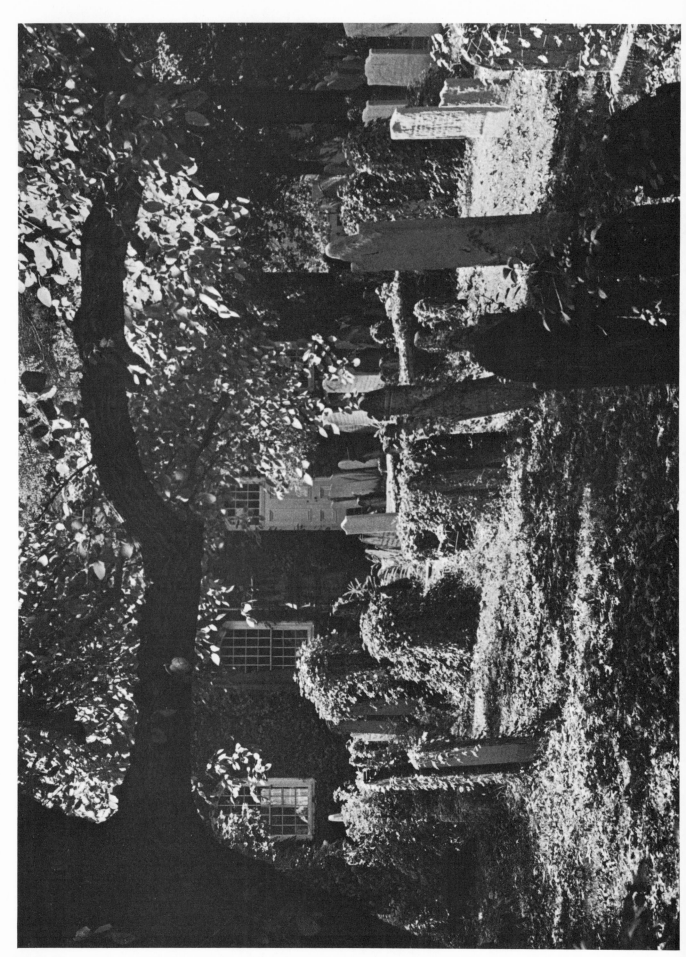

Plate 66

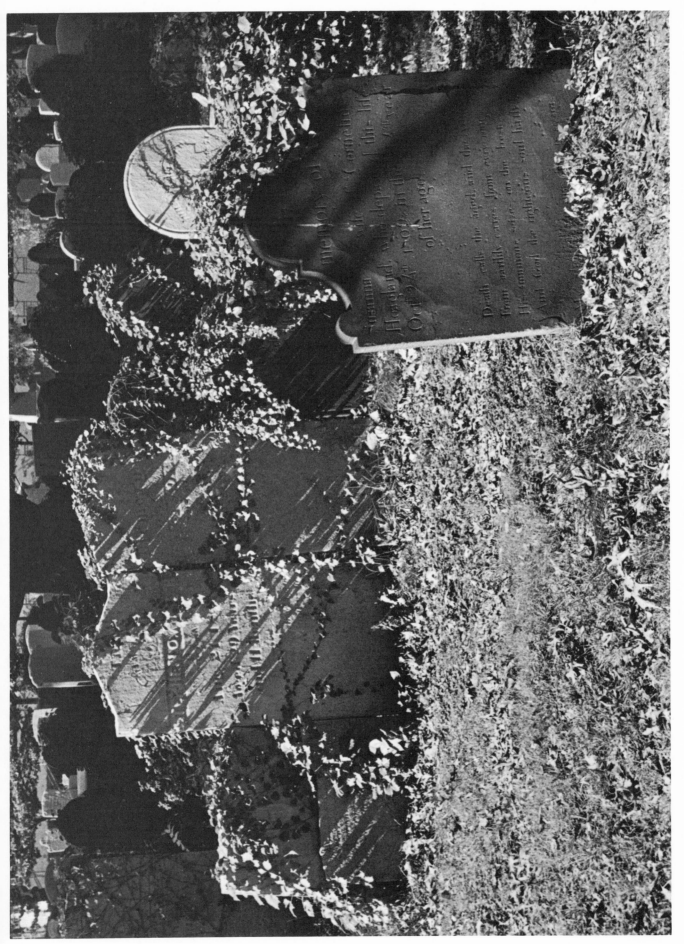

Plate 67

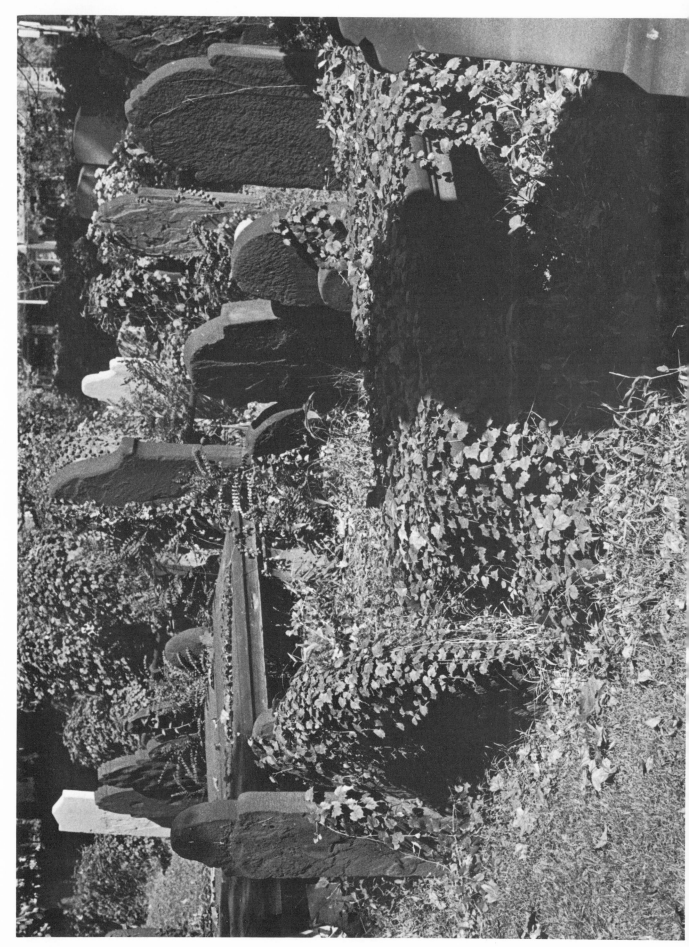

Plate 68

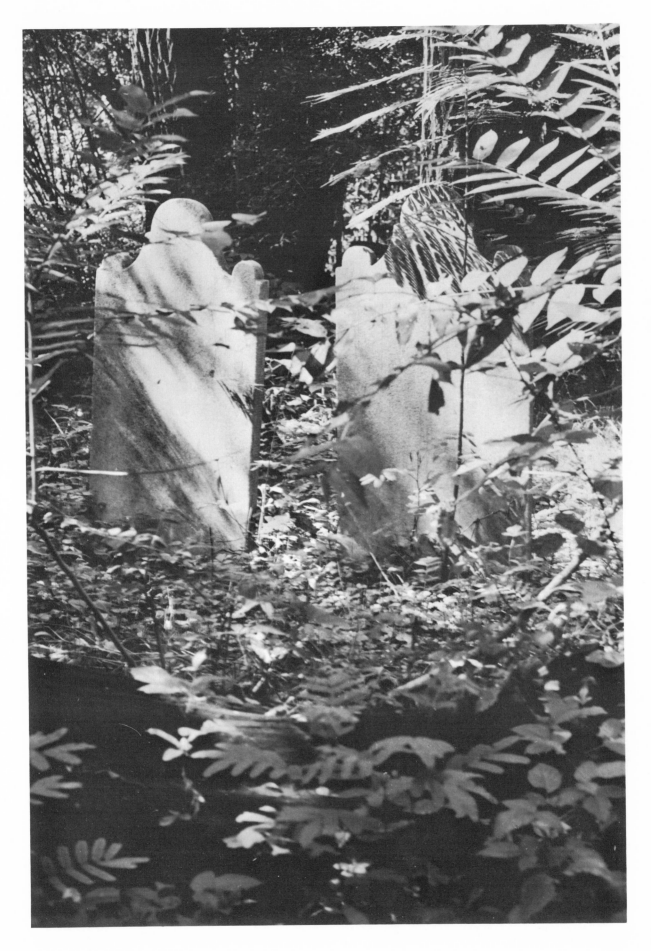

Plate 69

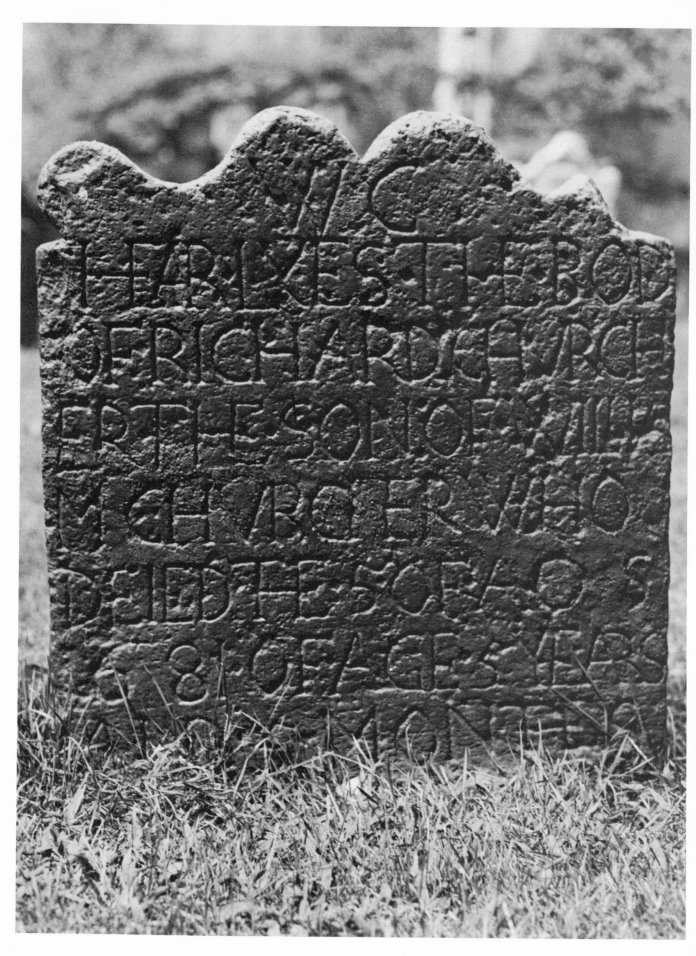

Plate 70

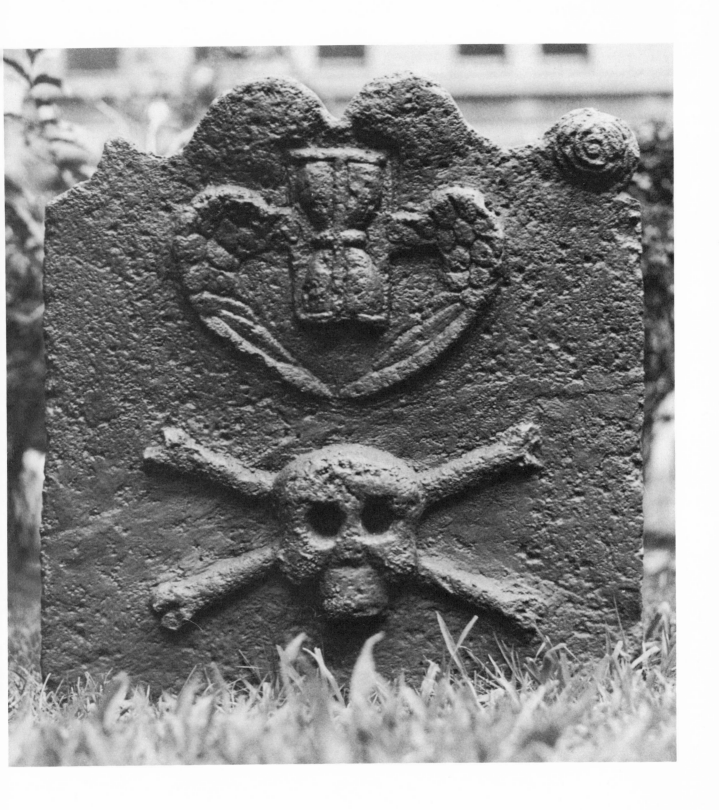

Plate 71

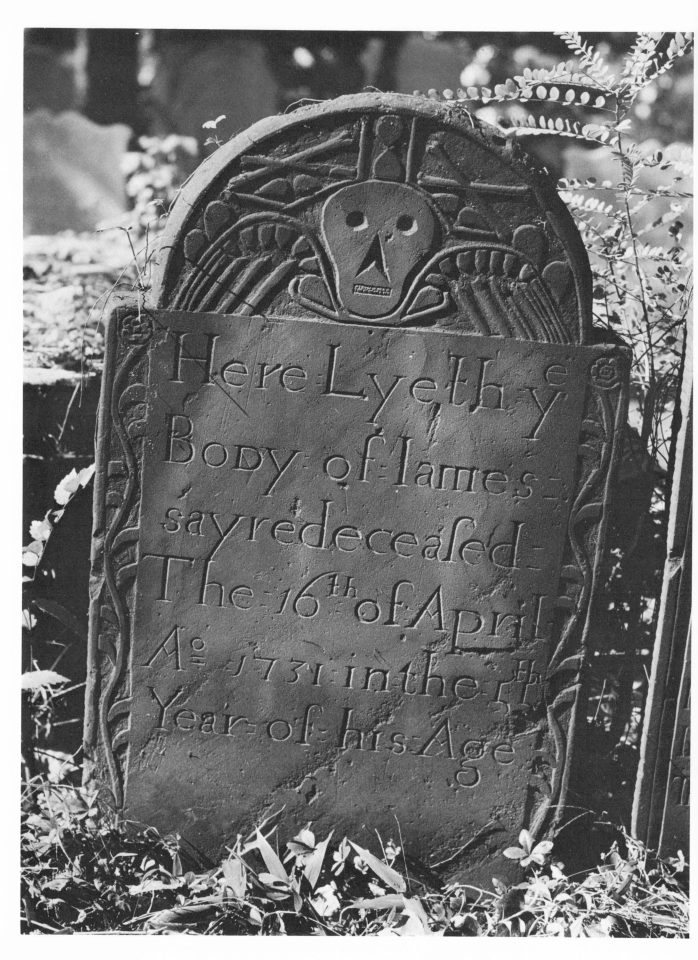

Plate 72

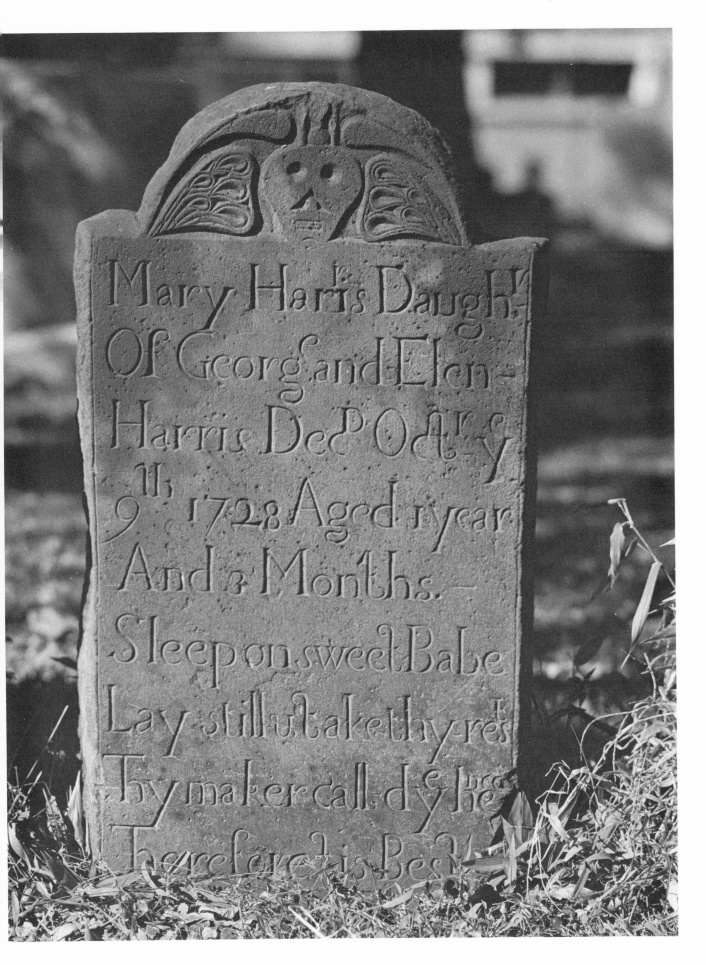

Plate 73

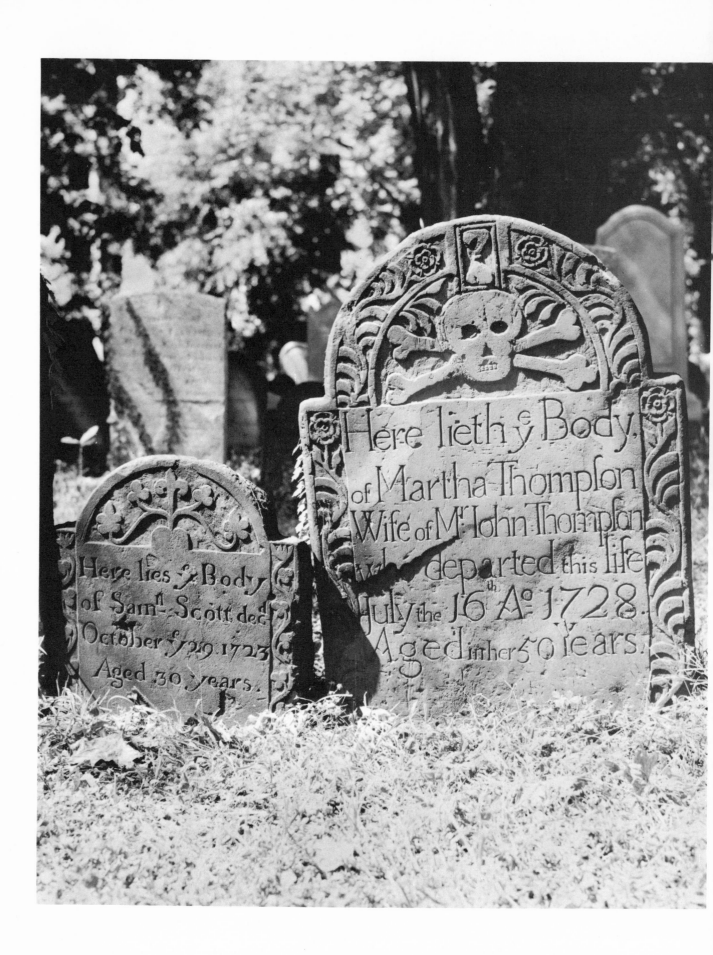

Plate 74

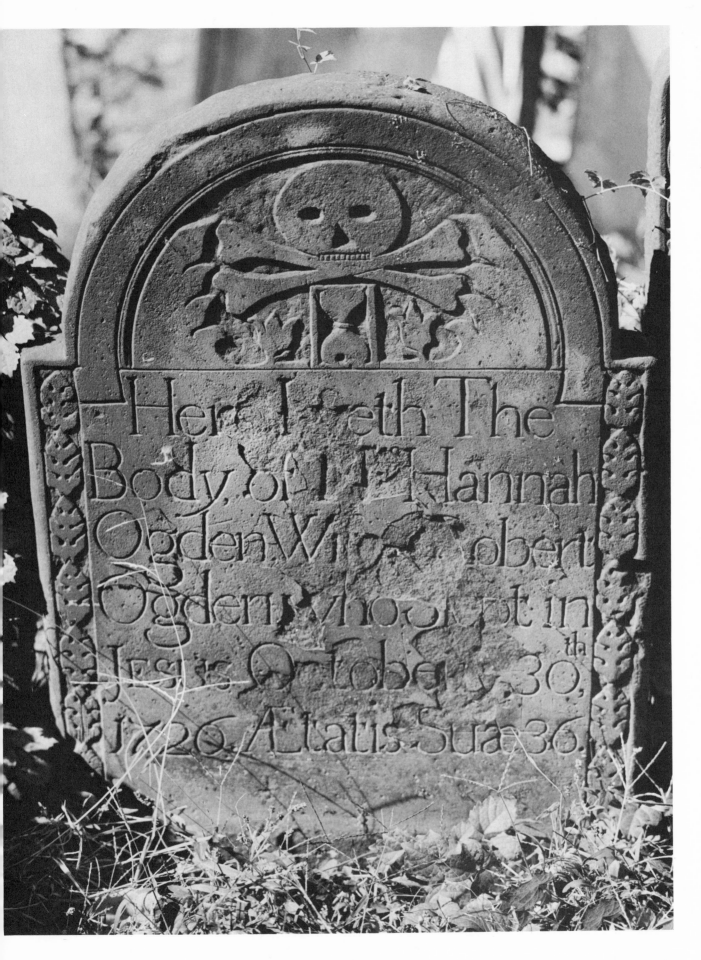

Plate 75

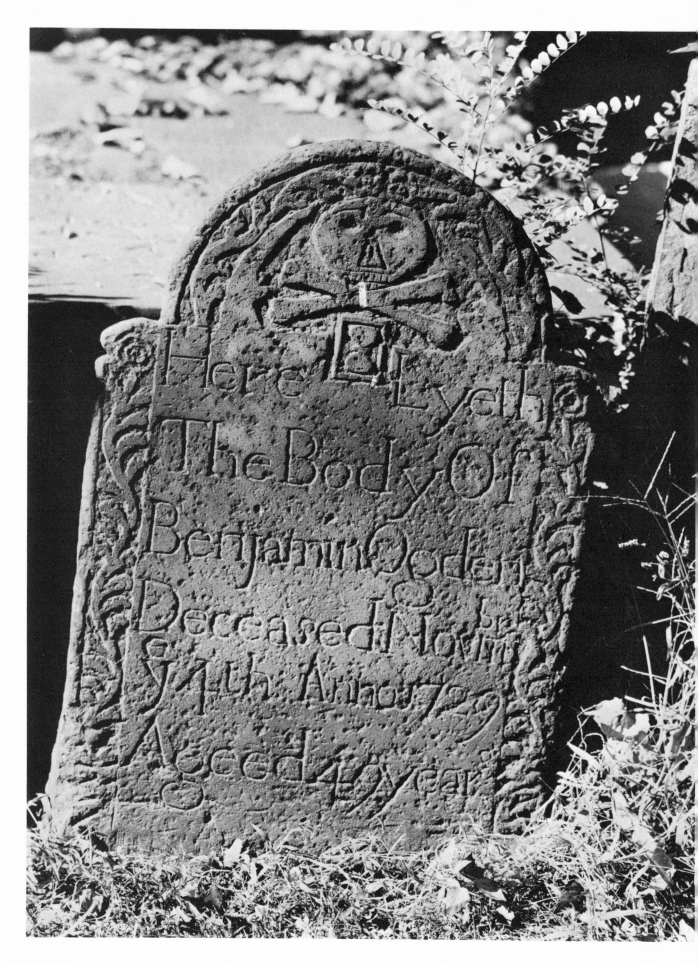

Plate 76

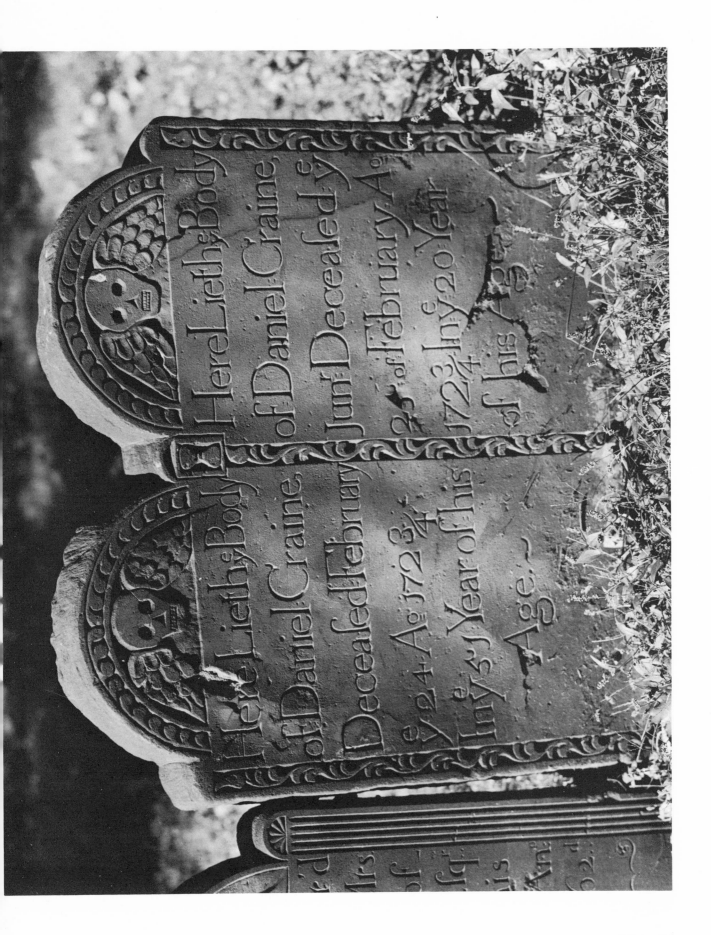

Plate 77

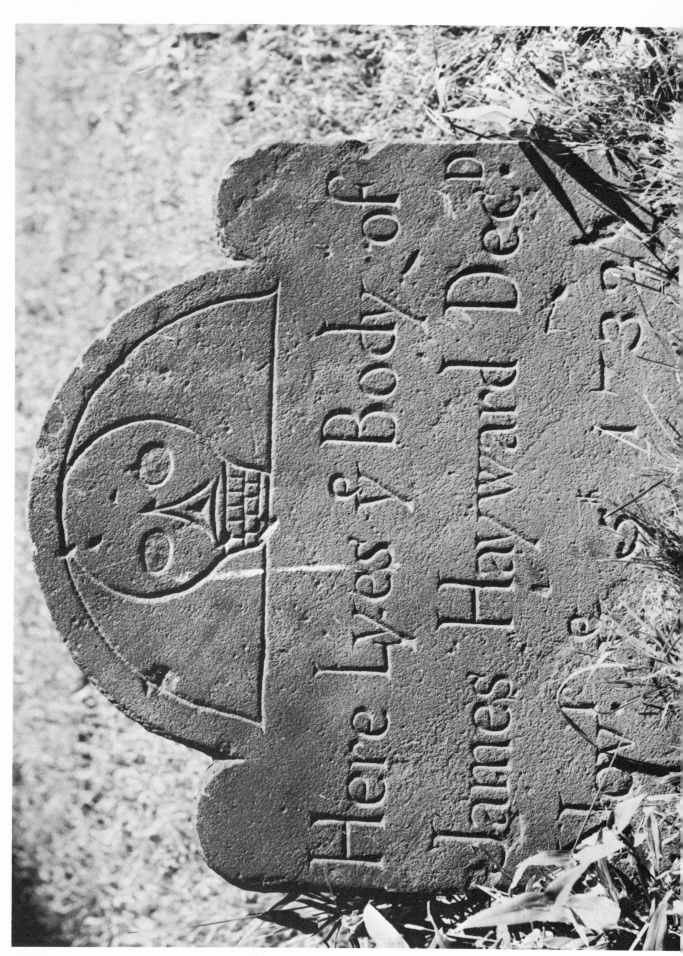

Plate 78

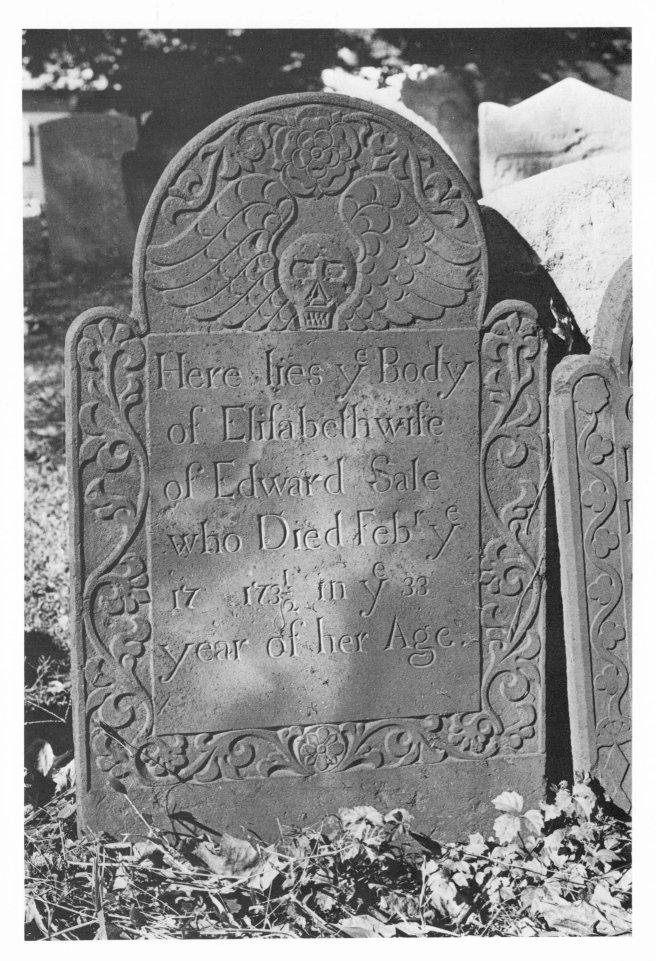

Plate 79

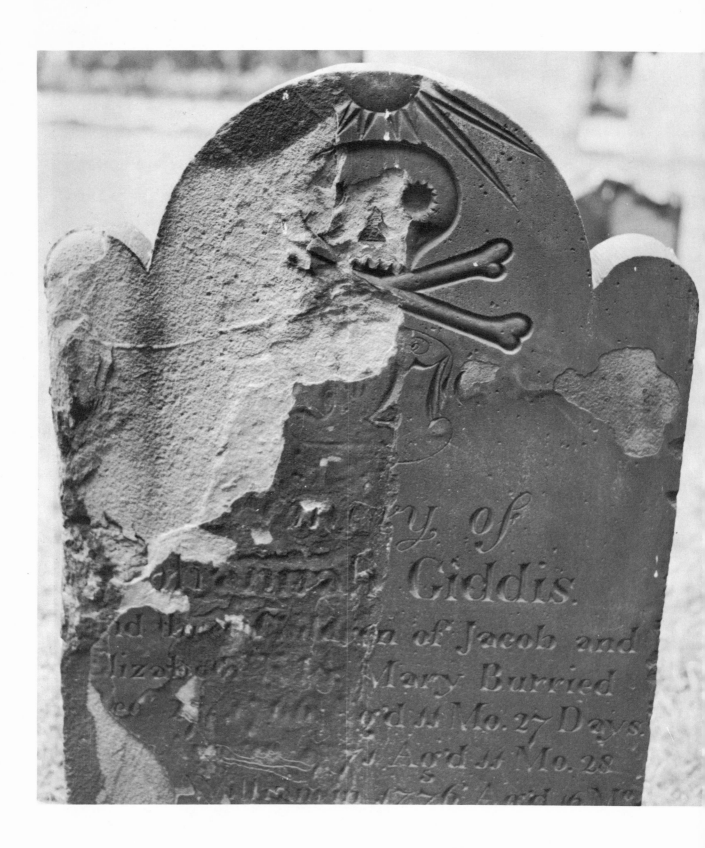

Plate 80

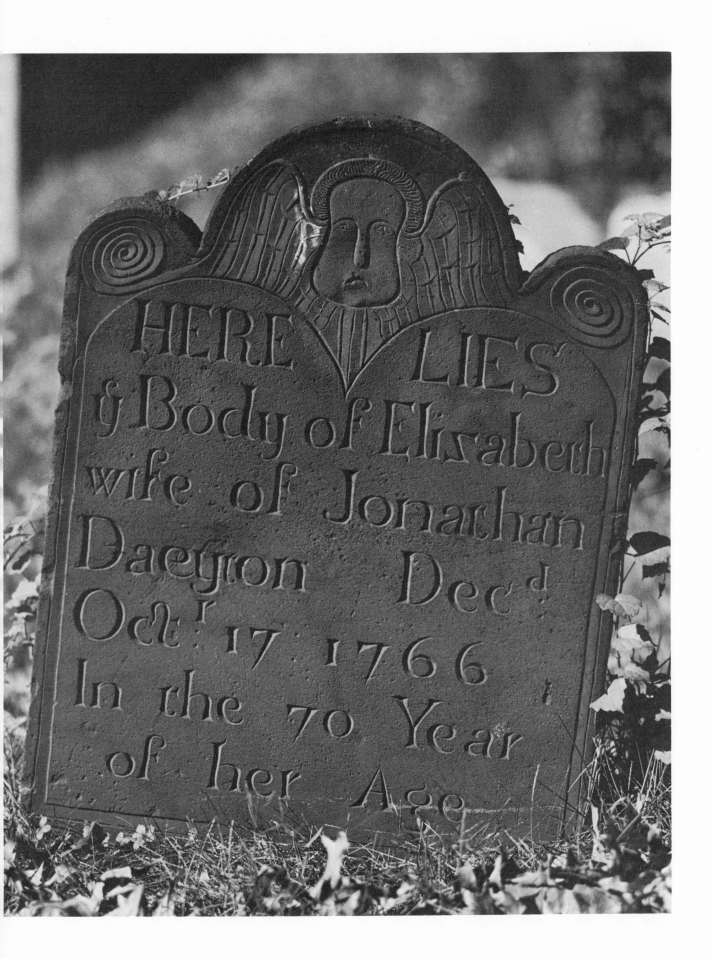

Plate 81

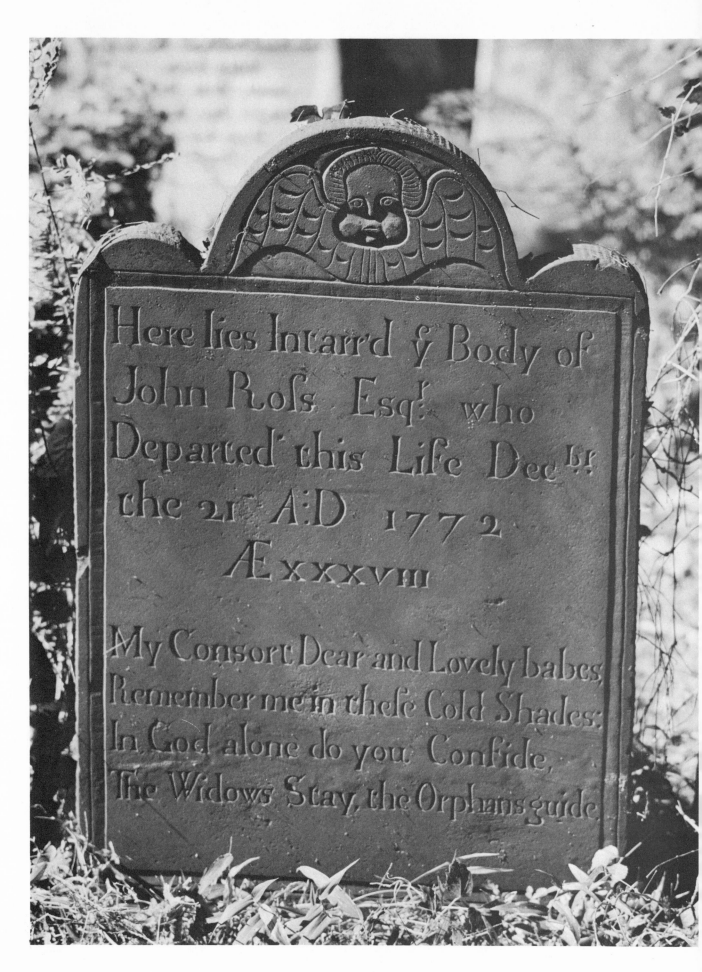

Plate 82

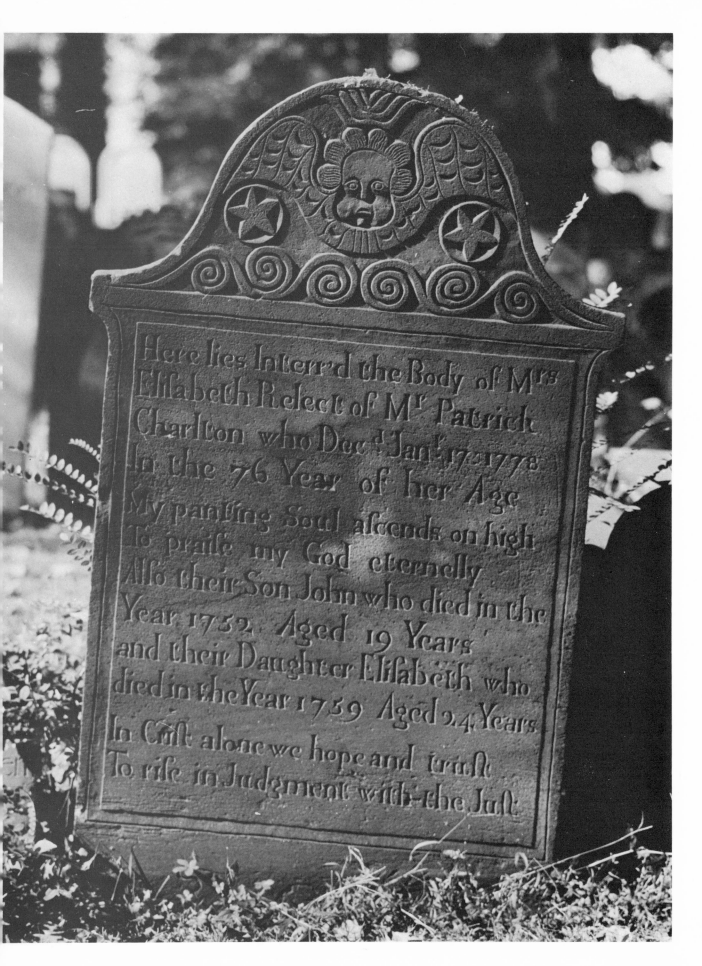

Plate 83

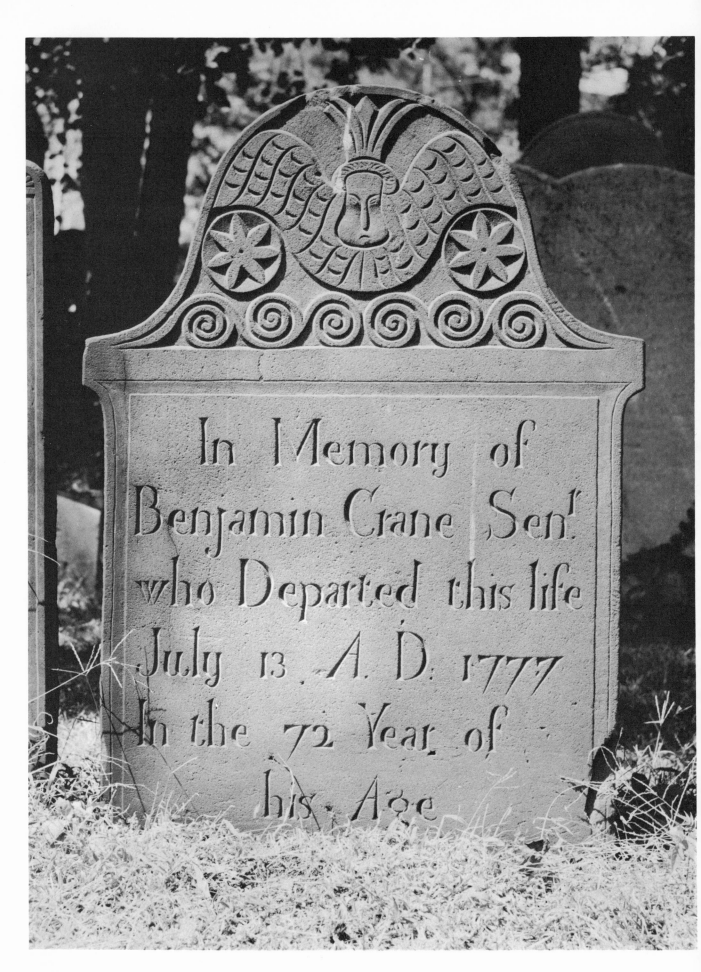

In Memory of
Benjamin Crane Sen.ʳ
who Departed this life
July 13 A. D. 1777
In the 72 Year of
his Age

Plate 84

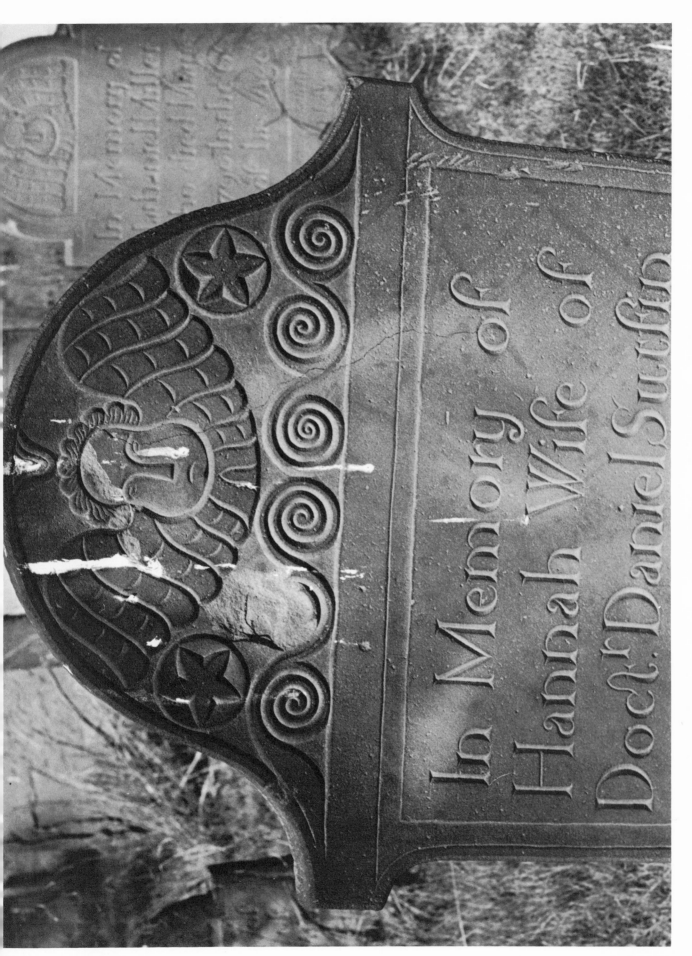

In Memory of
Hannah Wife of
Doct. Daniel Sutliff

Plate 85

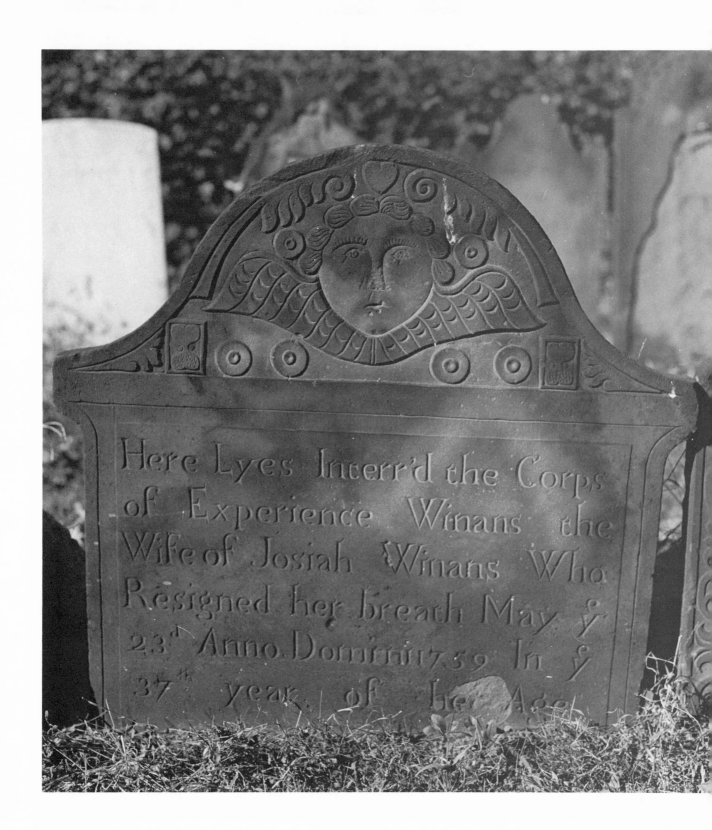

Plate 86

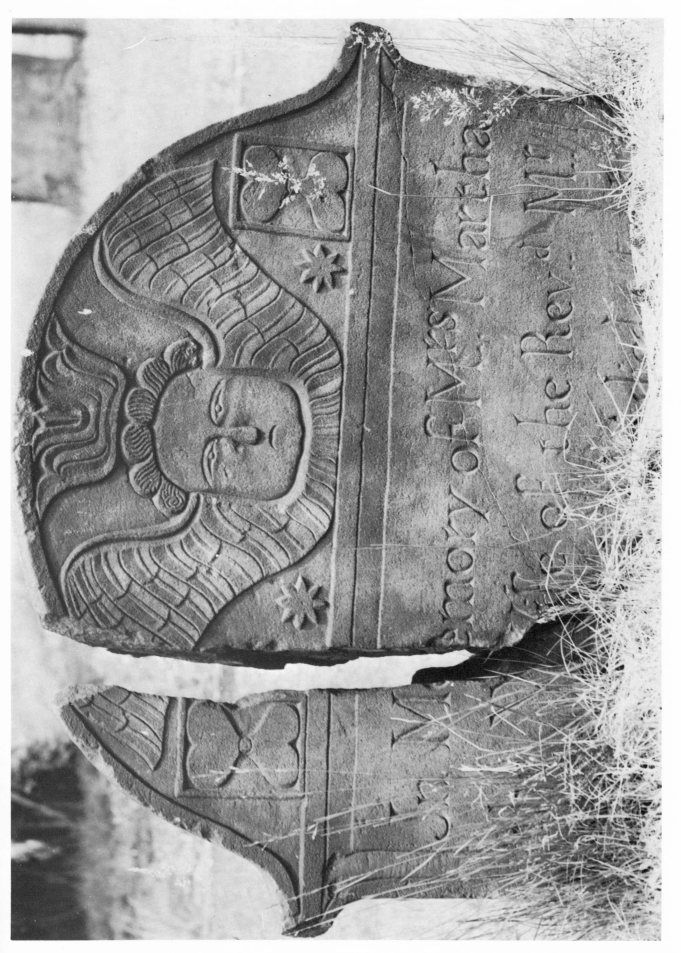

Plate 87

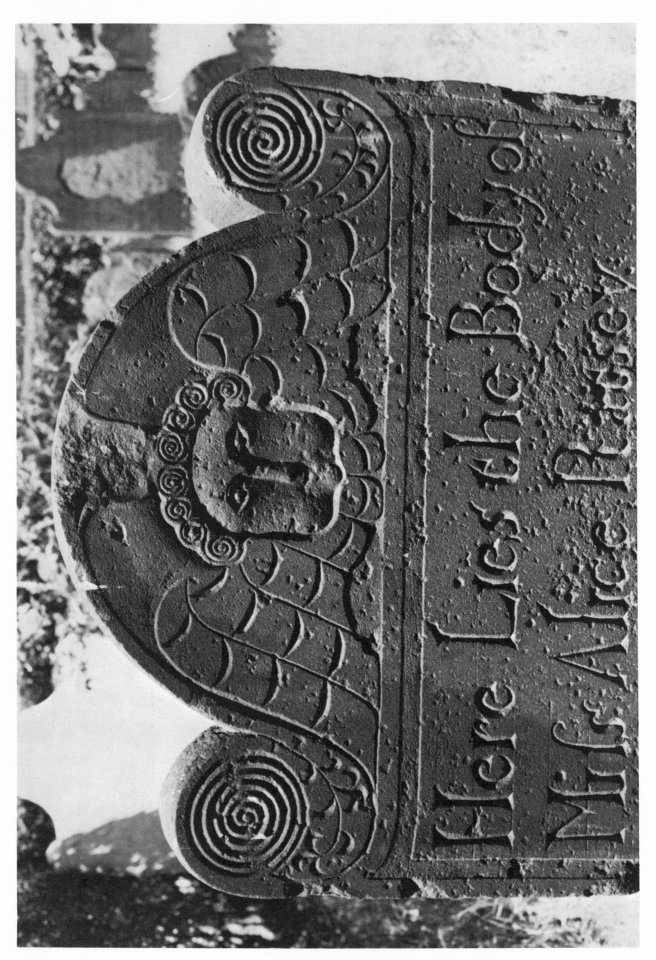

Plate 88

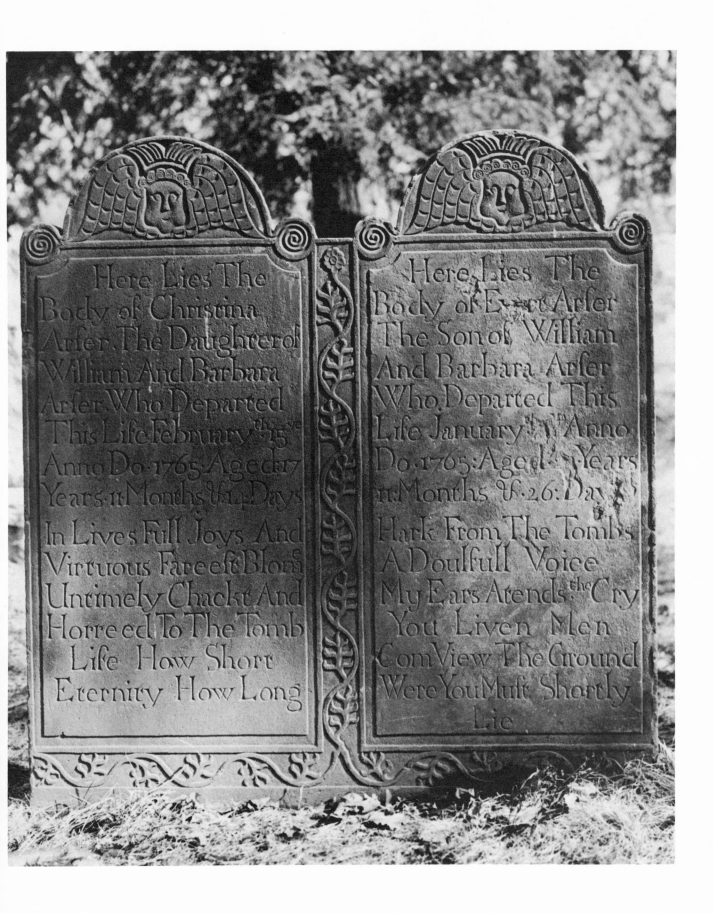

Here Lies The
Body of Christina
Arfer The Daughter of
William And Barbara
Arfer Who Departed
This Life February th 15
Anno Do 1765 Aged 17
Years 11 Months & 14 Days

In Lives Full Joys And
Virtuous Fareeft Blom
Untimely Chackt And
Horre ed To The Tomb
Life How Short
Eternity How Long

Here Lies The
Body of Evert Arfer
The Son of William
And Barbara Arfer
Who Departed This
Life January th 17 Anno
Do 1765 Aged 5 Years
11 Months & 26 Day

Hark From The Tombs
A Doulfull Voice
My Ears Atends the Cry
Yott Liven Men
Com View The Ground
Were You Muft Shortly
Lie

Plate 89

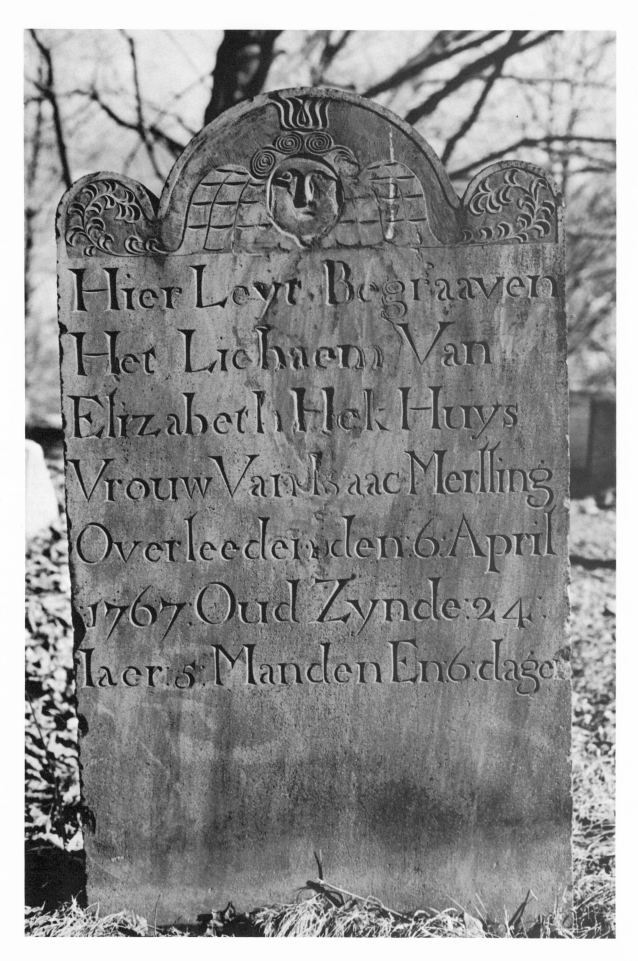

Plate 90

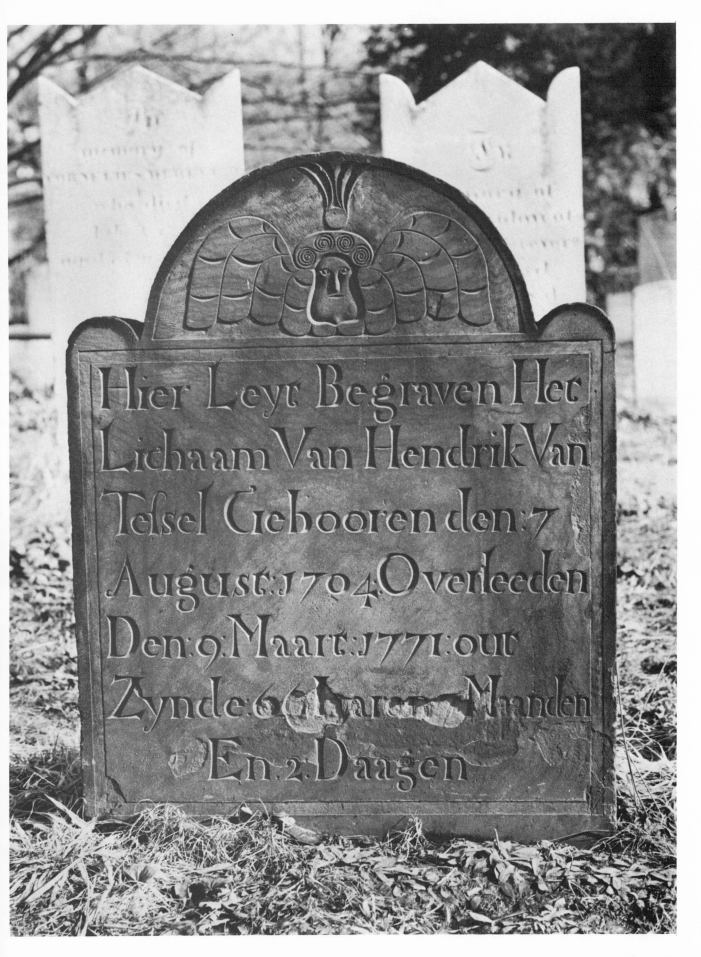

Plate 91

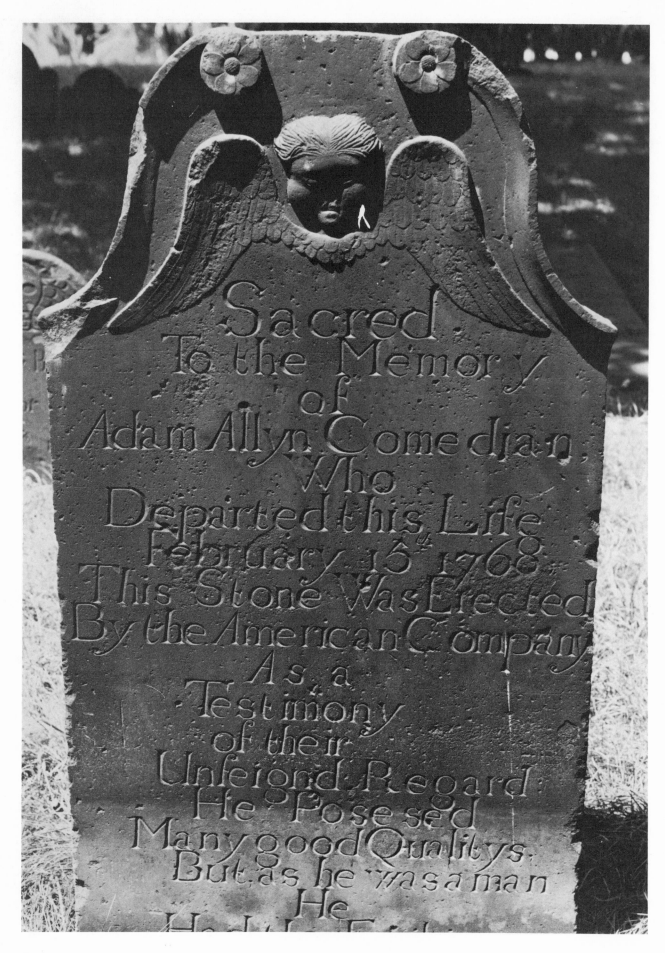

Plate 92

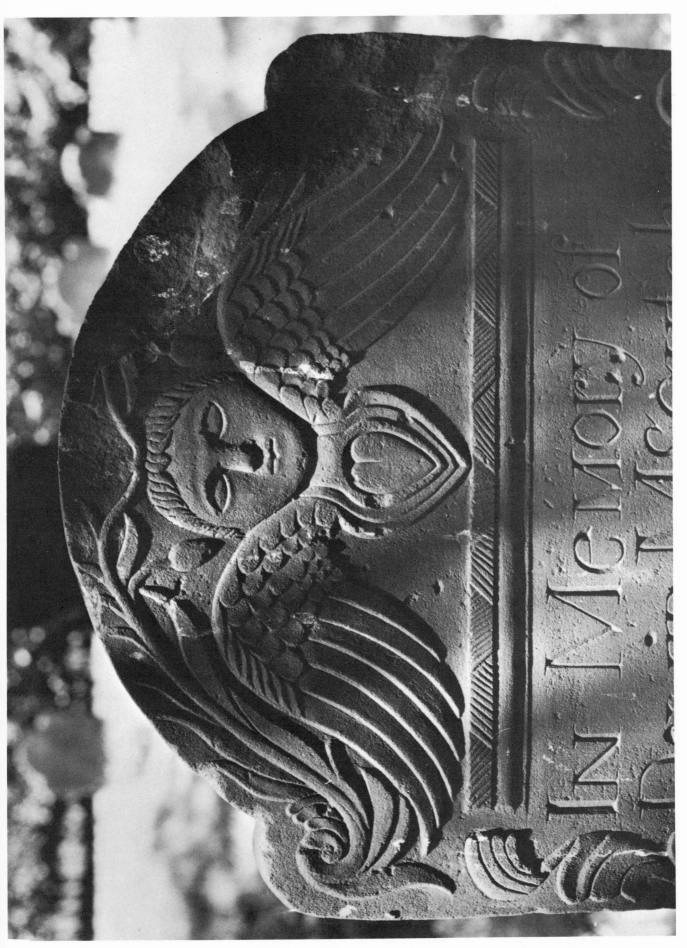

Plate 93

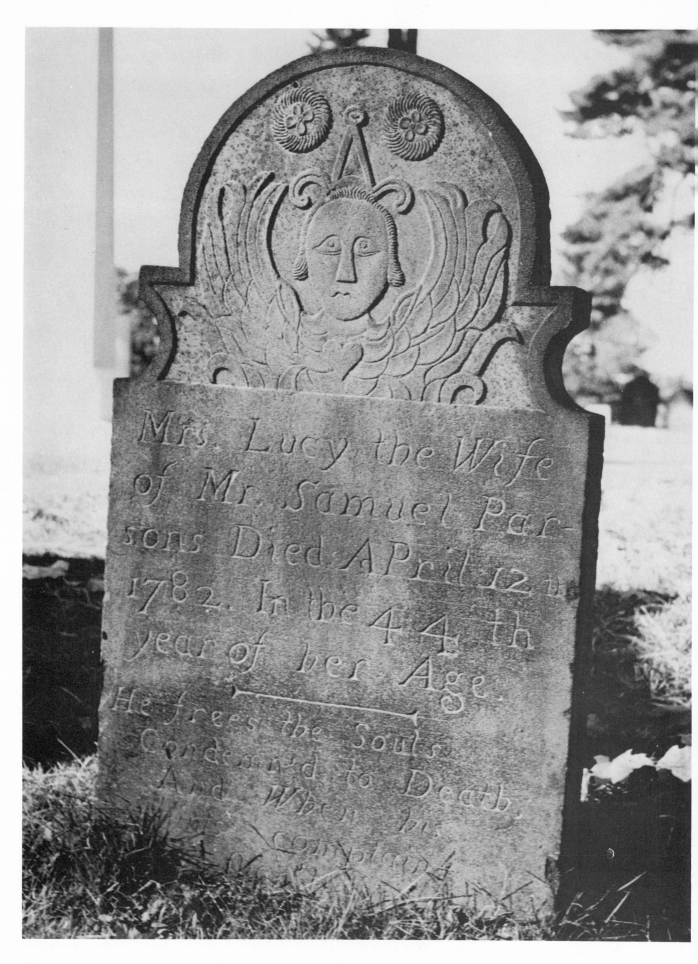

Plate 94

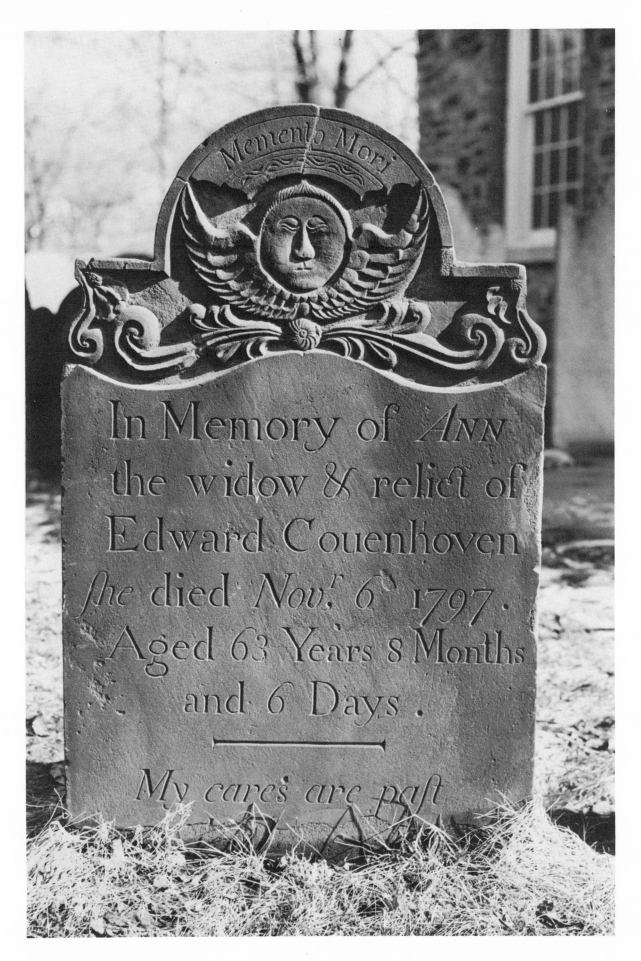

Plate 95

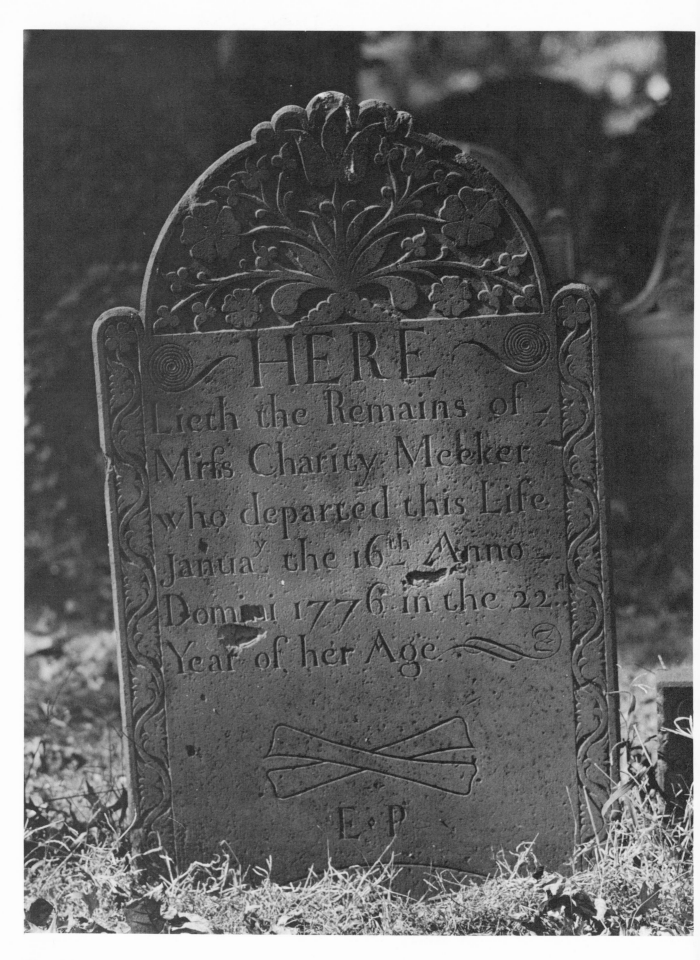

Plate 96

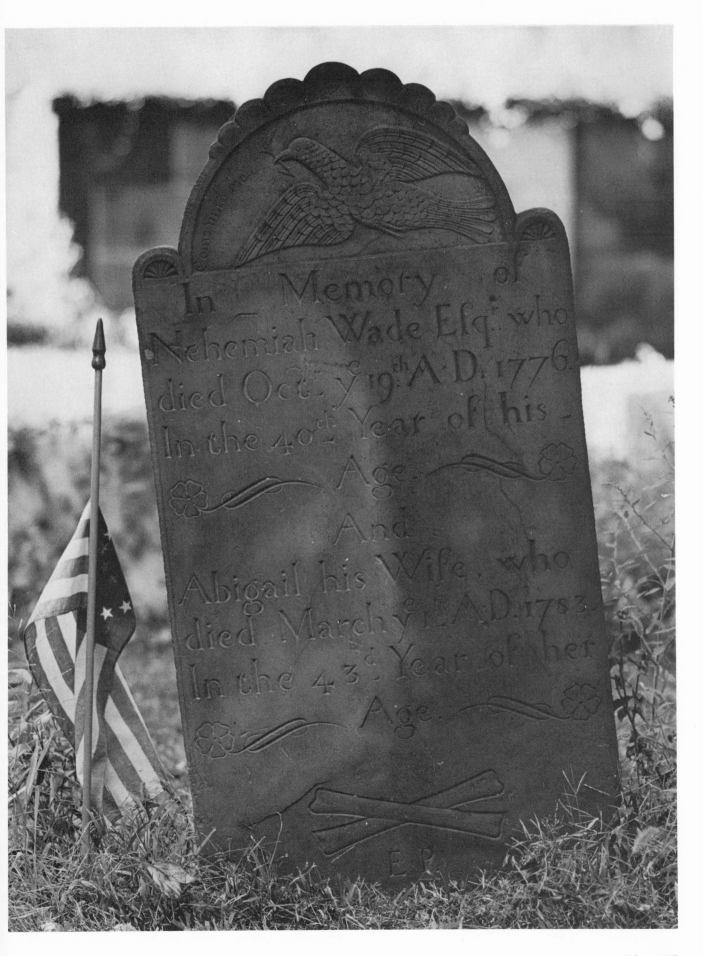

Plate 97

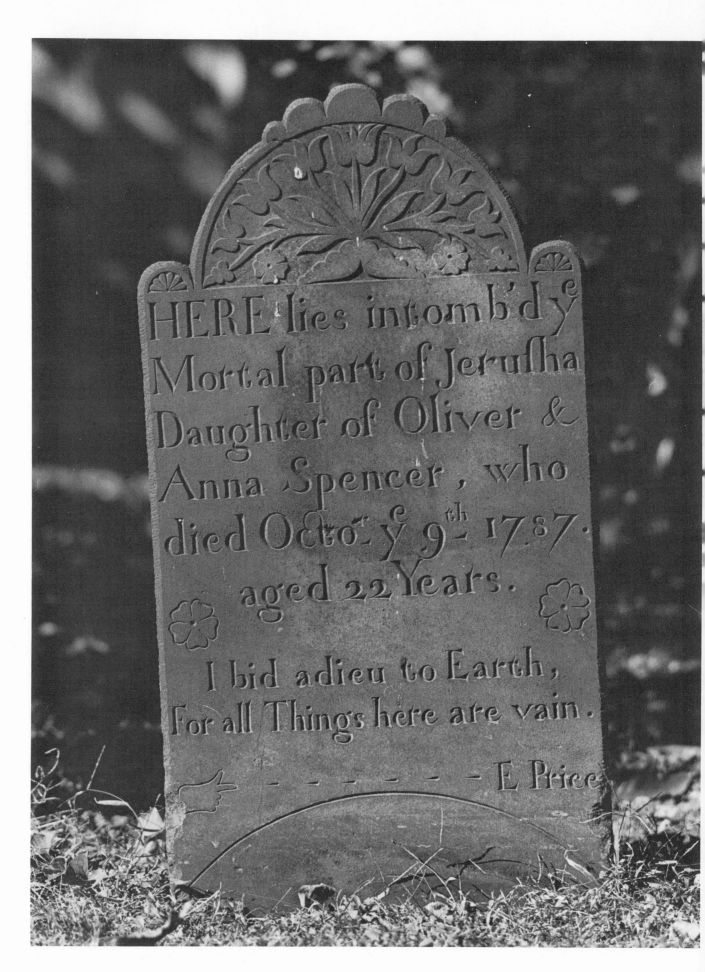

Plate 98

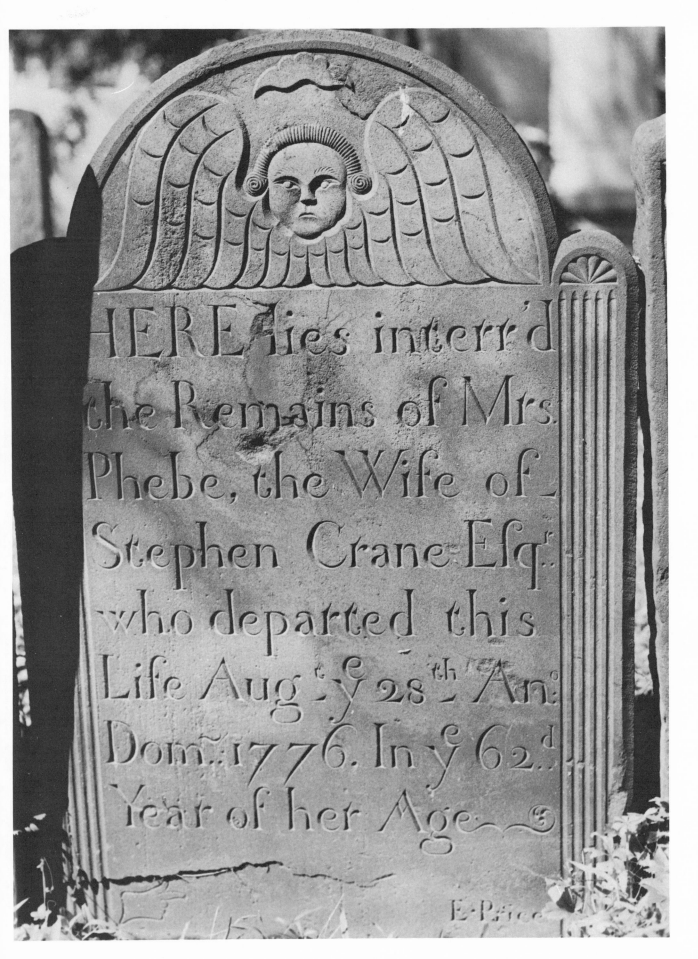

HERE lies interr'd the Remains of Mrs. Phebe, the Wife of Stephen Crane Esq̲. who departed this Life Aug.ˢᵗ y̲ 28.ᵗʰ An̲o Dom: 1776. In y̲ 62.ᵈ Year of her Age

Plate 99

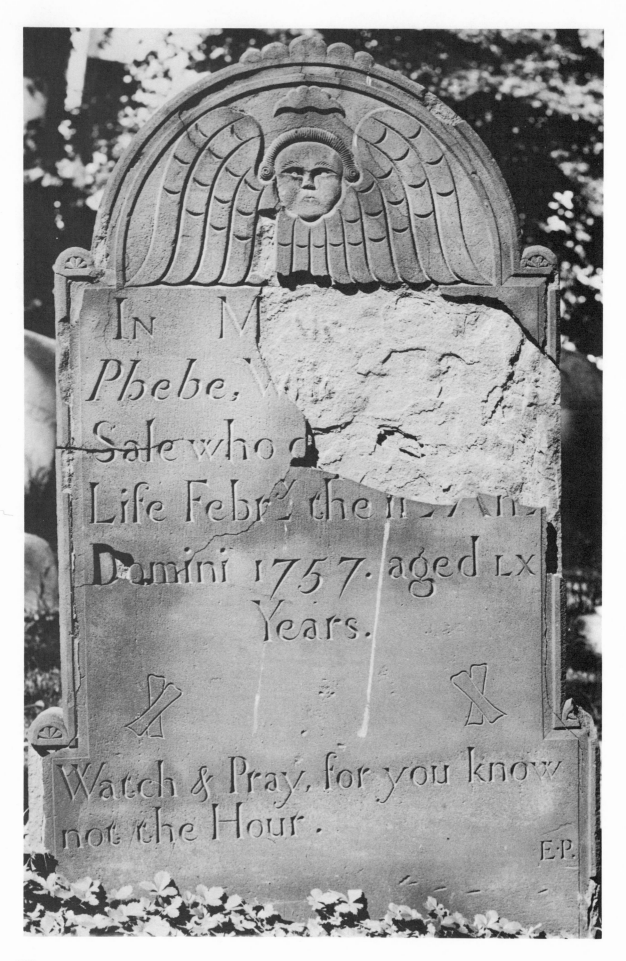

Plate 100

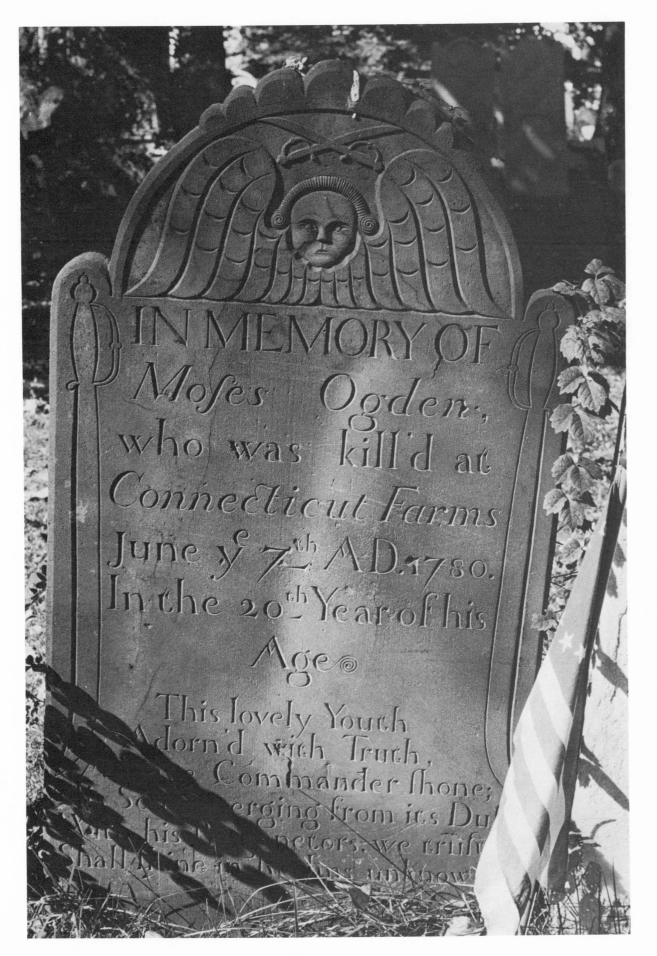

Plate 101

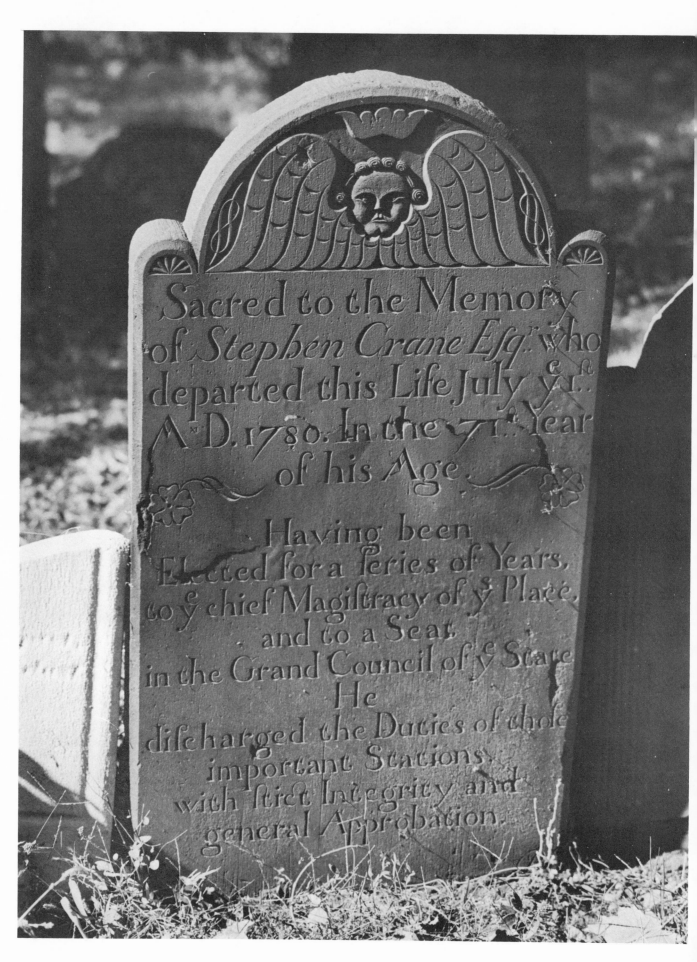

Plate 102

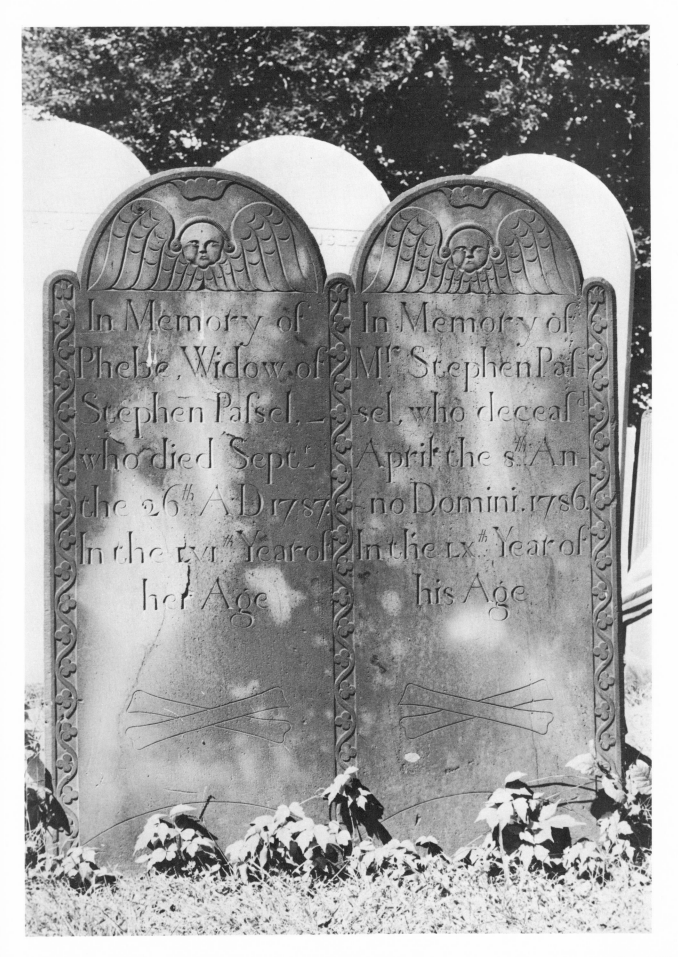

Plate 103

a

b

c

d

e

Plate 104

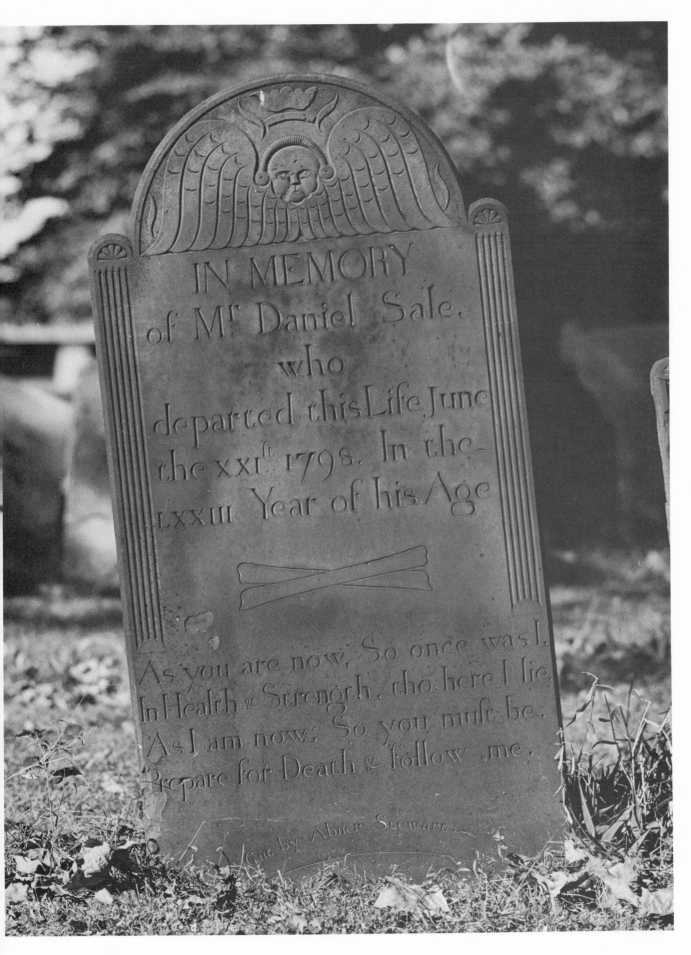

Plate 105

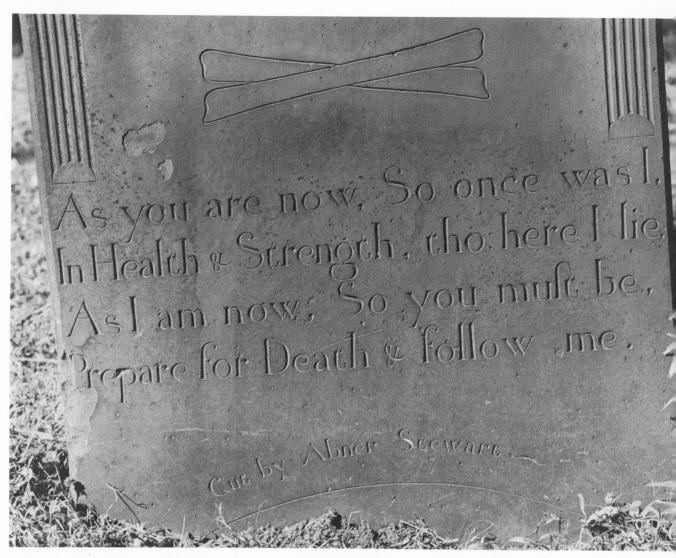

a

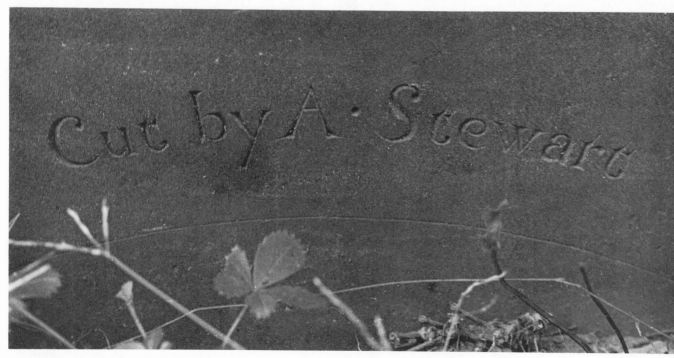

b

Plate 106

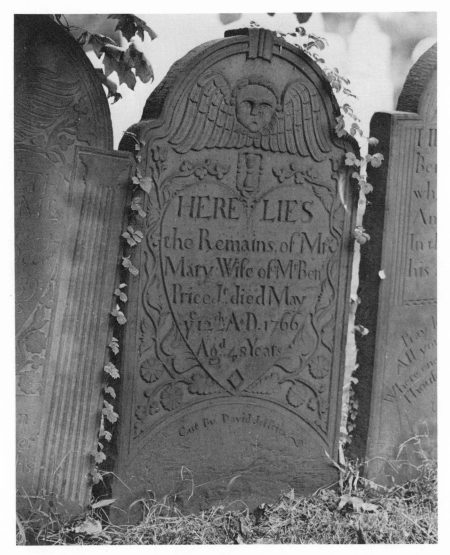

a

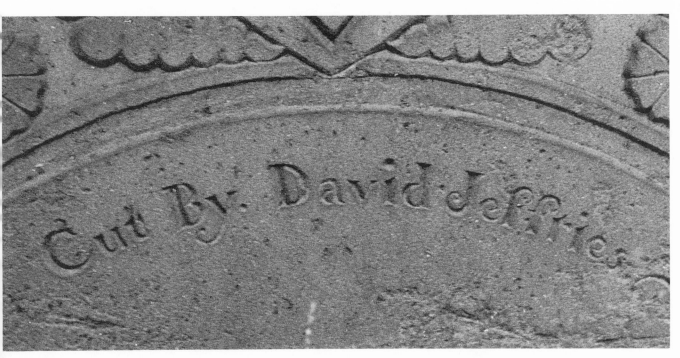

b

Plate 107

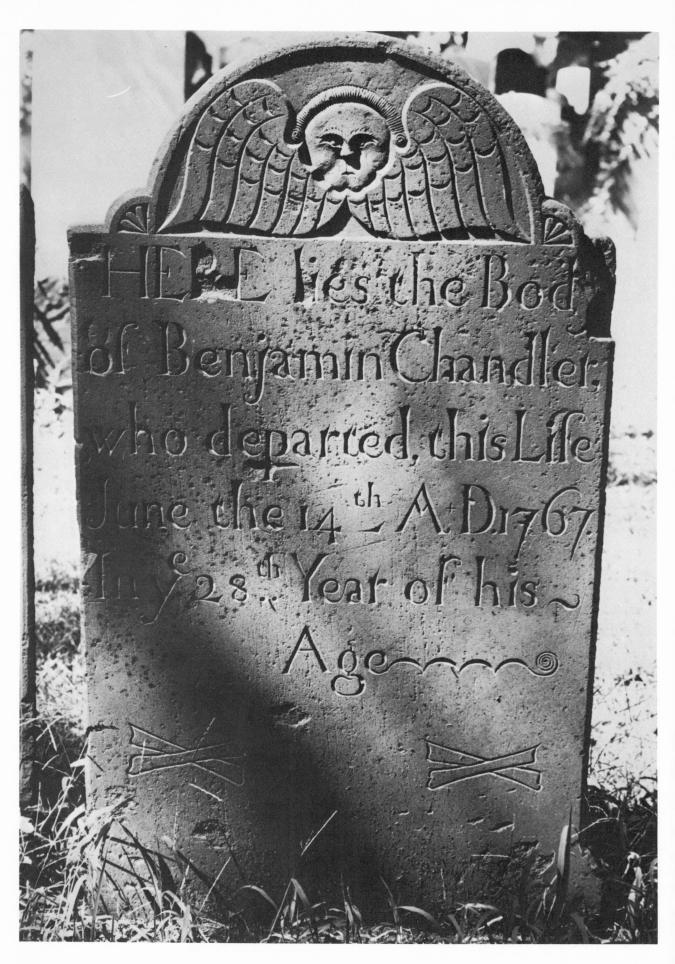

Plate 108

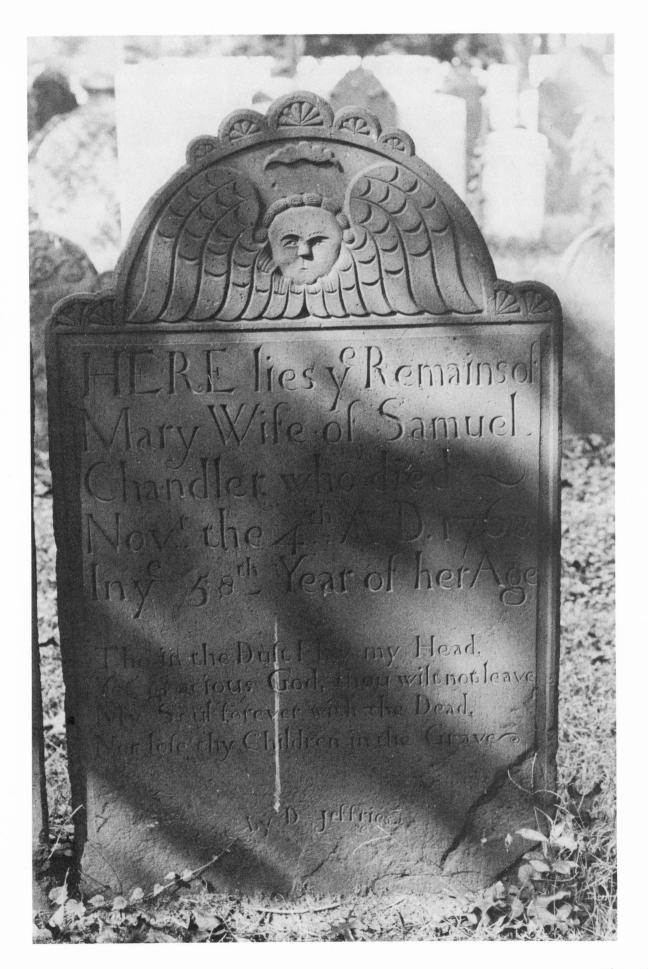

Plate 109

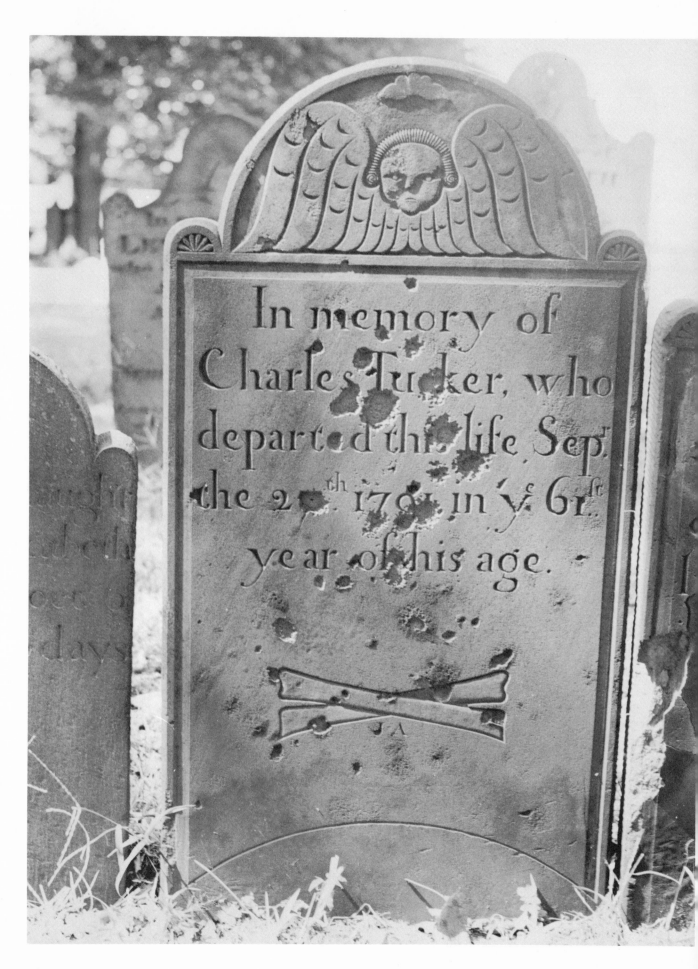

Plate 110

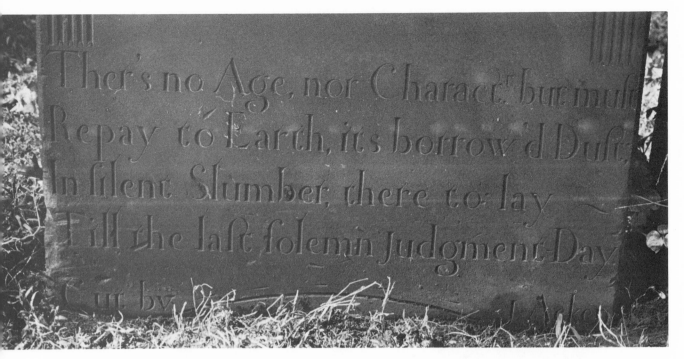

a

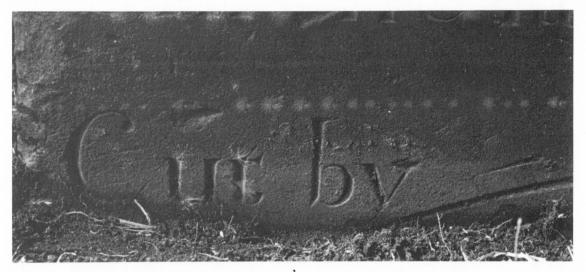

b

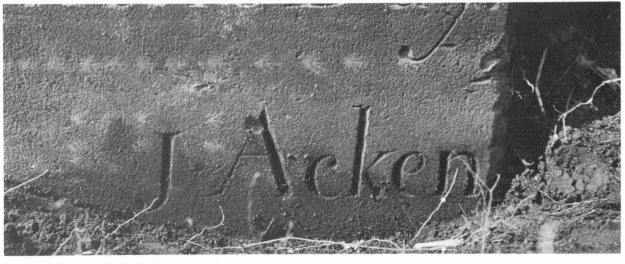

c

Plate 111

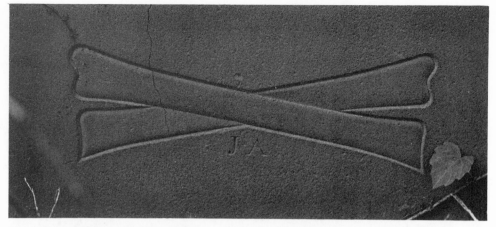

a

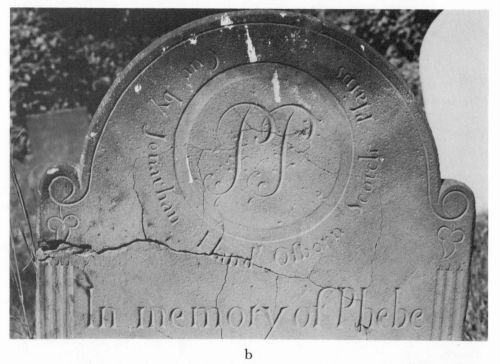

b

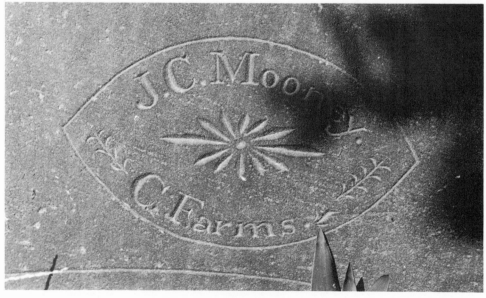

c

Plate 112

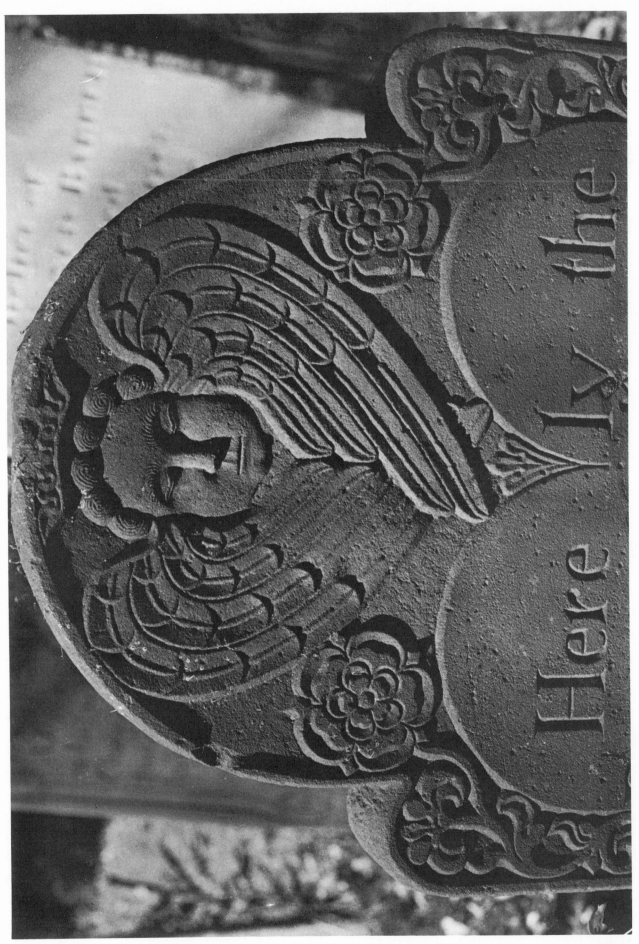

Plate 113

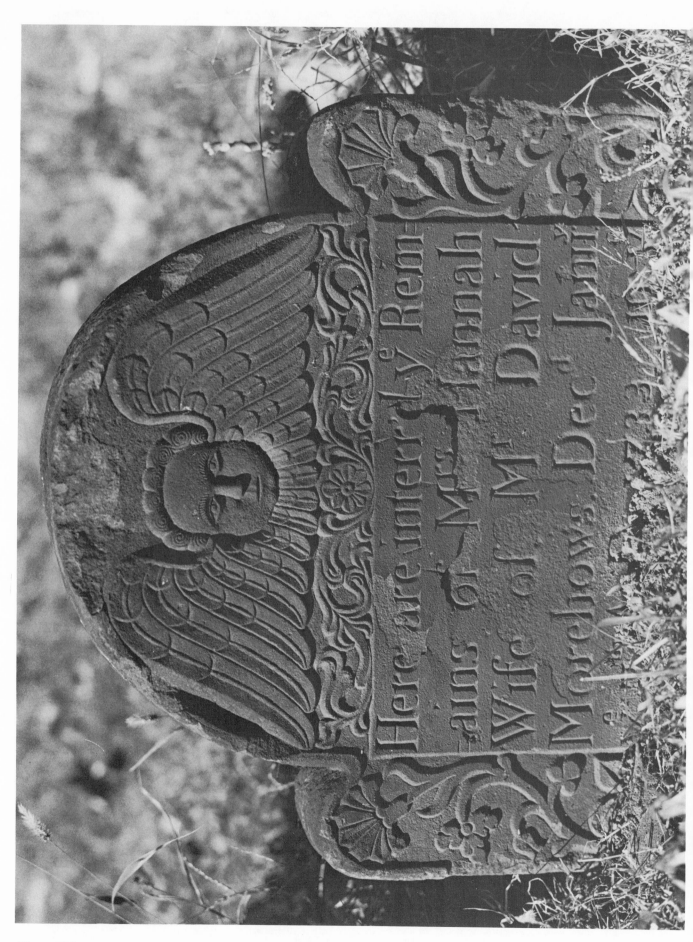

Plate 114

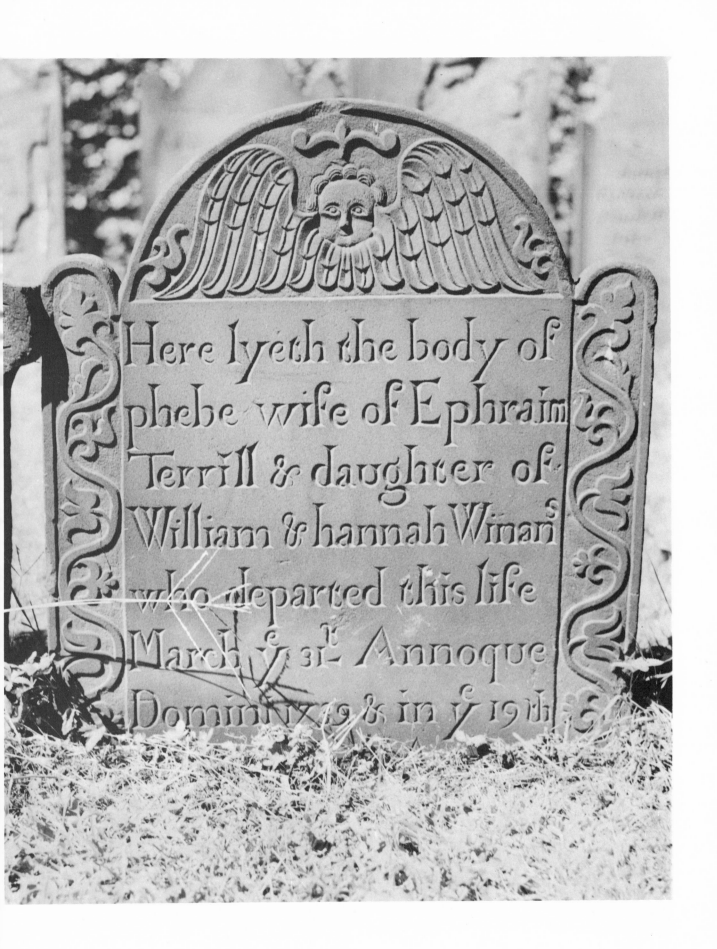

Plate 115

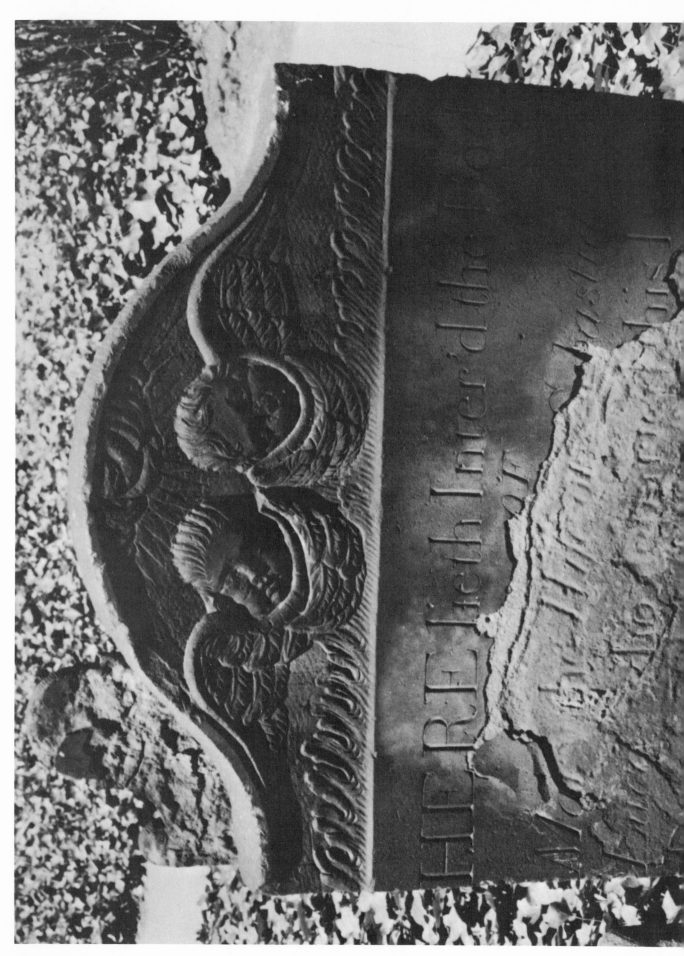

Plate 116

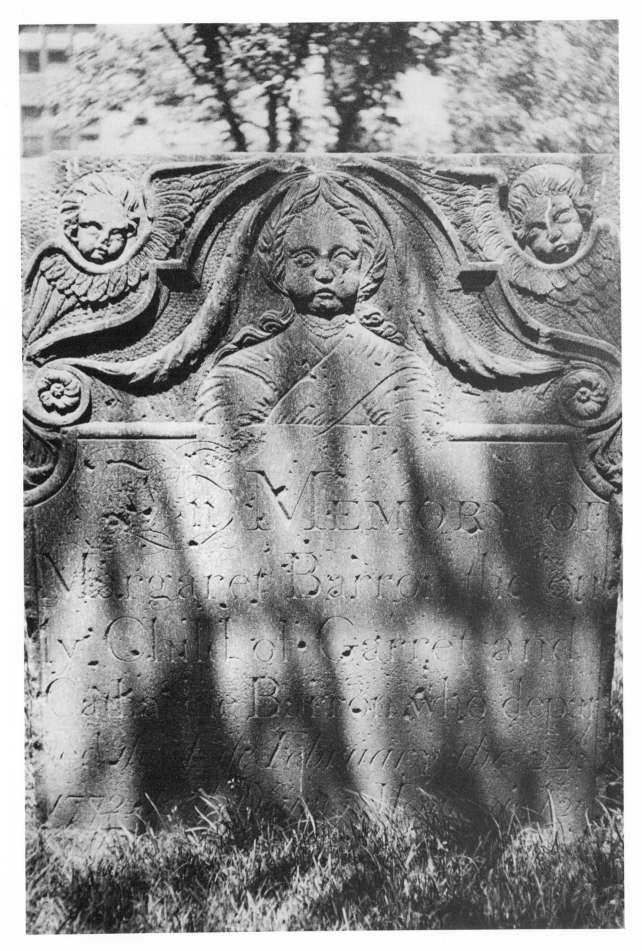

Plate 117

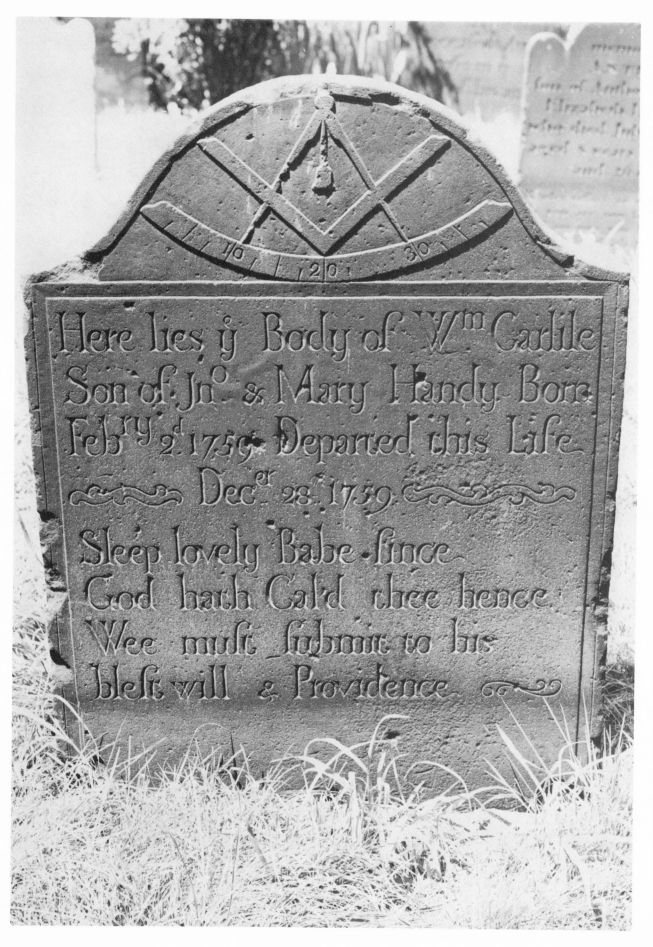

Plate 118

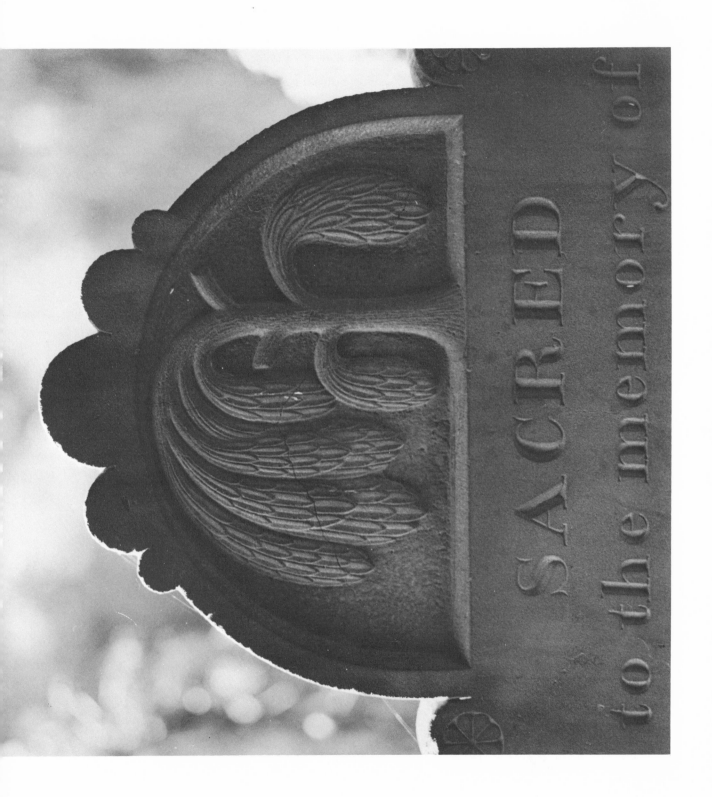

Plate 119

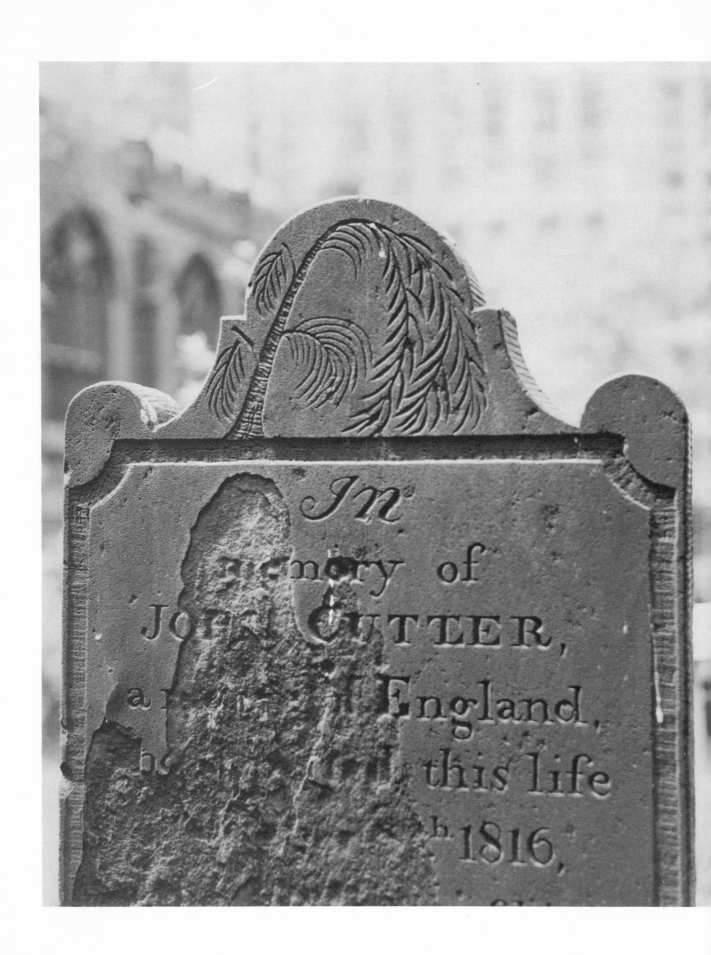

Plate 120

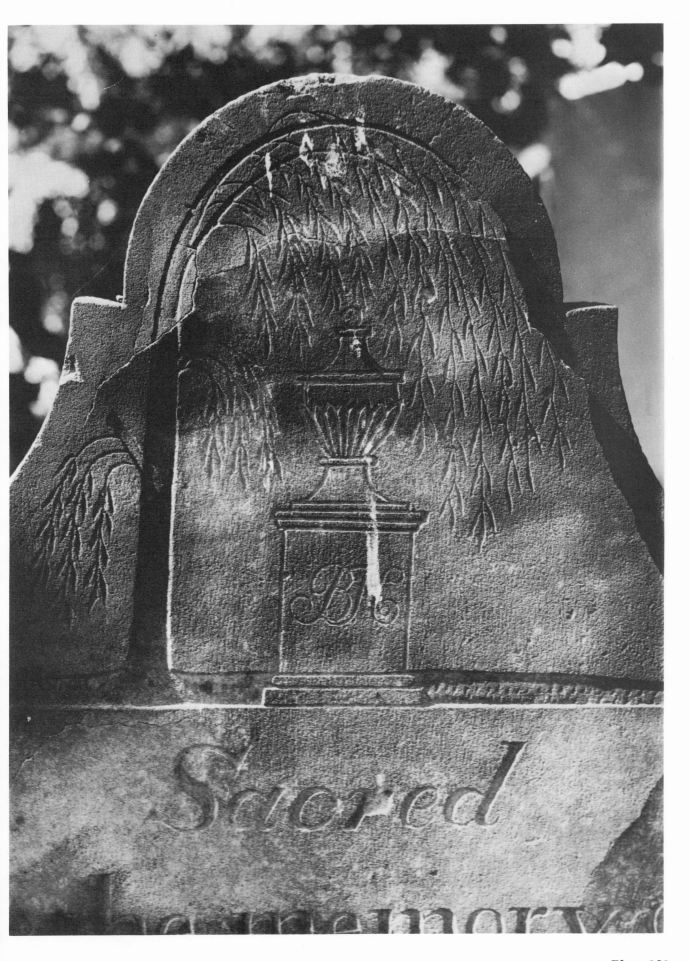

Plate 121

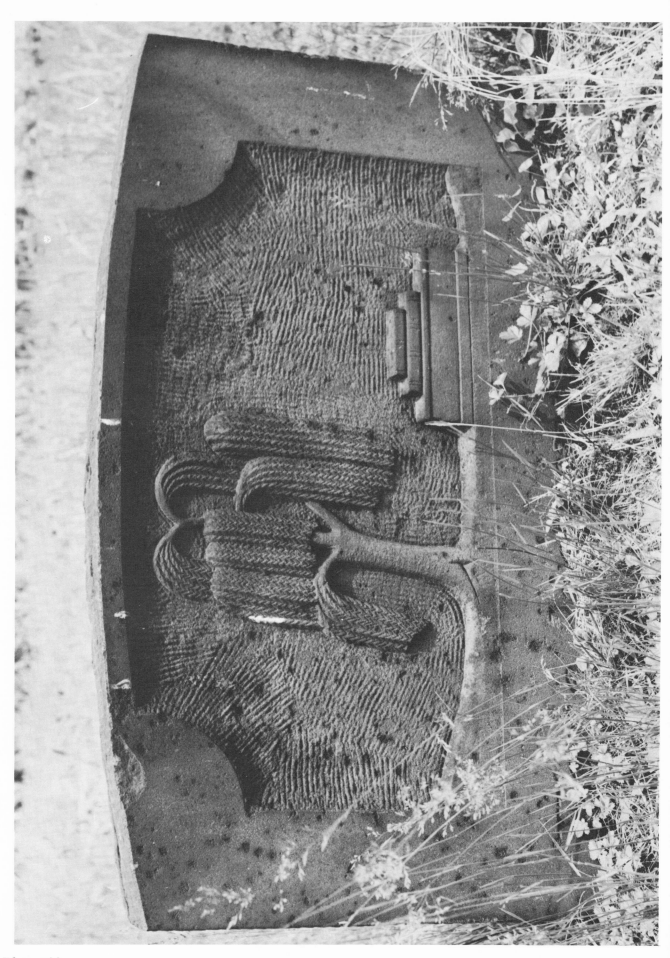

Plate 122

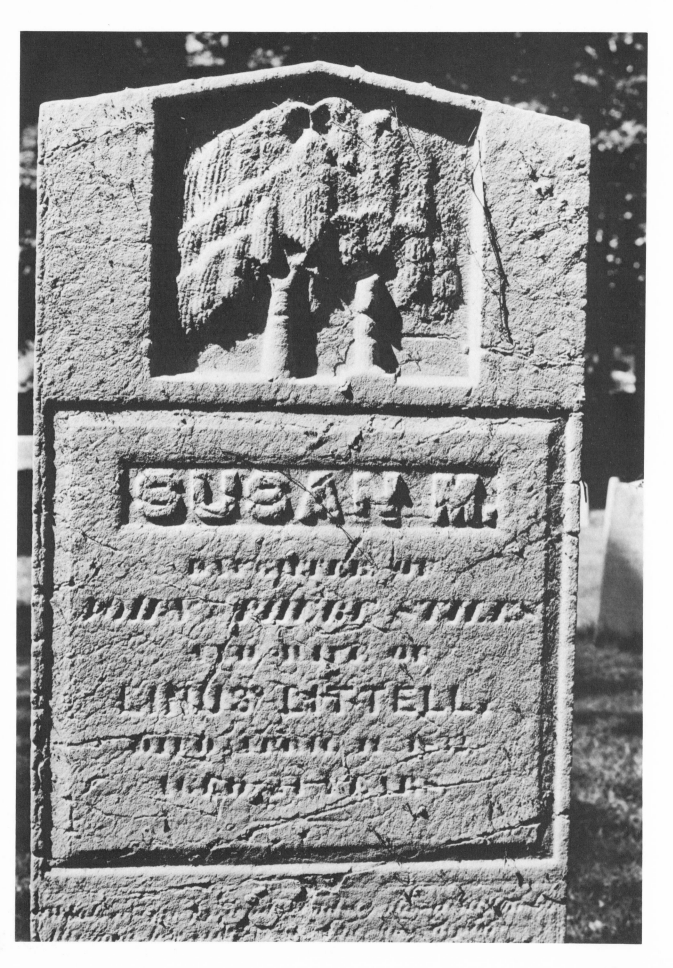

Plate 123

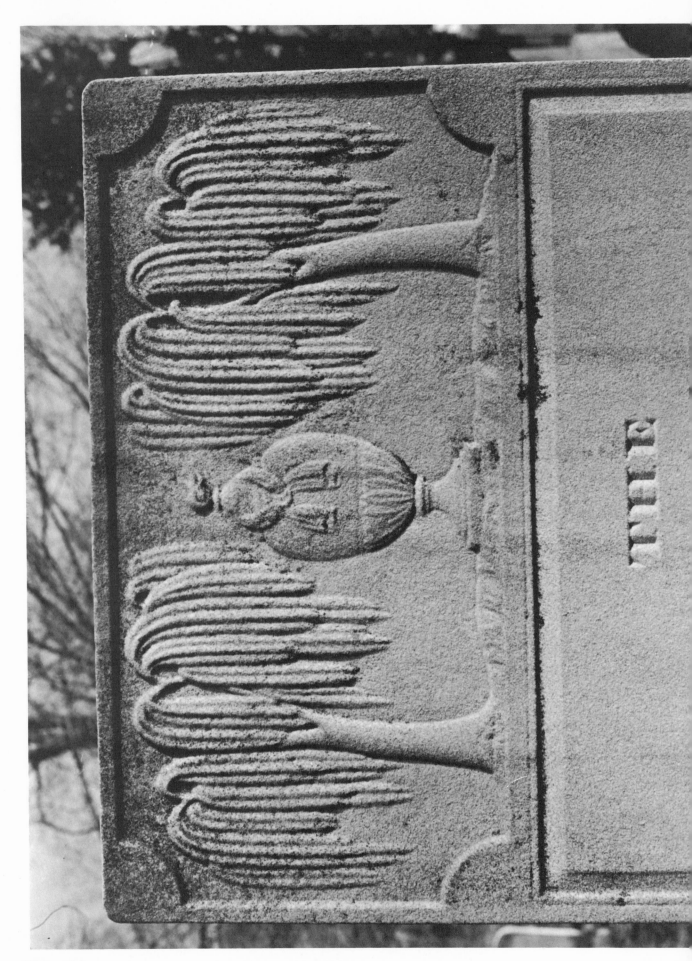

Plate 124

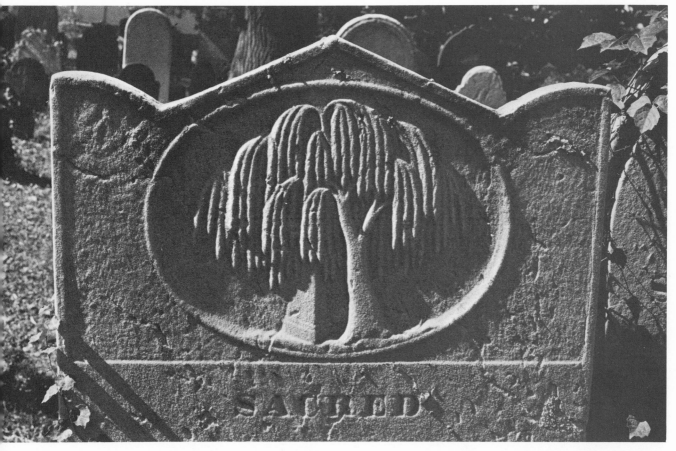

a

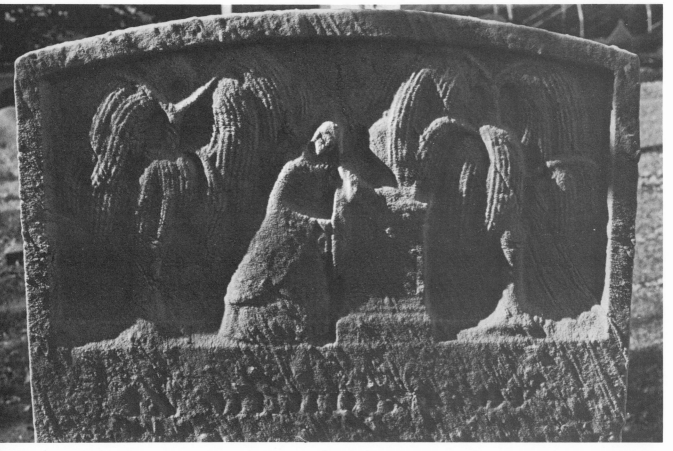

b

Plate 125

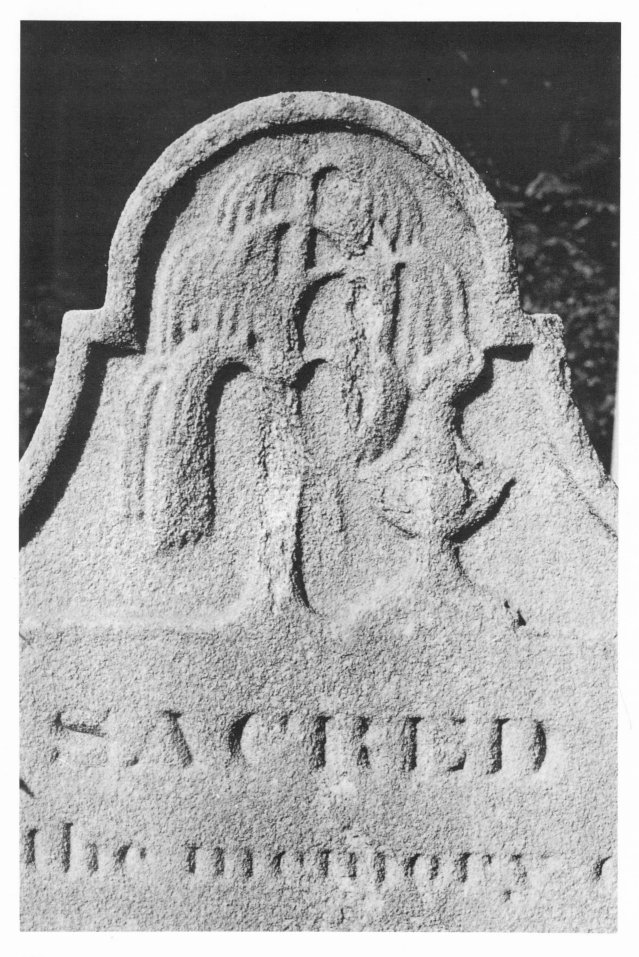

Plate 126

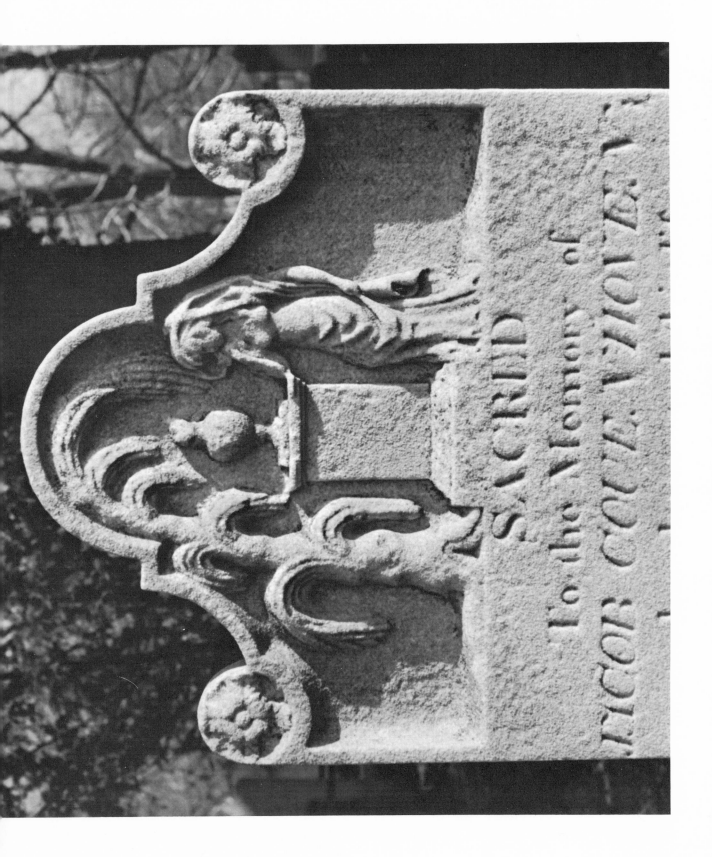

Plate 127

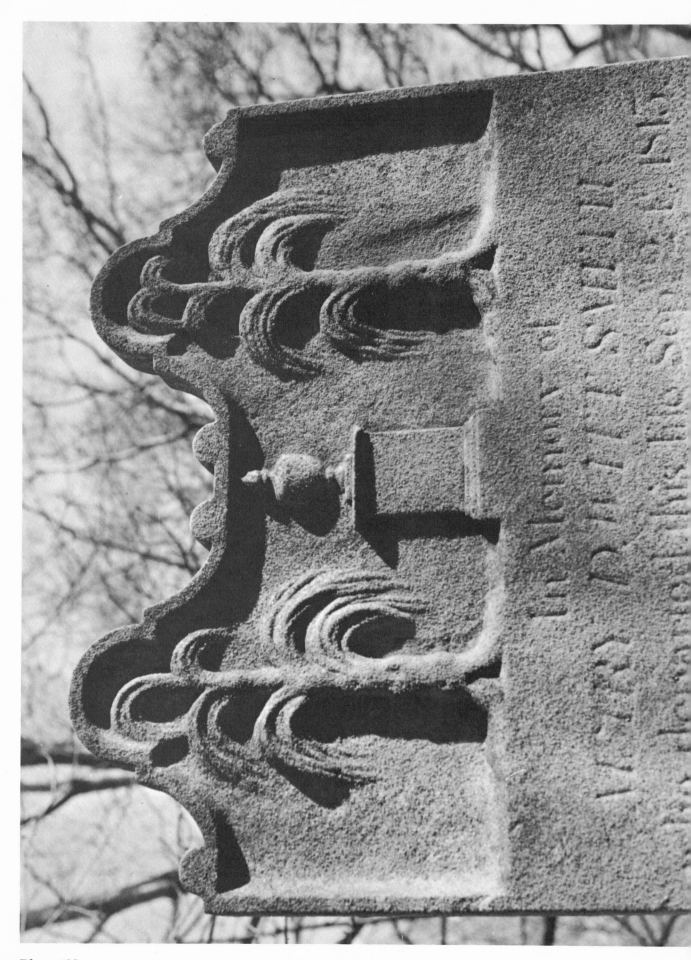

Plate 128

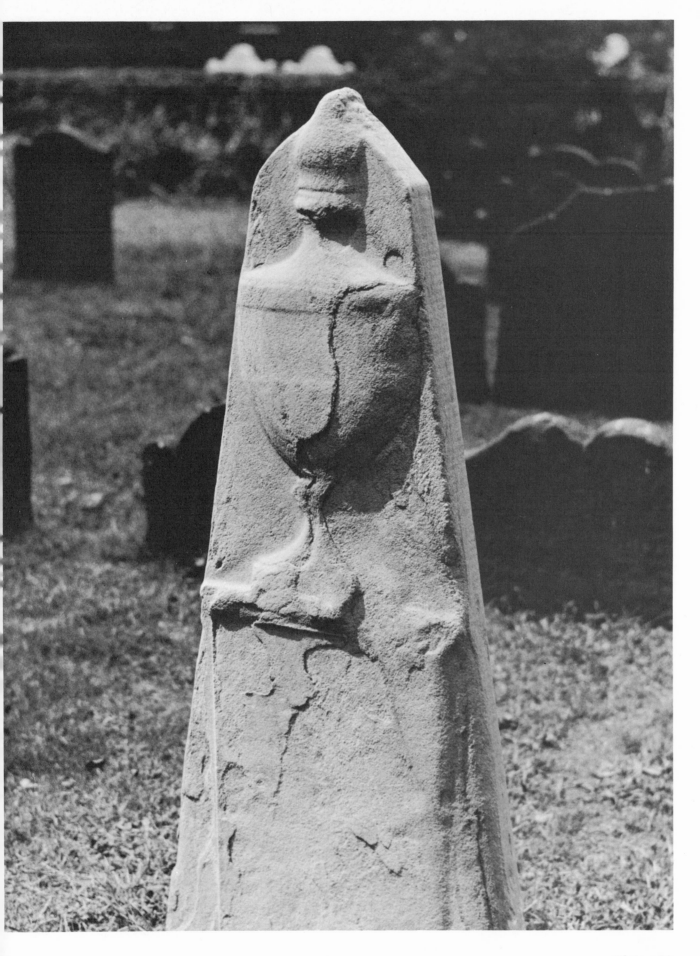

Plate 129

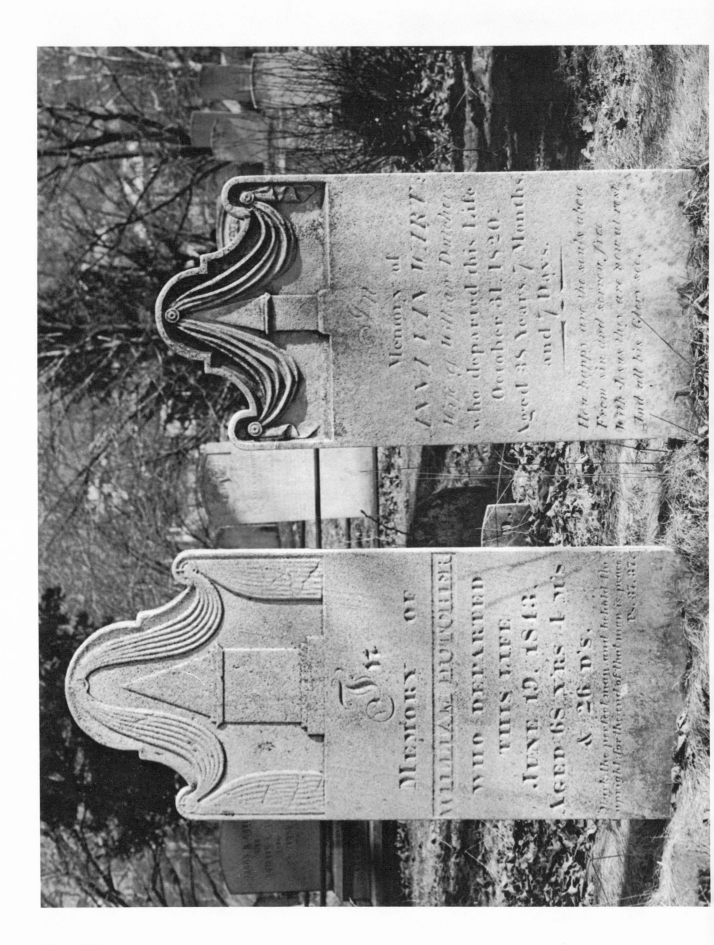

Plate 130

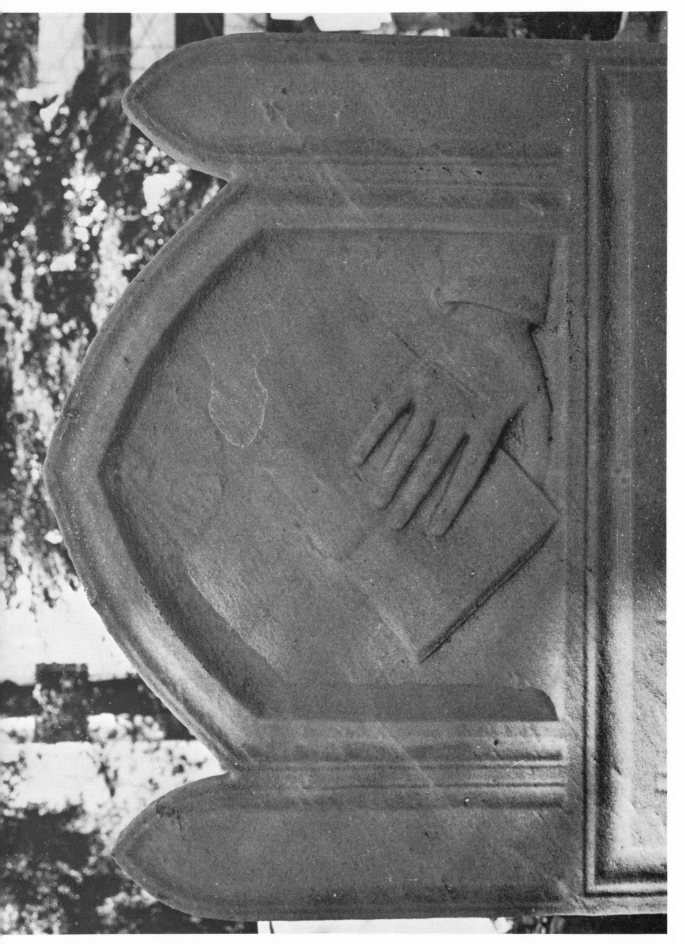

Plate 131

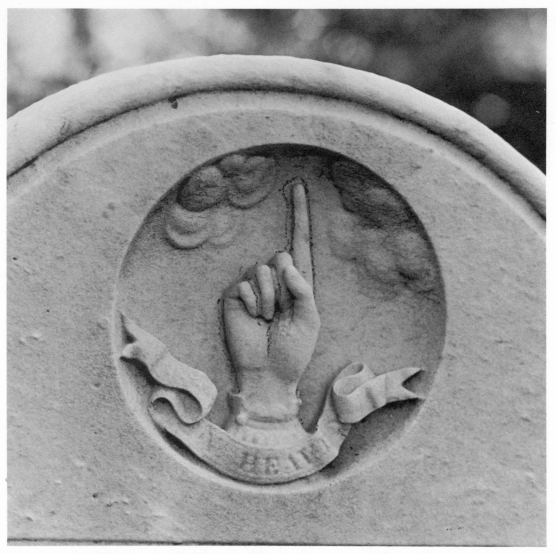

a

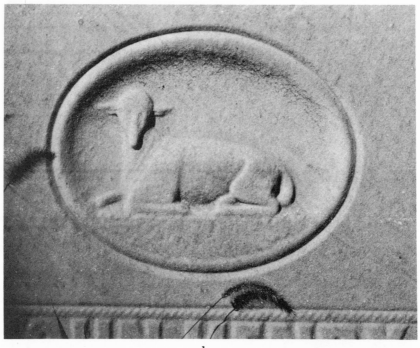

b

Plate 132

Plate 133

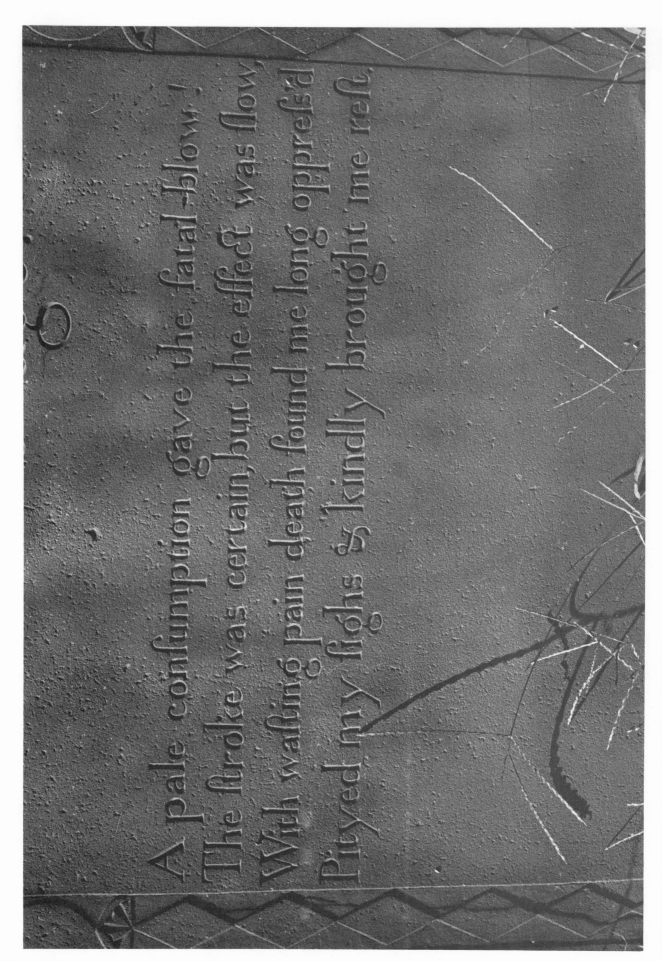

A pale consumption gave the fatal blow:
The stroke was certain, but the effect was slow,
With wasting pain death found me long opprefs'd
Pityed my sighs & kindly brought me rest.

Plate 134

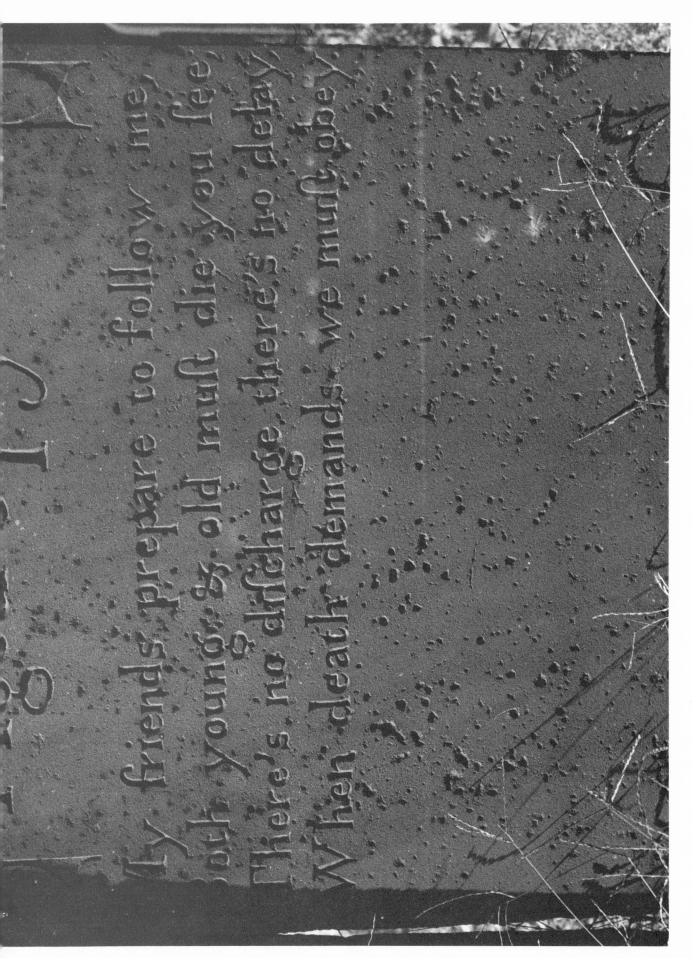

My friends prepare to follow me,
Both young & old must die you see,
There's no discharge there's no delay,
When death demands we must obey.

Plate 135

NOTES ON THE PLATES

The dimensions given (in inches, height before width) refer only to the parts of the gravestones actually illustrated. All the stones are red-brown sandstone, unless otherwise indicated.

1. Elizabeth, N.J. By a carver active in Elizabeth in the 1730's, represented by Plates 1a through 3a. He is identified by his use of skulls with triangular notched noses, circular or almond-shaped eye-sockets, rectangular mouths and crescent-clefted chins, bordered with tear-drop leaves or vines.

(a) 10 x 18¼. Stone of James Sayre, died 1731 at age 11. Note the crossbones, hourglass and characteristic checkerboard teeth. See the photograph of this stone, Plate 72.

(b) 9½ x 22¾. Stone of Jonathan Ogden, died 1732 at age 86. Here the hourglass is flanked by flowering vines. Epitaph:

> My life was Christ my Death is gain
> This bed gives ease to all my pain
> My dust is safe my Soul's at home
> To meet with Joy When Christ shall come.

2. Elizabeth, N.J. The same carver as Plate 1.

(a) 6 x 37. Triple stone of Isaac Winans, died 1730 at age 25; his wife Hannah, died 1731 at age 26; and Remember Winans, died 1722 at age 42. Though all three death's-heads have identical knob-like protrusions on top, each face is subtly different.

(b) 9¼ x 31. Double stone of Hannah Hendricks, died 1732 at age 39, and her son David Hendricks, died 1732 at age 9. Vine and tulip-type borders on sides of stone; legend "Here ly ye Remains of" around hourglass. Epitaph at bottom:

> Adieu vain World our dearest Friends farewel
> Prepare with us in this dark House to dwell
> Till ye last Trump our ruin'd Frame repair
> At Christ's Descent to meet him in ye air.

3. Elizabeth, N.J.

(a) 7 x 15½. Same carver as Plates 1 and 2. Stone of Samuel Millir, Jr., died 1732 at age 27. Here a tiny cross surmounts the crown over the skull, and a more elaborate linear design is used within the wings.

(b) 10¼ x 20½. Stone of Martha Thompson, died 1728 at age 50. By a carver active in Elizabeth in 1726-1729, also represented by Plates 4a and 4b. Close in style to the preceding carver, he uses crossbones, hourglasses and skulls with round eye-sockets, triangular nose cavities and rectangular mouths filled with teeth. Here there are also typical leafy borders and two flowers. See photograph, Plate 74, and compare Plate 76.

4. Elizabeth, N.J. By the same carver as Plate 3b.

(a) 9 x 19½. Stone of Sarah Woodruff, died 1727 at age 62. Two heavenly birds untouched by the hellish flames licking along either side of the death's head; an image of blessing and threat combined.

(b) 17 x 20¾. Stone of Hannah Ogden, died 1726 at age 36. More flames, but here an hourglass flanked by lilies. See photograph, Plate 75, and also Plate 76.

5. Orange, N.J. From two markers by another unidentified carver.

(a) 7 x 17. Stone of Samuel Ward, died 1733 at age 52. A simplified skull with no mouth and bare wings: a stark image of mortality and death.

(b) 7 x 17½. Stone of Phebe Ward, Samuel's daughter, died 1733. Here three rows of checkerboard teeth are added.

6. (a) Whippany, N.J. 6½ x 18½. Stone of Rebecca Stills, died 1731 at age 40. Unusual features are the double triangle cut for the nose and the solid wings forming an arc that parallels the top contour of the stone. Compare the photograph of a related stone, Plate 78.

(b) Orange, N.J. 4½ x 14½. Stone of the three Dod children: Elizabeth, died 1770 at age 22 months; Naoma, died 1766 at age 23 months; and Jonas, died 1766 at age 8. A tiny version of the winged toothy skull.

(c) Trinity Church, N.Y.C. 6½ x 16. Stone of Elizabeth Lepper, died 1746 at age 3 months. Crude skull with a row of crooked teeth and grid-incised wings. Epitaph:

> Infinite Joy or endless woe
> Attends on ev'ry Breath
> And yet how unconcern'd we go
> Upon the Brink of Death.

7. Trinity Church, N.Y.C.

(a) 8 x 20½. Double stone of Margaret Blake, died 1752 at age 25, and her son James, died 1752 at age 9 months. The realistic eyes with pupils, the fringed brows and the lipless prongs for teeth are notable here.

(b) 8 x 19. Stone of Hannah Carpenter, died 1771 at age 3. Another stone by the same carver with an identical design is that of Margaret Sweasey, died 1769 at age 75, at Mattituck, Long Island.

8. (a) Orange, N.J. 10 x 27½. Stone of Samuel Pairson, died 1730 at age 67. By a carver active in Orange and

Elizabeth. The typical death's-head wears a crown. Epitaph:

> Here Lyes Inter'd under this Mould
> A precious heap of dust Condol'd
> by Church of Christ and Children dear
> both which were th' objects of his Care.

(b) Elizabeth, N.J. 10½ x 18¼. Stone of Elisabeth Sale, died 1731/2 at age 33. By a carver active in Elizabeth 1731-1733. The full, billowing wings, the rows of sharp teeth, the graceful floral rosette and the vines with their multiple decorative sprouts on the borders distinguish this carver's refined style. See photograph, Plate 79, and compare Plate 9.

9. Elizabeth, N.J. 17 x 16. Same carver as Plate 8b. Entire marker of Joseph Crampton, died 1733 at age 21. The vine borders are topped by small thistle-like plants.

10. Trinity Church, N.Y.C. 14¾ x 19¾. Slate stone of Anne Churcher, died 1691 at age 17. The lavish borders containing gourds, pomegranates and leaves, are topped by concentric disc. The use of all capital lettering is characteristic of this early period. These features point to the work of William Mumford (Boston, 1641-1718), as exemplified by the stone of Nicholas Chatwell (Salem, Mass., died 1700), illustrated on page 16 (text, page 31) of *Gravestones of Early New England* by Harriette M. Forbes (Boston, 1927).

11. Trinity Church, N.Y.C. 21½ x 27. Slate stone of Ann Walling, died 1715 at age 21. The skull with a curving V cleft on its forehead, and the graceful leafy scroll and disc patterns, possibly indicate the work of Joseph Lamson (Charlestown, 1656-1722), illustrated on page 29 of Forbes, *Gravestones of Early New England*.

12. Trinity Church, N.Y.C. 17 x 21. Stone of Nicholas Elsworth, died 1731 at age 2. Only a few other stones in the same yard can be attributed to this carver whose trademarks are a broad skull with two neat rows of teeth slightly askew, and lilies.

13. Trinity Church, N.Y.C. From markers by a carver active at Trinity 1751-1769, represented by Plates 13a through 15b. Characteristics: oddly contoured stones, inscribed with effigies usually displaying scaly wings, almond-shaped eyes and heads with little or no hair.
(a) 6½ x 20½. Stone of John Yonge, died 1753 at age 60. Here there is a crude row of fang-like teeth.
(b) 8½ x 19½. Stone of John Lowther, died 1751 at age 29. A nose with nostrils and incised spirals on the outside lobes of its five-part top make the design of this stone unique.

14. Trinity Church, N.Y.C.
(a) 10 x 27. Stone of Elizabeth Beavans, died 1750 at age 18 months, and her father Thomas, died 1754 at age 42. The most sophisticated design by the same carver. A curved and stepped framework with its field cut out ("negative") and the figure in greater relief than on the earlier stones. The dour lady has curling locks of hair, frowning lips, a cleft chin and a scaly torso.
(b) 8 x 25. Stone of Catherine Thorne, died 1752 at age 12. Feathery wings and a decorative diamond-shaped "top-piece" are the distinguishing features here. Epitaph (lines run together on stone):

> Three days Fever Snatch'd her Breath,
> And Bow'd her to triumphant Death,
> Tho' scarce twelve Years, had crown'd her head,
> Behold In dust her peaceful Bed,
> Where every one must Shortly lye
> For all that live, live but to die
> Her Soul we hope will rest with God
> And dwell within his blest Abode.

15. Trinity Church, N.Y.C.
(a) 10 x 22½. Stone of Annastasia Yonge, John's daughter (see No. 13a), died 1752 at age 24, and a second unidentified person. Striated wings, distinct eyebrow hairs and two sets of incised spirals are notable motifs within the multilobed contour of the marker.
(b) 11 x 34. Stone of John Eagen, died 1751 at age 2; his brother William, died 1751 at age 2 weeks; and Henry Hagen, died 1765 at age 12. Although the pattern is symmetrical, actually the faces differ slightly. Epitaph is given in the Introduction, p. 6. Other stones (not illustrated) in Trinity by the same carver, with the same designs as on the Eagen stone, are those of Thomas Pullen, died 1754 at age 29; Ann Smith, died 1753 at age 18; and Josias Smith, died 1729/30 at age 5 months.

16. By a carver active 1764-1790 in Elizabeth, Orange, Parsipanny and Springfield, N.J., and in New York, represented by Plates 16a through 20 (see Introduction, p. 6). The eyes and noses of his angels are often quite naturalistic, but the lips are more stylized and the hair is a semicircular ridged "wig" or halo. Bands of continuous spirals, stars and timepieces are frequent trademark motifs. Compare the photos in Plates 82 and 85 (the latter perhaps by an apprentice of the present carver). Other stones (not illustrated) in Parsipanny are those of Capt. John Stiles the Elder, died 1777 (angels, stars, spirals); Boltis D. Hart, died 1777 at age 64 (long-nosed angel); and Phebe Cook, died 1775 at age 25 (angels, stars, spirals). See Appendix D.
(a) Elizabeth (?). 10½ x 25. Stone of Hannah Meeker, died 1764 at age 41. Epitaph:

> My flesh shall slumber in ye ground
> Till the last Trumpets' Joyful Sound
> Then burst ye Chains in Sweet Surprize
> And in my Savior's image rise.

(b) Elizabeth. 11 x 22. Stone of Elizabeth Daeyton, died 1766 at age 70. Perhaps by the carver under discussion, or possibly by an apprentice or related carver. The wing design here is different: low-relief vertical ridges define the scales. See photograph, Plate 81.

17. Elizabeth. 15 x 26. Stone of Benjamin Crane, Sr., died 1777 at age 72. A plumed crown rises over the semicircle of the angel's hair. Lettering is typical of carver's style. See photograph, Plate 84, and compare the photos in Plates 82 and 86.

18. (a) Trinity Church, N.Y.C. 13 x 23. Stone of Anthony Ackley, died 1782 at age 57. Epitaph:

> Hark From ye Tombs a doleful sound
> Mine ears attend the cry:
> Ye living men come vieu the ground
> Where you must shortly lie.

(b) Orange. 13¾ x 24¼. Stone of David Williams, died 1781 at age 78. Same epitaph as in Plate 16a.

19. Orange. 16½ x 26. Stone of Robart Baldwin, died 1772 at age 54. An inscribed "soul-heart" is above the angel's head.

20. Elizabeth. 17 x 32¼. Stone of Mrs. Elisabeth Charlton, died 1778 at age 76; her son John, died 1752 at age 19; and her daughter Elizabeth, died 1759 at age 24. One of the boldest of this man's designs: the angel has a rounder face and separate striated puffs of hair topped by a tulip-like crown. See photograph, Plate 83. Epitaphs:

> My Panting Soul ascends on high
> To praise my God eternally.
>
> In Christ alone we hope and trust
> To rise in Judgment with the Just.

21. From markers by a carver active 1736-1759 (and perhaps later) in Elizabeth, Orange and Whippany, N.J., represented by Plates 21a through 23 and by the photograph, Plate 87.

(a) Elizabeth. 6¼ x 13. Stone of Henry Norris, died 1752 at age 29. This is one of the carver's simpler stones, but it shows a characteristic portrait-like face, round to pear-shaped or squarish. Concentric discs, hourglasses, hearts and vine leaves appear on his more elaborate stones.

(b) Whippany. 11 x 20. Stone of Elizabeth Crane, died 1736 at age 19. Probably a more expensive job than the later but modest Henry Norris stone. Here the eyes and eyebrows are rather naturalistic. The hair, engraved in striated puffs, is crowned by a tulip-like appendage.

22. Elizabeth. 14 x 30. Stone of Experience Winans, died 1759 at age 37. A "soul-heart" and some leafy vine branches crown the head of this wide-eyed lady. A graceful, busy design, both symbolic and decorative in its effect. See photograph, Plate 86.

23. Elizabeth. 12½ x 28. Stone of Sarah Ross, died 1759 at age 54. An elaboration of the preceding design by the same carver. Here the wings are broader and more explicitly feathery, while the patterns fill the space more thoroughly. Epitaph:

> A more pious Christian, A more Faithful Wife
> A more Tender Mother, A sincere Friend
> Or a Kinder Neighbour
> She has not left Behind her
>
> READER
> Consider that as the Possession
> Of the Highest Virtues
> cannot ward off the Dart of DEATH
> Wee ought before the uncertain
> STROKE comes to make our [Peace?].

24. Markers in the style of John Zuricher, active c. 1760 through the 1770's in Manhattan, Staten Island, Middletown, N.J., Tarrytown, N.Y., northeastern Long Island (Southold and Cutchogue), represented by Plates 24 through 29. St. Paul's, N.Y.C. 36 x 30½. Stone of James Davis, died 1769 at age 39. Zuricher had a number of consistent motifs, which turn up in various combinations on his beautiful stones. The angel here, one of his favorite types, has an elongated, almost monkey-like face.

25. (a) 3⅜ x 24. Zuricher's signature from the stone in 25b.

(b) Middletown, N.J. 11 x 28. Stone of Catherine Norrss Crookshank, died 1776 at age 39. Here the sweet face is more rounded, with spiral curls of hair echoing the concentric rounded elements of the rosettes which top either side of the marker. This is the only signed stone by Zuricher, but his style is unmistakable. See Plate 88 for similar leafy branches. Epitaph:

> Here in Soft Peace For Ever Rest
> Soft as ye Love, that Filled thy Breast
> Let Hory Faith, Crown the Urn
> And all ye Watchfull, Muses Mourn
> Ye Messenger, which JESUS sends
> To Call us to ye Sky,
> For Ever there his Saints Do Dwell,
> Beyond ye Rage, of Death and Hell.

(c) Style of John Zuricher. 7 x 18. Stone of Nicholas DeForest, died 177(1?) at age about 1 year. Pear-shaped face topped by a tiny leafy finial.

26. Style of John Zuricher.

(a) Trinity Church, N.Y.C. 9 x 22¾. Stone of Henry Roome, died 1762 at age 5, and his sister Sarah, died 1762 at age 2. Here the facial expression is both mournful (the tiny, worried eyes) and happy (the smiling mouth). The stone of Richard Ayscough (died 1760), also in Trinity, has the identical face, wings and crown. Another stone with the same design is that of William Wells (died 1696) in Southold, Long Island. The Roome epitaph (lines run together on stone):

> Sleep Lovely Babes, Since God hath Call'd the hence,
> We Must Submit to his Blesst Will & Providence.

(b) Richmondtown, Staten Island, N.Y. 10 x 21¾. Stone of Sarah Richards, died 1760 at age 52. A small pronged crown, different from any of the others used by Zuricher, alludes gracefully to the deceased lady's heavenly station. The fine lettering on this marker is exactly like that on Plate 26a. Compare photograph, Plate 88. Epitaph:

> She Was a Good Neighbor
> A Tender Mother to Ten
> Children And An Obedient
> Wife 35 Years Six Months And
> 28 Days Whose UnsPotted
> Characters May Call Her the
> Patran [pattern] of A Christian.

27. Style of John Zuricher.

(a) Richmondtown, Staten Island, N.Y. 8½ x 26½. Stone of Jeremiah Stanton, died 1771 at age 37. Epitaph:

> Here lyes the Body of Jeremiah Stanton
> Esquire Born in England at Lynn Regis
> In the County of Norfolk January the 3d
> 1734 Who From his Earliest Days having
> Devoted Himself to the Service of his
> Country Supported with Honour the
> Respectable Name of his Ancestors,
> After the Conquest of Martinico his Health
> Being Impaired by the Vicissitudes of A
> Toilsome Life He Retired from the Army
> Having Served As a Captain In the 60th or
> Royal American Regt of Foot, Ever Since Its
> Creation: And Died on the 23d of September
> 1771. Louisa Theresa his Widow has Erected this
> Monument to His Memory.

(b) Trinity Church, N.Y.C. 9½ x 27¼. Stone of Margaret Bowles, died 177? at age 5 weeks; her brother William, died 1776 at age 3; and John Bowles, Sr. Epitaph:

> The Lord Gave and the Lord Hath Taken Away
> Blessed be the Name of the Lord.

28. Style of John Zuricher, Trinity Church, N.Y.C.

(a) 9 x 22¼. Stone of Hester Weyman, died 1769 at age 34. The frowning mouth and staring eyes make the expression of this angel a bit more intense. The typical repetition of spiral motifs both enlivens and harmonizes the whole.

(b) 11 x 24½. Stone of Mary Alsop, died 1772. A neat, uncluttered design formula, which Zuricher sometimes repeated, as in the stone of John Alsop, Mary's husband (died 1761), also in Trinity.

29. Style of John Zuricher, Trinity Church, N.Y.C. 20 x 26¾. Stone of Sarah Jauncey, died 1763 at age 45. The facial shape is a cross between the elongated pear-shaped and square types. Compare photographs in Plates 88 and 89. The stone of Abraham Williams (died 1763 at age 29), also in Trinity, has the same design as this Jauncey stone, and bears the epitaph:

> Free From Invay [envy] and Strife Was All his Life
> Little of the World Did He Shear
> Because His Thoughts Was on Christ His Saviour Dear
> Stay Reader Stand and Sheed A Tear
> And Think on Me Who Now Lies Here
> And As You Read This State of Me
> Think Of the Glass Which Runs For The[e]
> In Christ Alone I Put My Trust
> To Rise in Judgment With The Just.

30. Style of Ebenezer Price (1728–1788), active c. 1757–1788 in Elizabeth, Orange, Union, Woodbridge and Succasunna, N.J., represented by Plates 30a through 33b and possibly by Plates 34 and 65.

(a) Elizabeth. 15 x 23. Stone of Charity Meeker, died 1776 at age 22. The spirals on either side of the word "HERE" are a feature of Price's lettering, later copied by apprentices like David Jeffries. See the photographs of the stone and its signature, Plates 96 and 104a.

(b) Orange. 6 x 14. Stone of Mary Condict, died 178? when less than 1 year old. Probably by Price, though unsigned. Epitaph:

> Sleep dear Babe and take thy rest
> Both Young and old must die
> God Cald you home he thought it best.

See photo of Jerusha Spencer stone, Plate 98.

31. (a) Elizabeth. 10¼ x 20½. Stone of Nehemiah Wade, died 1776 at age 40, and his wife Abigail, died 1783 at age 43. This is the only known Price stone with a bird motif. See photograph, Plate 97.

(b) Price's signature from the Wade stone.

32. Elizabeth. 30½ x 24. Stone of Benjamin Price, Jr., died 1759 at age 51. The rubbing includes ⅞ of stone. Initialed "E.P." at bottom of stone. See Introduction, p. 17, for the relationship of this stone to apprentice D. Jeffries' work.

33. Five signatures, all from markers in Elizabeth, by Price and two of his apprentices.

(a) 5½ x 15. Stone of Abigail Hetfield, died 1781 at age 70. "Cut by E. Price" in script on the uppermost part of the stone. The seven-lobed top contour and the small sinuous branches with round or pointed cloverleaves and tulips filling in the area above the angel's wings are marks of Price's style. Epitaph:

> This excellent Person
> was an examplary Pattern
> Of Sincerity, Piety, Charity,
> And all other Christian [virtues?]

(b) 5 x 16¼. Stone of Jerusha Spencer, died 1787 at age 22. Signature also used by David Jeffries. The top of this stone is of the flower-bunch type, like those in Plate 30. See the photograph of this signature, Plate 104b, and of the entire stone, Plate 98, and compare the photograph of the signature on Plate 104c. Epitaph:

> I bid adieu to Earth,
> For all Things here are vain.

(c) 7 x 15¾. Stone of Daniel Sale, died 1798 at age 73. This is a fused rubbing of the two parts (crossbones and lettering) of the signature of Abner Stewart, apprentice to Ebenezer Price. See the photograph of this signature, Plate 106a, and the design of the whole stone, Plate 105, and compare the photograph of the signature on Plate 106b. Epitaph:

> As you are now, So once was I,
> In Health & Strength, tho here I lie,
> As I am now, So you must be,
> Prepare for Death & follow me.

(d) 5½ x 17. Stone of Mary Price, wife of Benjamin Price, Jr. (see Plate 32), died 1766 at age 48. Signature of David Jeffries, apprentice to Ebenezer Price. The heart-shaped inscription field has a small diamond filling out its point, an original addition by the pupil cutter. See the photograph of the whole stone and the detail of the signature, Plate 107.

(e) 3¾ x 12¾. Stone of Mary Chandler, died 1763 at age 48. Another signature of David Jeffries. A square-nosed angel with the type of crown also used by Price. Epitaph:

> Tho in the Dust I lay my Head,
> Yet gracious God, thou wilt not leave
> My soul forever with the Dead,
> Nor lose thy children in the Grave.

See photograph of entire stone, Plate 109.

34. Elizabeth, N.J. 19 x 22 (fragment of a larger table-stone set flat in ground). Possibly by David Jeffries, apprentice to Ebenezer Price, or by Price himself.

Stone of Sarah Platt, died 1782 at age 31. The seraph here is the square-nosed angel type characteristic of Price or his workshop. Compare Plates 32 and 107. Epitaph:

> In the Bloom of her Life
> Adorned with every outward Grace
> Enriched with every Christian virtue
> She, bid adieu to Earth and went to Heaven
> 'Twas the Survivor died
> Grief-worn traveller
> Go, learn Submission to the will of God
> Permanent Felicity is not
> For Man on Earth.

35. Elizabeth, N.J. 25½ x 17¼. By a carver active in Elizabeth and Union, N.J., 1733 through 1739 and possibly

to 1745, represented by Plates 35 through 37a. Stone of Robert Ogden, died 1733 at age 46. The bushy eyebrows and well-defined lips with a dour expression are distinctive features of this man's style, as is the heart-shaped inscription field framed by curling branches or vines with their rosettes and imaginary leaves or fruit in the form of fleur-de-lis. See the photograph of the top of this stone, Plate 113, and compare Plate 115. Epitaph:

> One dear to God to Man most dear
> A pillar in both Church & State
> Was he whose precious Dust lies here
> Whose soul doth with bright seraphs mate
> His name immortal shall remain
> Till this cold Clay revive again.

Other stones (not illustrated) by the same carver (all in Elizabeth) are those of John Megie (died 1741/2), Mary Woodruff (died 1745) and John Alling (died 1734). See Appendix F.

36. (a) Elizabeth. 10 x 21½. Stone of David Morehouse, died 1739 at age 51. Sweet-faced seraph sporting a tiny smile, puffed hair, bushy eyebrows and a decorative crown. The border panels have curving vines with floral protrusions. Compare Plate 115 and the photograph of the stone of Hannah Morehouse, David's wife, Plate 114.

(b) Union (Connecticut Farms Burying Ground). 7½ x 17¼. Stone of Matthias Wade, died 1739 at age 13 months. The carver's characteristic concentric flowers, multilobed or fleur-de-lis forms and diamond-shaped elements take over here, omitting an angel or seraph. Compare Plates 114 and 115.

37. (a) Elizabeth. 11½ x 22. Stone of Phebe Marsh, died 1736 at age 10. Another bouquet, with tulips and wildflowers, complemented by rosettes on side panels. Compare Plates 114 and 115.

(b) Whippany, N.J. 7¾ x 18. Stone of Aaron Burnet, died 1788 at age 10, cut by an unidentified carver.

38. From markers in Springfield, N.J., reminiscent of the style of David Jeffries, Price's apprentice (see Plates 33d, 33e, and 34).

(a) 11 x 20. Stone of Richard Stites Woodruff, died 1814 at age 23. It is questionable that Jeffries was still working in 1814, but the stone may have been cut much earlier than it was used. Epitaph:

> Farewell dear wife my life is past
> My love to you till deth doth last
> Then after me no sorrow take
>

(b) 8¾ x 19½. Stone of Charlotte Meeker, died 1771 at age 5 months. Many-petaled tulips characteristic of Jefries. Ebenezer Price used flower bunches in Elizabeth and Orange during the same period.

39. (a) Orange, N.J. 6 x 29½. Stone of the Wright children, who all died at the beginning of October, 1784: Sarah at age 8, John at age 3, Moses at age 5 months, and Joseph at age 5. Perhaps by an apprentice of an Orange, N.J., carver who used similar angels, elaborated with spirals and stars. (See Appendix D and Plates 16–20 and 78–82. Epitaph:

> Dust Thou Wert and
> Dust Thou Art.

(b) Trinity Church, N.Y.C. 5 x 14. From stone of Sarah Johnson, died 1751 at age 10 months. Carver unidentified; similar to work of some Orange and Elizabeth cutters.

(c) Trinity Church, N.Y.C. 5¾ x 16½. Stone of John Alexander Robe and his brother Thomas; the latter died 1770. Carver unidentified. This small, round-faced angel has a ridged halo.

40. Trinity Church, N.Y.C. 9 x 23½. From stone of Elizabeth Guthrie, died 1802 at age 4. Carver unidentified. This motif is unique in New York: a raised-relief cherub, swathed in a loincloth, flying across a "negative" field. One of his hands is extended in greeting or salute, the other is clasped to his heart.

41. Two markers in Trinity Church, N.Y.C., by a carver active in Trinity and St. Paul's yards and Lawrence manor, Astoria, Queens, 1768-1770, represented by Plates 42a and b.

(a) 6½ x 13½. Stone of . . . Bolton and Martha Bolton; the latter died at age 5. A pouting baby whose wings taper gracefully to long feathered tips.

(b) 8¾ x 19. Stone of Elizabeth Pundt, died 1770 at age 11. Here the cherub's face is in slightly raised relief, but the hair and wings are incised. A dimple in the chin adds an individual note.

42. (a) St. Paul's, N.Y.C. 8½ x 18½. Stone of Abijah Abbot, died 1768. The closed eyes and rosebud lips, and the wings with feathers notched at their centers or "spines," make this a lovely, subtle carving unrivaled by New Jersey cutters.

(b) Trinity Church, N.Y.C. 12 x 25½. Stone of the Slidell children, who all died in September 1770: Jane at age 5, Elizabeth, and Mary at age 1.

43. Three markers by a carver active in New York and Middletown, N.J., 1781-1785. This carver uses round-faced effigies that are suggestive of women or children. Characteristics of his style are almond-shaped eyes with well-defined pupils and eyebrows; elongated tubular noses which continue the incised lines of the eyes; fluted crowns or striated semicircular bands of hair; tiny "eyelets" beneath the chins; long- or wide-feathered wings. Sometimes, as in No. 43b, the noses are more square, short and cleft. Other stones (not illustrated) by the same carver (all in St. Paul's) are those of James Bryant, died at age 53 (same design and verses as No. 43b); Elizabeth Hilliker, died 1783 at age 3; and John Mooney, died 1781 at age 7 months; and also that of Harman Carpenter, died 1782, at Trinity.

(a) 7 x 7¾. St. Paul's, N.Y.C. Stone of Elizabeth Anderson, died 1783 at age 26; Mary Stewart, died 1779 at at age 27; and William McBride, died 1782 at age 26.

(b) 7¾ x 20¼. Middletown, N.J. Stone of Caty Leonard, died 1785 at age 24. The facial expression here is delicately elegiac. Epitaph:

> Here lies Quiet free from Life's Destracting Care,
> A tender Wife A freend sinceer—
> Whom death cut downe in Prime of Life you See,
> But stop my Grief we Soon Shall Equal Be—
> And when the Lord thinks fit to End my time,
> With her beloved Dust I Mingle Mine.

(c) 9½ x 18. Trinity Church, N.Y.C. Stone of Mrs. Sarah Venning, died 1783 at age 26, and her son John,

died 1783 at age 4 months. A fancier stone by this carver. The crown incorporates a heart at its center.

44. Two markers in Trinity Church, N.Y.C., by a carver active there in 1777.

(a) 6¼ x 15½. Stone of Peter Holmer, died 1777 at age 14 months. Unusual treatment of an effigy's face, enveloped in semicircular, scored wings.

(b) 8¼ x 20¾. Stone of Sarah Morris, died 1777 at age 31. The motif is larger here. The stone of David Morris in Trinity presents a variant of the same image, with a winged square above the head, perhaps referring to a winged hourglass or the soul rising to Heaven.

45. (a) Trinity Church, N.Y.C. 9 x 20. Stone of Sarah Vallintine, died 1749 at age 45. Carver unidentified. Striated leaf shapes double as both crown and hair for this lady.

(b) Elizabeth, N.J. 10 x 21½. Stone of Nathanael Bonnel, died 1736. Carver unidentified. Angel with another unique coiffure, of coiled spiraling locks.

46. From markers by unidentified carvers in Whippany, N.J.

(a) 6½ x 12½. Stone of Hannah Burnet, died 1777 at age 15 months. This seemingly male face, with its narrow, pinched mouth, wears a slightly pained expression.

(b) 8¾ x 17¾. Stone of Luas Burnet, Hannah's brother, died 1788 at age 5. The incised circle over the wig of the angel may indicate the sun, or it may be only ornamental.

47. (a) Elizabeth, N.J. 11½ x 21¼. Stone of Rachel Woodruff, died 1783 at age 28. Carver unidentified. Wings and eyebrows (as well as a pronounced scowl) are exaggerated for an elegant decorative effect.

(b) Union, N.J. (Connecticut Farms Burying Ground). 9 x 19¼. Stone of Synesy Burnet, died 1778 at age 31. The face of this dour old man is creased and jowled, frowning with a warning of death for the passerby.

48. From two markers by unidentified carvers in Elizabeth, N.J.

(a) 11 x 24. Stone of Zeruiah Winance, died 1737 at age 53. A wavy-haired lady with delicate, fluttery eyelashes or brows.

(b) 9½ x 22¾. Stone of Frances Watkins, died 1787 at age 57. The cherubic face is carved in high relief on an otherwise bare, flat field. The wing feathers have detailed veins. Disc-like flowers spin the side lobes of the design into motion, like the wheels of a chariot bound for Heaven. Epitaph:

> A fabric once on Earth I was
> And nothing Else but dust
> I'm gone to Join the Heavenly tribe
> And with my God to Rest.

49. From two markers in Orange, N.J., by an unidentified carver active from 1758 to the 1790's in Orange, Elizabeth and probably also Union, N.J., as well as Trinity Church, N.Y.C.

(a) 10 x 18½. Stone of Mary Peck, died 1790 at age 61. This frowning angel is graced by fringed brows and a finely carved stylized tulip crown.

(b) 12½ x 30. Stone of Mary Morris, died 1761 at age 84. The masculine angel may refer to Mary's husband, Captain John Morris. Crowned with a leafy sprout, he guards her tomb. Neat, delicate delineation of eyes,

brows and puffs of hair make this an especially fine job of carving. Other stones (not illustrated) by the same carver are those of Phebe Williams (died 1769), James Williams (died 1758) and Adonijah Cundict (died 1770), all in Orange; and those of Isaac Brafen (died 1760) and Sarah Byvanck (died 1768), both in Trinity. See Appendix E.

50. Old Hadley, Mass. 21 x 12½. Stone of Lemuel Hide, died 1800 at age 45. By the "Carver of Enfield." The profile portrait type characteristic of this carver's style is not found south of Connecticut, where he also worked. The military buttons and collar, the pigtail and the strong, jutting chin are features that refer directly to the deceased. The stylized plants and the frontal eye reveal the more primitive origins of the stonecutter's style. Epitaph:

> In Memory of Ma-
> jor LEMUEL
> HIDE Who Was
> Drowned Jan. 24th
> 1800. In the 45 Year
> of His Age.
> Major Hide belong
> To W. Haven in the
> State of Vermont.

51. From two markers by an unidentified carver in Trinity Church, N.Y.C.

(a) 8½ x 24¾. Stone of Mrs. Mary Roberts, died 1793 at age 36, and her children Thomas Ketland (died at 4 months), Thomas Albian (died at 6 months) and Frances (died at 19 days). The angel's face is carved in slight relief, while the wings are incised with calligraphic precision. Rays of light emanate from the head, denoting the holiness of the angel or the triumph over death in Heaven.

(b) 13½ x 25. Stone of Mrs. Esther Shepherd and her son James, who died on the same day in 1798 (at the age of 31 and 5, respectively).

52. From two markers by an unidentified carver who worked in the vicinity of New York, with stones appearing at Elizabeth, N.J., and at Tarrytown, N.Y., from the 1770's to the 1790's.

(a) Elizabeth, N.J. 8¾ x 18¼. Stone of John Drewe, died 1771 at age 80. Raised relief angel with elaborate scrollwork patterns surrounding the wings. The step-like contours of the headstone reflect the interior design admirably.

(b) St. Paul's, N.Y.C. 15½ x 23. Stone of Jane Spingler, died 1790 at age 53. The face of this frowning denizen of Heaven is in raised relief. Curving above the head are wavy lines, perhaps a suggestion of clouds. The scrolls, wing pattern and stepped contour recall the preceding stone from Elizabeth, which is just across the Hudson River from downtown New York. The epitaph is given in the Introduction, p. 25 . A very similar design appears on the stone in Plate 95.

53. (a) Trinity Church, N.Y.C. 10 x 25¼. Stone of Isaiah Rogers, died 1795 at age 39. Carver unidentified. The influence of calligraphic penmanship is clear in this graceful carving. Epitaph:

> The Sweet remembrance of the just
> Shall flourish when they sleep in dust.

(b) St. Paul's, N.Y.C. 8 x 20. Stone of William Muckelvain, died 1786 at age 23. Carver unidentified. A purely ornamental design resembling the patterns of Pennsylvania Dutch (German) "fraktur" drawings and decoration.

54. (a) Union, N.J. (Connecticut Farms Burying Ground). 8 x 20¼. Stone of Phebe Brant, died 1799 at age 66. Carver unidentified. The bird is a common metaphor for the soul or spirit, and was frequently cited as such in eighteenth-century sermons. Compare Plate 4a. Epitaph:

> Mourn not for me my friends
> Since God has thought it best
> To Take my Soul from here below
> To his eternal rest.

(b) Elizabeth, N.J. 6¾ x 15. Stone of Jonathan Oliver, died 1733 at age 34. Carver unidentified. The winged hourglass was a classic symbol of mortality (see Introduction, p. 23).

55. From two markers by unidentified carver(s) in Trinity Church, N.Y.C., with Masonic symbols.
(a) 10½ x 25. Stone of James Leeson, died 1794. The cryptographic legend across the top is decoded as "Remember death." In the central circle a cinerary urn encloses a small "soul-heart" in its flames. At the left is a winged hourglass (compare Plate 54b) and at the right are a plumb, sector, square and compass—Masonic symbols referring to reason, moral propriety and the organization of Freemasonry.
(b) 9 x 23¾. Stone of William Carlile Handy, died 1759 at the age of 10 months. The design probably refers to Masonry. Perhaps John Handy, William's father, was a member. See photo of this stone, Plate 118. Epitaph (compare Plate 26a):

> Sleep lovely Babe since God hath Cal'd thee hence
> Wee must submit to his blest will & Providence.

56. From two markers by unidentified carvers.
(a) Union, N.J. (Connecticut Farms Burying Ground). 5 x 6¼. Stone of Captain John Allen, died 1826 at age 65. The crossed sabers on the stone of this Revolutionary War soldier refer to his military role and rank. Compare the photo of the stone on Plate 101. Epitaph:

> Let this vain world engage no more
> Behold the gaping tomb:
> It bids you seize the perfect hour
> Tomorrow Death may come.

(b) Trinity Church, N.Y.C. 13 x 26¾. Stone of Daniel Rowls Carpenter, died 1787 at age 44. Three cannons, ready to roll on their spoked wheels. Below, the embellishment of the word "In" is a beautiful addition. Inscription: "He was a member of the Company of Officers sent To this place by the Honourble Boared of Ordinance under the direction of Major Dixon: Chief Engineer of America."

57. Northampton, Mass. 24 x 20. By Nathaniel Phelps (1721–1789) of Northampton. Marker for Colonel Seth Pomeroy, died 1777 at age 71 (buried at Peekskill, N.Y.) This elaborate display of military symbolism is never to be found in such complexity in the New York area.

58. Northampton, Mass. 14½ x 29¾. By Nathaniel Phelps.

Stone of Major Jonathan Allen, died 1780 at age 43. The intricate eschatological imagery portrayed here is also unknown in the New York area. Epitaph is given in Introduction, p. 13.

59. (a) St. Paul's, N.Y.C. 9¼ x 27. Stone of James Targay, Jr., died 1795 at age 23. Carver unidentified. Late in the eighteenth century, calligraphic inscriptions and purely ornamental motifs became popular, replacing the crude death's-heads, as religious sentiment moved away from the need for pictorial reminders about the inevitability of death and the hope for immortality. Epitaph:

> Weep not for me you Standers by
> That here beset me round,
> For in this grave I . . .
> Until [the last Trumpet's sound?]
> When Christ . . . the Clouds,
> To judge the world abroad,
> To get . . . Saints crying aloud,
> . . . and I meet the Lord.

(b) Randolph Township, N.J. (Dover Quaker Monthly Meeting House Yard). 12 x 9½. Carver unidentified. This type of fieldstone is the earliest and most rudimentary type of grave marker. The inscription "OOY" is a Leni-Lenape Indian word meaning "friend."

60. Elizabeth, N.J. 15½ x 22. Stone of Elias Darby, died 1798 at age 26. The carver may have been Jonathan Hand Osborn of Scotch Plains, N.J. On this striking marker the dead man's initials are set within a sunburst. The crescent, in Masonic symbolism, denotes nature's obedience to God. The rising sun may also have its traditional meaning as a symbol of the Resurrection. The twining band pattern across the top of the stone, as well as the fan shapes and rosettes, also appear in Plate 61a.

61. (a) Elizabeth, N.J. 14½ x 24½. Stone of Farrington Price, died 1802 at age 45. The signature "H.O" at the bottom right of the stone appears in other versions in the area of Elizabeth, Union, Springfield and Scotch Plains, N.J., and Staten Island. It may consist of the last two initials of Jonathan Hand Osborn of Scotch Plains, active from the 1780's into the 1800's. A small "soul-heart" is echoed below with three smaller hearts in the decorative band which divides the ornamental field from the inscription area. Compare the Osborn signature on Plate 112b. Epitaph:

> Thus death you See will not relieve
> The bravest men in life
> No Mortal Soul hee'l not retrieve
> Beware of worldly strife.

(b) Signature of Plate 61a.

62. (a) Union, N.J. (Connecticut Farms Burying Ground). 12 x 19¼. Stone of Elias Osborn, died 1807 at age 84. Probably carved by Jonathan Hand Osborn, whose style is indicated by the hearts, the script initials of the deceased, diamond patterns on the side panels, and scalloped borders. The arched branch is an additional elegiac note in the design. Epitaph:

> Lord, Since thou hast permitted Death
> To fully stop our Parent's breath
> Yet from repining may we keep,
> Since he in Christ has fell asleep.

(b) Springfield, N.J. 5½ x 30. Stone of the three Wade

children: Robert, died 1808 at age 5; William W., died 1809 at age 8 days; and Matthias D., died 1818 at age 2. Signed by J. C. Mooney, Connecticut Farms (Union, N.J.), who worked there and in Springfield from about 1800 to 1825 or later. The decline in the originality of carving is symptomatic of this period; a stencil was employed here. Compare the photograph in Plate 121. In the inscription, the Wade parents "look forward, with joyful hope, to that auspicious morn, when all this dust shall rise."

(c) Signature of J. C. Mooney from the stone just described. Compare the photograph of his signature in Plate 112c.

63. From two markers possibly by Jonathan Hand Osborn. Note his characteristic scallop elements and fan-design finials.

(a) Union, N.J. 12 x 20¼. Stone of Esther Baldwine, died 1816 at age 56. The step-and-arch contour is also a favorite Osborn element. A downturned crescent appears above an urn that rests inside a circle. This reference to a sun and moon may allude to the beginning and end of existence, or may be simply decorative. Compare the photographs of the stones in Plates 121 and 129. Epitaph:

> This sudden death, which to us all
> Contains a loud and solemn call
> To all the friends and neighbours too,
> Prepare to bid this world adieu.
> For God who governs all this for the best
> . . . eternal rest.

(b) Livingston, N.J. 11¾ x 18½. Stone of Phebe Watson, died 1818 at age 40. The epitaph is given in the Introduction, p. 2.

64. Richmondtown, Staten Island, N.Y. 12½ x 20¼. Stone of Morris Leonard Taylor, died 1822 at age 77. Signed, inside a small imitation of a metal name plate: "P. D. Braisted." Other stones (not illustrated) on Staten Island by the same carver are those of Ann Cubberly, died 1815, and Jane Dobson, died 1816. Epitaph:

> Farewell dear wife I have bid adieu
> To all time; things and likewise you,
> For God hath call'd and I must go,
> And leave all earthly things below.

65. Elizabeth, N.J. 13 x 22½. Stone of Jonathan Dayton, died 1776 at age 76. Probably cut by Ebenezer Price (see Plates 30 through 34) Life has been cut down by the small axe. The legend across the top originally read: "As the tree falls, so it lies." This rubbing was done in 1964, and in the very rough winter of 1965 the finely wrought image on this stone weathered away. Perhaps this is the last record of a design which is on a par with the dove that Price placed on the nearby stone of Nehemiah and Abigail Wade (Plate 31a).

66. Elizabeth, N.J. First Presbyterian church burial ground.

67. Elizabeth, N.J. First Presbyterian church burial ground.

68. Elizabeth, N.J. First Presbyterian church burial ground.

69. Middletown, N.J. Family burial ground in the woods.

70. Trinity Church, N.Y.C. Front of the granite or slate stone of Richard Churcher, died 1681 at age 5.

71. Back of the Richard Churcher stone.

72. Elizabeth, N.J. Stone of James Sayre, died 1731 at age 11. See rubbing, Plate 1a.

73. Elizabeth, N.J. Stone of Mary Harris, died 1728 at age of 15 months. Compare the rubbing in Plate 3a.

74. Elizabeth, N.J. Stone of Martha Thompson, died 1728 at age 50. See rubbing, Plate 3b.

75. Elizabeth, N.J. Stone of Hannah Ogden, died 1726 at age 36. See rubbing, Plate 4b.

76. Elizabeth, N.J. Stone of Benjamin Ogden, died 1729 at age 49. Compare the rubbings in Plates 3b, 4a and 4b.

77. Elizabeth, N.J. Double stone of Daniel Craine, died 1723/4 at age 51, and Daniel Craine, Jr., died the same year at age 20. Compare the rubbings in Plates 2a and 2b.

78. Whippany, N.J. Stone of James Hayward, died 1732. Compare the rubbing in Plate 6a.

79. Elizabeth, N.J. Stone of Elisabeth Sale, died 1731/2 at age 33. See rubbing, Plate 8b.

80. Trinity Church, N.Y.C. Stone of Johannah Giddis and others, 1771 and 1776. See Introduction, p. 26.

81. Elizabeth, N.J. Stone of Elizabeth Daeyton, died 1766 at age 70. See rubbing, Plate 16b.

82. Elizabeth, N.J. Stone of John Ross, died 1772 at age 38. Compare the rubbing on Plate 20.

83. Elizabeth, N.J. Stone of Elisabeth Charlton, died 1778 at age 76, and her children John, died 1752 at age 19, and Elisabeth, died 1759 at age 24. See rubbing, Plate 20.

84. Elizabeth, N.J. Stone of Benjamin Crane, died 1777 at age 72. See rubbing, Plate 17.

85. Springfield, N.J. Stone of Hannah Sutfin, died 1790 at age 29. Includes verse:

> Remember Man, As You Pass By
> As You are now so Once was I
> As I am now so must you be
> Prepare for death and follow me!

Compare the rubbing on Plate 16a.

86. Elizabeth, N.J. Stone of Experience Winans, died 1759 at age 37. See rubbing, Plate 22.

87. Orange, N.J. Stone of Martha —— (1750's-1780's?). The stone of Sarah Payne, 1746, in Trinity Church, N.Y.C., has exactly the same design. Compare also the rubbing on Plate 23.

88. Trinity Church, N.Y.C. Stone of Alice Ratsey, died 1767 at age 28. Cut by John Zuricher. Compare the rubbings of stones by Zuricher, Plates 24-29.

89. Old Dutch Cemetery, Sleepy Hollow, Tarrytown, N.Y. Stone of Christina and Evart Arser, died 1765 (Christina at age 17). Cut by John Zuricher or workshop. A similar angel appears in Plate 29.

90. Tarrytown, N.Y. Stone of Elizabeth Merlling, died 1767 at age 24. Cut by John Zuricher. The curving branches with their deeply cut leaves are the prototypes for the signed Crookshank stone in Middletown, N.J. (Plate 25b). Perhaps Zuricher originally lived in the Dutch community at Tarrytown, or had relatives there.

91. Tarrytown, N.Y. Stone of Hendrik Van Tessel, died 1771 at age 66. Cut by John Zuricher. Compare Plate 27a.

92. Trinity Church, N.Y.C. Stone of Adam Allyn, died 1768. End line reads: "He Had the Failings common to many Men." This three-dimensional, protruding carving is an unusually plastic rendering for the New York stones.

93. Trinity Church, N.Y.C. Stone of David McCutcheon, died 1779 at age 43. Compare the rubbing on Plate 61a for a similar "soul-heart" in a more abstract, calligraphic context.

94. Northampton, Mass. Stone of Lucy Parsons, died 1782 at age 44. A New England "soul-heart" effigy, with the heart set centrally between the upraised wings. Such elaborate and fanciful designs are characteristic only of the regions north of New York.

95. Tarrytown, N.Y. Stone of Ann Couenhoven, died 1797 at age 63. Compare Plates 52a and 52b. Similar designs appear on the Tarrytown stones of Catriena Ecker, died 1793, and Petrus Van Tessel, died 1784.

96. Elizabeth, N.J. Stone of Charity Meeker, died 1776 at age 22. See rubbing, Plate 30a, and photo of signature, Plate 104a.

97. Elizabeth, N.J. Stone of Nehemiah Wade, died 1776 at age 40, and his wife Abigail, died 1783 at age 43. See rubbing, Plate 31a.

98. Elizabeth, N.J. Stone of Jerusha Spencer, died 1787 at age 22. See the rubbing of the signature, Plate 33b, and the photo of the signature, Plate 104b, and compare the rubbing on Plate 30 b.

99. Elizabeth, N.J. Stone of Phebe Crane, died 1776 at age 62. Note the characteristic Price angel with ridged wig, flat wings and ornamental crown. The fluted pilasters topped by fan motifs are also typical of his work. See photo of signature, Plate 104c.

100. Elizabeth, N.J. Stone of Phebe Sale, died 1757 at age 60. The same angel as in No. 99, under a five-lobed framework. See photo of signature, Plate 104d.

101. Elizabeth, N.J. Stone of Moses Ogden, died 1780 at age 20. Crossed sabers appear above the angel's head and flanking the inscription, which tells of the youth's military valor.

102. Elizabeth, N.J. Stone of Stephen Crane, died 1780 at age 71. The two rosettes on stems within the inscription field are marks of Price's. The angel wears a more regular crown here, and his hair is composed of separate coils. See the photo of the signature, Plate 104e.

103. Elizabeth, N.J. Double stone of Phebe Passel, died 1787 at age 56, and her husband Stephen, died 1786 at age 60. The stone of Sarah and Joseph Potter, 1774, Union, N.J., has the same sets of crossbones, beneath which is inscribed "Cut by . . . E. Price" over the same scored arcs.

104. Various signatures of Ebenezer Price.
 (a) From the Charity Meeker stone, Plate 96.
 (b) From the Jerusha Spencer stone, Plate 98.
 (c) From the Phebe Crane stone, Plate 99.
 (d) From the Phebe Sale stone, Plate 100.
 (e) From the Stephen Crane stone, Plate 102.

105. Elizabeth, N.J. Stone of Daniel Sale, died 1798 at age 73. Cut by Price's apprentice Abner Stewart. See rubbing, Plate 33c.

106. Signatures of Abner Stewart.
 (a) From the Daniel Sale Stone (preceding Plate).
 (b) From the stone of Daniel Price, died 1783, Elizabeth, N.J.

107. (a) Elizabeth, N.J. Stone of Mary Price, died 1766 at age 48. Cut by Price's apprentice David Jeffries. See rubbing, Plate 33d.
 (b) Detail of signature.

108. Elizabeth, N.J. Stone of Benjamin Chandler, died 1767 at age 28. Probably cut by Jeffries. The same angel appears on the signed stone of Mary Chandler, 1763 (Plate 33e), on which a tiny glove points to the name "D. Jeffries." See also Plate 104d (by Price) and 106a (by Stewart).

109. Elizabeth, N.J. Stone of Mary Chandler, died 1763 at age 58. Signed at bottom by D. Jeffries.

110. Elizabeth, N.J. Stone of Charles Tucker, died 1791 at age 61. Probably cut by J. Acken, possibly an apprentice of Price, judging by the similarity of the angel types and lettering, and the use of crossbones with initials as signature.

111. Acken's signature on the stone of Joseph Barnet, died 1784 at age 88, Elizabeth, N.J.
 (a) Bottom of the stone.
 (b) Detail of bottom left.
 (c) Detail of bottom right.

112. (a) Elizabeth, N.J. Signature on stone of Coopper Woodruff, died 1792 at age 80. Compare Plate 110.
 (b) Springfield, N.J. Signature on stone of Phebe Potter, died 1795 at age 24: "Cut by Jonathan Hand Osborn Scotch Plains."
 (c) Springfield, N.J. Signature of J. C. Mooney of

Connecticut Farms (Union, N.J.) on the stone of Sally Sayre, died 1819 at age 27. The epitaph on this stone reads:

> Alas how chang'd that lovely flow'r
> Which bloom'd and cheer'd my heart
> Fair fleeting comfort of an hour,
> How soon we're call'd to part.
> And shall my bleeding heart arraign
> That GOD, whose ways are love?
> Or vainly cherish anxious pain
> For her who rests above?
> No—let me rather humbly pay
> Obedience to His will
> And with my inmost spirit say
> The LORD is righteous still.

113. Elizabeth, N.J. Stone of Robert Ogden, died 1733 at age 46. See rubbing, Plate 35.

114. Elizabeth, N.J. Stone of Hannah Morehouse, died 1733. Compare the rubbing on Plate 36a.

115. Elizabeth, N.J. Stone of Phebe Terrill, *c.* 1730's–1740's. Compare Plate 36a.

116. St. Paul's, N.Y.C. Stone of Mary Luc . . ., *c.* 1770's. The high relief and modeled carving are unusual for New York. Compare the next plate. For a single small cherub by the same carver, set level in a more standard fashion, compare the stone of Philip Lynch, died 1776 at age 31, in Trinity Church (not illustrated).

117. Trinity Church, N.Y.C. Stone of Margaret Barron, died 1772. This rare portrait stone depicts the bust of a young woman quite naturalistically. She is draped with a mourning cloth overhead, and escorted to Heaven by two cherubs whose wings run at diagonals to the corners of the marker, another unusual feature. Compare the preceding plate.

118. Trinity Church, N.Y.C. Stone of William Carlile Handy, died 1759 at the age of 10 months. Masonic symbolism. See rubbing, Plate 55b.

119. Elizabeth, N.J. Stone of Elizabeth O. Barnet, died 1859 at age 47.

120. Trinity Church, N.Y.C. Stone of John Cuttler, died 1816, and another person. Another willow with two cut branches.

121. Elizabeth, N.J. Stone of Benjamin Haines, *c.* 1820–25. Probably by J. C. Mooney (compare Plate 62b, signed by Mooney).

122. Orange, N.J. Josiah Williams, died 1828, cut by "Schenck, New-Ark." Newark was the former name of the part of Orange where this cemetery is situated.

123. Elizabeth, N.J. Stone of Susan M. Littell, *c.* 1832. This granular marble weathers badly, and very quickly.

124. Tarrytown, N.Y. Marble, *c.* 1815. The two willows defer slightly to a sash-tied urn with the gentle arc of their trunks.

125. Elizabeth, N.J.
(a) From a marble stone, 1860's.
(b) From the marble stone of Richard Williams, *c.* 1852.

126. Elizabeth, N.J. From the stone of Eliza (no family name), 1860's.

127. Tarrytown, N.Y. Stone of Jacob Couenhoven, died 18(0?)4. The bending willow is gracefully complemented on the opposite side of the urn and pedestal by a female weeper who is draped with her mourning cloak.

128. Tarrytown, N.Y. Stone of Mary DeWitt Smith, died 1815. Two staunch young willows with pronounced roots flank the cinerary urn on its pedestal.

129. Trinity Church, N.Y.C. Urn on an obelisk, marble. After 1860.

130. Tarrytown, N.Y. Stones of William Dutcher, died 1813 at age 68, and his wife Anna, died 1820 at age 38. Coped-roof tombs with mourning palls adorn these handsome marble markers from the later period.

131. Elizabeth, N.J. Marble, 1860's.

132. Elizabeth, N.J.
(a) Marble stone of Samuel Bradbury, died 1861 at age 65.
(b) Stone of John Guest, died 1860 at age 35, and John Henry, died 186[4]. The lamb is probably a reference to the Christian flock or to Christ as the Lamb of God.

133. Elizabeth, N.J. Marble, 1860's.

134. Elizabeth, N.J. Stone of John Burnet, died 1813 at age 27. Probably cut by Jonathan Hand Osborn. The epitaph is explicit about the cause of death.

135. Elizabeth, N.J. Stone of Baker Thorpe, died 1809. The most basic message expressed by the early carvings and verses.

BIBLIOGRAPHY

Much of my fieldwork and most of my rubbings were done either before I knew of many printed sources on the subject of gravestones, or while I was attempting to gather documentation about the New Jersey and New York cutters. But to my knowledge, there is still no existing study on these men aside from the present effort. A more definitive and scholarly work was not in the realm of possibility for me.

The chief literary sources for New England stonecutters, which later served to establish a theoretical and comparative framework for my thinking, are Mrs. Forbes' *Gravestones of Early New England and the Men*

Who Made Them, and Allan Ludwig's more philosophical scholarly and photographic record, *Graven Images*. The latter book has been immensely useful to me, and has served as a point of reference and contrast for some of the illustrations here; many of Ludwig's findings and conclusions concurred with my own discoveries and thoughts about gravestones and their makers.

Among the best visual sources are the portfolios of New England rubbings compiled and made by photographer Ann Parker and writer Avon Neal, sponsored by *Art in America*, 1963. There is a forthcoming book by these authors, and they have exhibited their work widely.

Bridgman, Thomas, *Inscriptions on the Gravestones, Northampton and Vicinity,* 1850, Northampton, Mass., Hopkins and Bridgman and Co., 1850.

Burgess, Frederick, *English Churchyard Memorials*, London, 1963 (quoted in Ludwig, *Graven Images*).

Caulfield, Ernest, articles in *Bulletin of the Connecticut Historical Society.*

Corporation of Trinity Church, *Churchyards of Trinity Parish*, N.Y., 1948.

Clark, Rev. Solomon, *Antiquities, Historicals & Graduates of Northampton,* Northampton, Mass., Gazette Printing, 1882, ch. VII.

Curwen, George R., *Funeral Customs . . . Funeral Rings*, Salem, Mass., 1893.

Daughters of the American Revolution, *Early Northampton*, Northampton, Mass., D.A.R., 1914: "The Burying Grounds," pp. 89, 98.

Dunlap, William, *A History of the Rise and Progress of the Arts of Design in the United States*, N.Y., Dover, 1969 (reprint of 1834 ed.): "John Frazee," vol. II, part 1, pp. 266–269.

Ferguson, George, *Signs and Symbols in Christian Art*, N.Y., Oxford University Press, 1961.

Flexner, James T., *First Flowers of Our Wilderness*, Boston, Houghton Mifflin Co., 1947 (Dover reprint, N.Y., 1969).

Forbes, Harriette M., *Gravestones of Early New England and the Men Who Made Them*, Boston, Riverside Press, 1927 (Da Capo reprint, N.Y., 1967).

Foster, Elizabeth A., *The Northampton Book*, Northampton, Mass., The Tercentenary Committee, 1954: "Seth Pomeroy," p. 22 and ch. 5.

Frazee, John, "The Autobiography of Frazee, the Sculptor," *North American Quarterly Magazine*, vol. 6, no. xxxi, July 1835, chs. 2–4.

Gardner Collection of Genealogies, N.J. Special Collections, Rutgers University, New Brunswick, N.J.: family of Benjamin Price I (1621–1712).

Gillon, Edmund Vincent, Jr., *Early New England Gravestone Rubbings*, N.Y., Dover, 1966.

Green, Samuel, *American Art: A Historical Survey*, N.Y., Ronald, 1966, p. 178.

Jacobi, Jolande, *The Psychology of C.G. Jung*, revised ed., New Haven, Yale University Press, 1964.

Johnson, Clifton, *Old-Time Schools and School-Books*, N.Y., Macmillan Co., 1904 (Dover reprint, 1963).

Lipman, Jean, *American Primitive Painting*, N.Y., Oxford University Press, 1942.

Ludwig, Allan, *Graven Images*, Middletown, Conn., Wesleyan University Press, 1966.

———, "Stone Carving in New England Graveyards," *Antiques*, July 1964.

Mann, Thomas, and Green, Janet, *Over Their Dead Bodies; Yankee Epitaphs and History*, Brattleboro, Vt., Stephen Greene Press, n.d.

Neal, Avon, review of *Graven Images* by Allan Ludwig, *The New England Quarterly*, XXXIX, March–Dec. 1966, pp. 547-9.

Neal, Avon, and Parker, Ann, "Archaic Art of New England Gravestones," *Art in America*, June 1963.

———, "Carvers in Stone," *Vermont Life*, Fall 1964.

———, "Graven Images: Sermons in Stone" (rubbings by Parker and Neal, text by Neal, *American Heritage*, XXI, no. 5, August 1970, pp. 18 ff.

———, "The Graverubbers," *Look*, 1963.

———, "The Graverubbers," *Time*, March 22, 1963.

———, *"Know Ye the Hour," Early American Stone Carving*, an exhibit at the Hallmark Gallery, N.Y., March–April 1968.

———; *Rubbings from Early American Stone Sculpture, Found in the Burying Grounds of New England*, 3 portfolios sponsored by *Art in America*, 1963.

New England Primer, Boston, James Loring Cornhill, *c.* 1800.

New Jersey Journal, Elizabeth, N.J., advertisements, June 4, 1788; June 15, 1789; July 5, 1789.

Panofsky, Erwin, *Tomb Sculpture*, N.Y., Harry N. Abrams, 1964.

Puckle, B., *Funeral Customs*, N.Y., Frederick A. Stokes Co., 1926.

Ross, Aaron, broadside advertising the stonecutting business, printed by A. Blauvelt, May 13, 1797, New Brunswick, N.J.

Trumbull, J.R., *History of Northampton*, vol. II, Northampton, Mass., 1902.

Vincent, J.A., *History of Art*, N.Y., Barnes and Noble, 1955: "Sources of Early American Design," pp. 216–218.

Wasserman, Emily, "The Art of the Tombstone," *Grécourt Review*, Smith College, Northampton, Mass., February 1966.

——— and Beaver, Martha, "Reviving the Lost Art of Gravestone 'Rubbing,'" *Hampshire Gazette*, Northampton, Mass., May 13, 1966.

——— and Van Hoesen, Walter H., "Early Carvers in Stone," Newark (N.J.) *Evening News*, September 1965.

Weever, John, *Ancient Funerall Monuments*, London, 1631 (quoted in Ludwig, *Graven Images*).

Wheeler, William Ogden, *Inscriptions on Tombstones*, Elizabeth, N.J., 1892; records of First Presbyterian Church, Elizabethtown, N.J. (1664–1892).

Whitehill, Walter M., "American Stones," review of *Graven Images* by Allan Ludwig, New York *Times*, July 3, 1966.

Willard, Samuel, A Compleat Body of Divinity, Boston, 1726 (quoted in Ludwig, *Graven Images*).

APPENDICES

NEW YORK CITY

Trinity Church Burying Ground, Broadway at Wall Street.
St. Paul's Church Burying Ground, Broadway between Fulton and Vesey Streets.
Richmondtown, Staten Island.

NEW JERSEY

Elizabeth, First Presbyterian Church, North Broad Street (est. 1668). This is the chief source
 for my explorations and rubbings, a large cemetery dating from the early period of the
 church's foundation, through the Revolutionary War, and up to about the 1870's.)
Orange (formerly called New Ark).
Union (formerly called Connecticut Farms, where the Revolutionary battle was fought).
Short Hills (Revolutionary War to 1800's).
Springfield (Pre-Revolutionary to mid-1800's).
Livingston.
Morristown.
Hanover.
Caldwell.
Middletown (South Jersey, near the shore, where stones could be easily shipped across the
 water, to and from New York).
Parsippany (c. 1757 until the Revolution).
Whippany.
Randolph Township (Dover Quaker Meeting House).

 Other Towns in New Jersey Containing Burial Grounds

Cedar Grove.
Mount Freedom.
Mount Olive.
Oakridge.
Pequannock.
Perth Amboy.
Rockaway Valley.
Scotch Plains.
Tenant.
Tranquility.
Woodbridge.

ADJACENT TO OR OUTSIDE OF METROPOLITAN AREA

 Long Island, N.Y.

Easthampton.
Southampton.
Southold.
Cutchogue.
Aquebogue.
Jamesport.
Mattituck.
Shelter Island.
Orient Point (Brown's Hill Burying Ground, Oyster Ponds).

 Massachusetts

Old Hadley.
South Hadley.
Northampton.

[Includes New England cutters who sent stones to New York, or whose works are cited for the purpose of comparison. Other anonymous carvers are identified by style and motifs in the Introduction and in the Notes on the Plates.]

J. Acken: active at Elizabeth between c.1784 and 1792.

P. D. Braisted: active at Richmondtown, Staten Island, c.1815 to 1822 or later; a carver of highly stylized willows and tombs.

David Jeffries: active from c.1766 through c.1780's or later at Elizabeth. Apprentice of Ebenezer Price.

Joseph Lamson (Charlestown, 1656–1722): active at Charlestown, Mass.; cf. Forbes.

J. C. Mooney: active at Connecticut Farms (Union, N.J.) and Springfield c. 1800 to 1825 or later.

William Mumford (Boston, 1641–1718): active at Boston, Mass., c.1690 through 1700; cf. Forbes, p. 31.

Jonathan Hand Osborn: signed with full name or possibly with initials "H. O."; active at Staten Island, Springfield, Elizabeth, and Scotch Plains between 1783 and after 1800.

Nathaniel Phelps (1721–1789): active around Northampton, Hadley, and South Hadley, Mass., during Revolutionary War period.

Ebenezer Price (1728–1788): active at Elizabeth, Orange, Union, Woodbridge, Succasunna, N.J., c.1757–1788. Abner Stewart and David Jeffries were his apprentices.

Schenk: active at Orange ("New Ark") c.1828; a carver of willows and coffins.

Abner Stewart: active at Elizabeth, Union and surrounding towns after 1788 through 1800 or later. Apprentice of Ebenezer Price.

"P. W.": initialed at Staten Island, 1793 (Unidentified).

John Zuricher: active in New York City, Staten Island, possibly Long Island, and Middletown, N.J., c.1760 through 1770's.

Appendices C through F are intended to provide a guide or handbook *additional* to the illustrated stones, for those who might want to explore the graveyards themselves or do rubbings of stones not shown here. Only the more significant carvers mentioned within the text are included, with the exception of E. Price—a catalogue of his work would have been exhaustive, since it almost entirely fills the graveyard at Elizabeth, as well as occupying large portions of other northern Jersey cemeteries.

Plate numbers are indicated for visual cross-referencing, and the reader may also consult the Notes on the Plates for further detailed information about styles, dating, design motifs, etc.

[John Zuricher, New York, active c.1759-1776 at Trinity Churchyard, St. Paul's Churchyard, N.Y.C.; Richmondtown, Staten Island; Tarrytown, N.Y.; northeastern Long Island (Southold, Cutchogue); and Middletown, N.J.]

ELONGATED-FACED ANGELS WITH RIDGED OR SPIRALED BANDS OF HAIR, VARIOUS CROWNS, FLATTENED OR ROUND SPIRALS ON SIDE LOBES OF STONES (cf. Plates 24, 27a, 27b, 28a, 28b)

Mary Mallam, 1769, age 44; Trinity; same crown as Plate 27a.
Capt. Thomas T[u]d[e], 1770; Trinity; same calligraphy as first line of Plate 24.
George, son of Thomas and Lydia (?), 1772, age 56; Trinity.
Matthew Dial, 1768, age 30; Trinity.
Thomas Candill, 1771; Trinity.
Nicholas Jamson, 1771, age 46; Trinity.
Michael Cresap, 1775; "First Cap't. of the Rifle Battalions"; Trinity.
Elizabeth Mansfield, 1770, age 76; Trinity.

ROUNDED, PEAR-SHAPED ANGEL FACES WITH RIDGED OR SPIRALED BANDS OF HAIR, TULIP-LIKE OR SPROUTING CROWNS, etc. (cf. Plates 25a, 25b, 25c, 88)

Sarah Minthorne, 1773, age 35, and son Phillip, age 22 mos., also Elizabeth, age 8 mos., and Hannah; Trinity; cf. Plates 25b, 25c.
Tim McCarthy, 1762, age 29; Trinity.
Capt. Mark Vallintine, 1773, age 57; Trinity; cf. above and Plates 25b, 25c.
Jonathan Stout, 1775, age 71; Middletown, N.J.; cf. Plate 24 for same verses in inscription.

SQUARED ANGEL FACES WITH RIDGED HAIR BAND, TULIP-LIKE OR REGULAR PRONGED CROWNS, ROUND SPIRALS ON SIDE LOBES, CHIN WITH DEFINED JOWLS; FINE, SMALL LETTERING (cf. Plates 26a, 26b, 29, 88, 89)

Jemima Ross, 1760, age 75, and Mary Van Gelder, 1789; Trinity.
Ruth Taylor, 1752, age 8 mos., and Sarah Taylor, 1757, age 13 mos.; cf. Plate 26a for angel; addition of hourglasses formed by heart-shaped halves.

Catherine Wiggins, wife of Charles; Trinity; unfinished inscription on husband's half of stone; unusual motif of angels leaning inward as a pair—probably early.

Thomas Charley, 1760, age 2; Trinity; cf. Plates 26a, 26b.

John Crum, 1759, age 37, and Rachel Crum, 1759, age 9 mos.; Trinity; cf. Plate 18a, same verses.

John Abrell, 1762, age 40, and his six children: Edward, 1752, 9 mos.; John, 1752, 4 mos.; Susannah, 1757, 10 days; Edward, 1760, 4½ yrs.; Susannah, 1760, 1 yr.; and Elizabeth, 1762; cf. Plate 26b.

Dr. Richard Ayscough, 1760, age 37; Trinity; cf. Plates 26a, 26b.

John Wright, 1761, age 65; Trinity; cf. Plates 26a, 26b, 88.

Capt. Richard Ptea, 1768, age 61; Trinity.

Robert Ratsey, 1767, age (?)3; Trinity; cf. Plate 88, his wife's neighboring stone.

Abraham Williams, 1763, age 29; Trinity; cf. Plate 29.

Thomas Palmer, 1760, age 25; Trinity.

John Jones, 1761, age 32; Trinity.

Esther, wife of Henry Lawrence, and Henry Lawrence, 1763, age 65; Trinity.

Catherine Bardin, n.d.; Trinity.

Richard Bydder, 1767, age 71; Trinity.

James Singer, 1764, age (?), and wife Kitty, 1789, age 67; Trinity.

Mary Spederwh(?), 1767, age 65; cruder cutting may indicate an apprentice here.

Appendix D
Unillustrated Stones by
Carver Active c. 1764–1790

[Unidentified carver, active c.1764 to 1780's or 1790, in Elizabeth, Orange, Springfield, and Parsippany, N.J. Large, broad lettering and scored frameworks typify the inscription fields on the fine-grained red sandstone used by this carver.]

ELONGATED-FACED ANGELS SURROUNDED BY INSCRIBED STARS, BANDS OF CONTINUOUS SPIRALS BETWEEN DESIGN AND INSCRIPTION PANEL (cf. Plates 17 & 84, 20 & 83, 16a, 85)

Phebe Cook, 1775, age 25; Parsippany, N.J.

Capt. John Stiles the Elder, 1777; Parsippany, N.J.

ANGELS SURROUNDED BY FIVE-POINTED OR INSCRIBED STARS AND OTHER MISCELLANEOUS MOTIFS (cf. Plates 17 & 84; 18b, with hourglasses; 18a, with upraised wings and three stars; 19, with incribed heart)

Benjamin Hunt, "Born in Rehoboth, New England, 1715," 1763, age 43; Elizabeth; heart and two stars overhead, two hourglasses and sets of large and small stars beneath wings.

Nancy, wife of Joseph Crane, and her child, 1774; Orange; three stars above wings and two below.

ELONGATED-FACED ANGELS WITH UPRAISED WINGS (cf. Plates 17 & 84, 16b & 81, and Nancy Carne, above)

Sarah Ball, 1770, age 35; Orange; wings are scaly, not feathery here.

Joseph Harrison, Sr., 1779, and Mary, his wife, 1778; double angels, same as above.

Mr. Boltis D. Hart, 1777, age 64; Parsippany; angel has concave cheeks here.

Appendix E
Unillustrated Stones by
Carver Active c. 1760's–1790

[Unidentified carver, active c.1760's to 1780's or 1790, at Elizabeth, Orange and Union, N.J., and Trinity, N.Y.C. Stylistic features include: angels with swelling cheeks or elongated faces, teardrop-shaped eyes, shapely frowning mouths and cleft chins, with bands of ridged hair topped by tulip or sprout crowns, as in Plates 49a and 49b.]

Phebe, wife of David Williams, 1769; Orange; same angel as in Plate 49b, and characteristic large, elegant lettering.

James Williams, 1758; Orange; angel has puffed hair here; many stones like this all over Trinity.

Adonijah Cundict [Condict], 1770; Orange; angel replaced by a skull, but same wings and lettering; examples at Trinity also.

Isaac Brafen, 1760; Trinity; for design and lettering, cf. Plate 49b; for the crown; cf. Plate 49a.

Sarah, widow of John Byvanck, 1768, age 64; Trinity: angel has ridged hair, long nose, eyes and mouth like Plate 49b.

TYPE SEEN IN PLATE 49a; ALL AT TRINITY

Thomas Perry, 1768; cf. Plate 49a.

Sarah Breasted, 1764, age 21 days; cf. Plate 49a.

James Dalzell, 1764, age 28; cf. Plate 49a.

TYPE SEEN IN PLATE 49b; ALL AT TRINITY

John Waddell, 1762, age 47; tulip crown, vine borders.
John Burnet, 1762, age 39.
George Meder, from London, 1768, age 54.
James Browne, 1759, age 70.
Robert and Catherine Crannell, 1761, and grandson Thomas, 1768.
Elizabeth, wife of John Stoute, 1764, age 40.
Joseph Penn, 1763, age 2.
Joseph Wright, Esquire, of Jamaica Island, 1763, age 44.
Hannah, wife of Joseph Varian, 1762, age 25.
Sarah, wife of Joseph Jadwin, 1769, age 18.
Deborah, wife of John Dowers, 1761.

Appendix F
Unillustrated Stones by
Carver Active c. 1733–1747

[Unidentified carver, active c.1733 to 1747, at Elizabeth and Union, N.J., and Trinity, N.Y. This carver's style is earlier and more sophisticated than that of Ebenezer Price and his workshop, who may have copied certain motifs from this man.]

SERAPHIM WITH CROSSED, FEATHERY WINGS, FLANKED BY FLORAL, GEOMETRIC OR FLEUR-DE-LIS MOTIFS (cf. Plates 35 & 113, 36a, 115)

SWEET-FACED ANGELS, WITH FLORAL, ROSETTE AND VINE ORNAMENTATION
(cf. Plate 114, with a horizontal vine-flower band below angel)

John Megie, 1741/2; Elizabeth; cf. Plate 36a; plants have diamond-shaped petals.
Mary Woodruff, 1745; Elizabeth.
John Alling, 1734, age 65; Elizabeth; cf. Plate 35 & 113.
Lewis Carré, 1744, age 85; Trinity; cf. above, format and angel; same border motifs as Megie stone; same horizontal panel as Plate 114.
Jonathan Woodruff, 1748, age 8 mos.; Trinity; cf. Carré stone, and that of Woodruff family at Elizabeth, below.
Mary Magdelene Leddell, 1740, age 66; Trinity; cf. Carré stone.
James Barnet, 1747, Trinity; top of stone broken, but heart-shaped inscription field remains; cf. Alling stone, above, and that of Barnet family in Elizabeth, N.J.

FLOWER BUNCH STONES (flowers supplant angel motif on top areas) (cf. Plates 36b, 37a)

Samuel Woodruff, 1747, age 7 mos., and Abigail Woodruff, 1736, age 13 days; Elizabeth; double stone with vines and rosettes in borders, as above.